18

Marcel Duchamp

Text by Arturo Schwarz

Marcel Duchamp

Harry N. Abrams, Inc. Publishers New York

LIBRARY OF CONGRESS CATALOGING IN PUBLICATION DATA

Duchamp, Marcel, 1887–1968.
 Marcel Duchamp.

 1. Duchamp, Marcel, 1887–1968. I. Schwarz, Arturo,
1924–
ND553.D774S31813 759.4 73–16230
ISBN 0-8109-0087-4

Library of Congress Catalogue Card Number: 73–16230
Copyright 1970 in Italy by Fratelli Fabbri Editori, Milan
Published by Harry N. Abrams, Incorporated,
New York, 1975

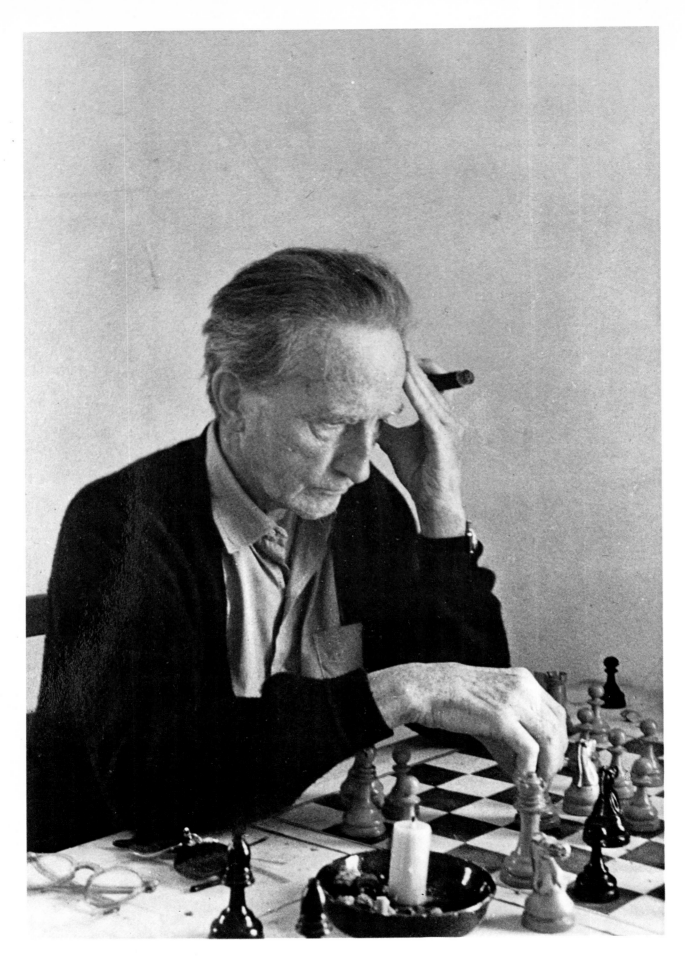

Marcel Duchamp photographed by Arturo Schwarz

Éros c'est la vie
(Rrose Sélavy)

Marcel Duchamp was brought up in a family where art was not regarded as a bohemian activity. The walls of his home were lined with etchings made by his maternal grandfather, Émile-Frédéric Nicolle, a shipping agent in Rouen and also a well-known painter and engraver who had studied with Meryon. His two elder brothers were both artists: Gaston abandoned law for painting in 1894, and chose Jacques Villon as a pseudonym because of his admiration for the poet François Villon; Raymond, under the partial pseudonym Raymond Duchamp-Villon, was to become the most important Cubist sculptor. Although the two younger sisters—Yvonne and Magdeleine—were not artists, the eldest, Suzanne, was a painter. The twice yearly visits of Duchamp's brothers to Blainville, in the course of which the conversation centered around their artistic experiences in Paris, may have been a spur to Duchamp's becoming a painter. In 1902, at the age of fifteen, he started painting quite naturally—in the garden of the family home.

From the very start he showed a boldness and a restlessness in his interests that were bound to favor the maturing of new and uninhibited views. His first three canvases, *Landscape at Blainville, Church at Blainville,* and *Garden and Chapel at Blainville,* were influenced by what was, at the time, the most extreme avant-garde movement—Impressionism. Seen today, outside the historical context in which they were born, one might mistake them for good examples of the work of a talented young man making his first attempts at rendering in oil the familiar aspects of his native countryside. But we are still in 1902—the Fauves made their first appearance as a group only three years later, at the historic Salon d'Automne of 1905—and conservative trends prevailed. Duchamp's option for Impressionism reveals a remarkable independence of spirit and a receptivity to new trends that is rather unusual in a boy of fifteen.

The formal achievement of *Garden and Chapel at Blainville,* and the facility with which it was attained induced young Marcel to start looking for something new; he lost interest in Impressionism, and its influence on his work steadily and rapidly declined. In order to develop his draftsmanship he stopped painting for a year and concentrated on drawings and sketches. His three sisters, especially Suzanne, were his favorite models. His first painting after the Impressionist experience was the *Portrait of Marcel Lefrançois* (1904). In reaction to the luscious colors of Impressionism, it was painted almost entirely in black and white and with a technique that went back to the formal experiments of some of the painters of the Renaissance; after finishing the portrait in oil, he allowed the color to dry and then went over it with color juices and varnishes to brighten it up.

Soon after leaving the Académie Julian, Duchamp volunteered for military service (not out of enthusiasm, but to avoid the two-year general conscription shortly to become law at the end of 1905), and after a year returned to Paris to live alone and paint. In the meantime, Jacques Villon had moved from Paris to Puteaux, a village just outside the city. Duchamp often spent Sundays with his brother; from the garden of the house he could see the view that became the subject of the painting *House Among Apple Trees* (1907). This work was the first to show a mild Fauve influence, and in *House in a Wood,* of the same year (probably painted in the summer in Normandy—the house is typically Norman), the Fauve influence is more marked and is coupled with a reminiscence of Van Gogh that is to be noticed in the nervous brush strokes. From 1905 to 1909, Duchamp often spent the summer at Yport, on the Normandy coast, with his brother Villon. In *On the Cliff* (1907) we can notice a new turn in his evolution; here the lessons of the later Monet combine with Bonnard's intimism, and the result is a fresh and transparent seascape.

In July, 1908, Duchamp moved to Neuilly, nearer to his brothers' homes in Puteaux, and lived there until October, 1913. Vuillard and Bonnard began to exert a more

decisive influence on his style, as is especially noticeable in *Peonies in a Vase* (1908) and in the *Red House Among Apple Trees* (1908) where it is the Fauve influence that predominates.

In the *Portrait of Yvonne Duchamp* (1909) he reverted to severer colors as a reaction both to his first experiments with the Fauve palette and to his excursion into Bonnard's Intimism—two trends that were, however, to mark his works in the following year. Even though it bears a trace of Intimism, this portrait is nearer to Manguin's austere conception of color than to Bonnard's romanticism.

The year when Duchamp became more hesitant than ever as to the road he should follow was 1909. It was then that he started taking part in the Sunday meetings held in the house of one or the other of his brothers, meetings frequented by poets and by the artists—Gleizes, La Frenaye, and others—who were later to form the Section d'Or group. He received his first invitation to the Salon des Indépendants, to which he contributed two paintings, one of which was *Landscape* (1908). In the same year he was also invited to the Salon d'Automne, and this time he sent three paintings, one of which was *On the Cliff*, painted the previous year. The painting listed as *Veules (Église)* in the catalogue of the Salon d'Automne is probably the one known today as *Saint Sebastian* (1909), an oil sketch representing a sculpture on the façade of the church at Veules-les-Roses. Both *Landscape* and *Saint Sebastian* suggest a more reserved attitude towards the Fauve palette than is apparent in earlier works.

In 1910 Duchamp saw his first Cézannes at Vollard's and was able to familiarize himself with some of the best examples of the Fauve style. In the same year, he painted his most important early works. The Impressionist influence, which had gradually weakened in the course of the years, now disappeared completely and the influence of the Fauves and then of Cézanne became paramount before fading in their turn during 1911. The fact that Duchamp was interested in Cézanne after having been involved with the Fauves should not astonish us; a young artist had many opportunities to see Fauve paintings while the works of Cézanne were known only to a small group of connoisseurs. *Nude Seated in*

a Bathtub (1910), probably done in January, is the first painting in which he used the Fauve colors more decidedly. In three other paintings of the same year (1910): *Two Nudes* (painted from professional models), *Nude with Black Stockings*, and *Red Nude*, the same theme recurs, with the Fauve influence gathering strength and culminating in the last-mentioned painting. While in the *Nude Seated in a Bathtub* the Fauve palette is tempered by a mild Intimist influence, in the *Nude with Black Stockings* the use of heavy black lines—characteristic of the Fauves' reaction to the Impressionists' careful avoidance of black—is freely adopted. On the other hand, in the *Red Nude* only the Fauve concept of the importance of color is remembered since the work is painted in subtle variations of a violent raw red, but without any of the Fauve blacks. This departure from Fauve orthodoxy demonstrates that Duchamp refused to allow himself to be confined within the rigid schemes of any particular school, however pioneering its program might have seemed.

Thus, in *Laundry-Barge* (1910), he used yet another approach, halfway between Intimism and Fauvism. The barge taken as a model belonged to an old woman who lived near the bridge of Neuilly on the Seine, in the neighborhood of Duchamp's home. He could watch the women washing laundry on weekdays, and on Sundays the deserted barge inspired him to make a painting that has since preserved its freshness and appeal throughout the years.

In *Bust Portrait of Chauvel* (1910), he gave us, in a Fauve style, a highly colored portrait of a friend and fellow painter who lived in Rouen and who, with Pierre Dumont and a few other artists, formed a sort of Rouen School. *Brunette (Nana) in a Green Blouse* (1910) is a quick sketch where the influence of Matisse is more noticeable than in any other painting of the same year.

The *Portrait of the Artist's Father* (1910), painted in Rouen, is the clearest example of Cezanne's influence on young Marcel. The structure of the portrait derives from Cézanne's proto-Cubist canons, while the colors are nearer to Cézanne's restrained range than to the Fauves' violence. This is a psychological portrait, more involved with expressing a mental concept than with experimenting in color. The

father's posture in the portrait—slightly bent forward, his head supported on his hand, his sharp eyes looking straight at the spectator—conveys the impression that the model must have been endowed with an intelligent, benevolent, and understanding nature. Duchamp succeeded in giving us an insight into the personality of his father, who had consistently helped his sons to follow the artistic career they had chosen for themselves by giving them financial aid, which was carefully noted in order to leave each son a just share of the family inheritance after the father's death.

Duchamp's interest in Cézanne is also manifest in *The Chess Game* (1910), the largest painting he had executed to that date. The painting was shown at the Salon d'Automne in the same year and it gave him the title of Sociétaire, which meant that he could exhibit at this Salon without submitting his entry to the jury. This privilege was used only once; Duchamp never exhibited at the Salon d'Automne after 1911. The painting portrays a game of chess between his brothers, Jacques Villon and Raymond Duchamp-Villon, in Villon's garden in Puteaux. In the company of their wives they have just had tea, and the atmosphere is that of a social gathering where intellectual activities are dominant. The absorbed attitude of the two brothers intent on their game is echoed in the thoughtful looks of their wives, who seem to be lost in daydreaming. As was the case with the portrait of his father, Duchamp is once again concerned with building a mental image of a situation rather than painting a composition in color.

The *Portrait of Dr. Dumouchel* (1910) is the third and last work of this series of psychological portraits. It is the painting that most clearly shows Duchamp's intentions. In a letter to Louise and Walter Arensberg, he was to write, "The portrait is very colorful (red and green) and has a note of humor which indicated my future direction to abandon mere retinal painting."[1] To compensate for the fact that his use of color is even more violent than the Fauves', the mental involvement is also greatly accentuated.

The humor to which Duchamp refers in his letter to the Arensbergs is, of course, black humor. This black humor, which anticipates the Surrealists', is related to that of Jarry, whom Duchamp had read and admired. His humor transpires even in the caption that dedicates the painting to Dumouchel—*à propos de ta 'figure' mon cher Dumouchel*. Black humor is used by Duchamp as a tool to undermine the concern with mere physical recipes in painting, in the same way that this humor anticipates his lifelong commitment to a mental rather than a retinal concept of art.

The mythical implications of Dr. Dumouchel in this portrait seem confirmed by the context in which we find him in the next painting entitled *Paradise* (1910). Here Dumouchel is pictured as Adam, in exactly the same pose as in the previous portrait, except that here he is nude and trying to cover himself. This painting seems to supply the bridge which will take Duchamp from the three psychological portraits just discussed to the three allegorical ones that were executed early the following year.

A step is thus taken towards a more universal subject matter and a greater concern with problems of a more general nature. These three compositions, *The Bush, Baptism,* and *Draft on the Japanese Apple Tree*, all of 1911, anticipate the mythical overtones of *Young Man and Girl in Spring* (1911).

In *The Bush*, the shrubs are depicted as a blue cloud-like formation that encloses two nudes. Indian and medieval iconography has familiarized us with the symbolic significance of such a scene—the Virgin (or the Goddess) is often represented as a burning bush, and the bush enclosing a Goddess between its branches is associated with sacred contexts in Indian iconology.[2] The hieratic posture of the two nudes and the ritual of initiation which the scene represents is confirmed not only by its mythical overtones, but also by the deeply absorbed expression of the faces of the two nudes and by the action of the standing nude extending a protecting hand over the kneeling nude—the neophyte. Furthermore, this gesture may also be a gesture of offering, of presenting the neophyte to the Grand Master whose presence in the painting one can feel without seeing. Lawrence Steefel emphasized the mythical character of this painting when he observed that it is "composed on the model of altar wings in fifteenth-century art." He also notes the profound

desire for renovation which is embodied in this painting: "*The Bush*, even more than the portrait of Dumouchel, seems to point towards the ultimate goal of turning the world inside out."[3]

In *Baptism* we again meet the two nudes of *The Bush*. This circumstance, and the title of the painting, may justify the hypothesis that *Baptism* adds a new chapter to the story that began with *The Bush*. Here the relationship between the two characters is no longer that of the neophyte and the master, as in *The Bush*; it is rather the relationship of the initiate and the initiator: the nude on the left is no longer kneeling before the initiator, and although the latter is painted in red (the color of immortality, the quality of the Grand Master), his protective attitude is not emphasized as in the preceding painting. Furthermore, the nude is sitting, not standing, and the hand is extended in a gesture which, although protective, respectfully refrains from touching the head of the initiate. Let us note that the two nudes are enclosed by the same type of cloud-like bush we have met before and that the baptism appears to be an esoteric rite.

Draft on the Japanese Apple Tree seems to provide the final chapter to the story developed by this trilogy. Here a Buddha-like figure is seen sitting before an apple tree whose branches are blown towards him by the wind, as if to offer its fruits—the fruits of wisdom—to the seated figure. The initiatory role of the tree and the apple in most religious systems is too familiar to require comment. While a draft has always been associated in esoteric writings with Revelation, the posture of the seated figure, which is identical to the typical posture of the Buddha, seems to indicate that the personage who is a neophyte in *The Bush* and an initiate in *Baptism* has finally attained *prajna* (enlightenment).

Standing Nude (1911) is a study in ink for the left-hand figure of *Young Man and Girl in Spring*. It should be noted that this sketch clearly derives from a schematic reduction of the essential features of the apple tree of the preceding painting. This seems to indicate that the left-hand figure of *Young Man and Girl in Spring* would be of an "arbor-type," and that to understand its psychology we should probably have to investigate the various symbolic implications of the tree.

From the very beginning of his artistic activity Duchamp thus showed a rebellious spirit. If he was to be influenced by any pictorial trend, it had to be the most advanced of the time. His use of avant-garde vocabulary was, from the very start, as personal as possible—what interested him was the game, not the rules. Passing from one style to another, never repeating the same game, he sought time and again a new outlet in a new direction. Formal problems lost all interest once they had been solved. Duchamp was to turn toward problems of content. With the *Portrait of the Artist's Father* he began to move in a direction that was to take him ever further from a "retinal" approach to painting, and toward a mental concept of art.

In 1911 Duchamp, then aged twenty-four, was living at Neuilly. This year is very important. From this point we can watch Duchamp progress from a rejection of conventional avant-garde styles and subject matter within the limits of the oil on canvas medium to the development of a concept of painting more mental than visual. While in the years previous to 1911 he had developed through the various avant-garde styles of Impressionism, Cézannism, and Fauvism, it was in this year that Duchamp turned his back on the very latest avant-garde, Cubism, and began the process of asserting his own personality through the development of an individual style. This liberation was first evidenced in paintings like *Young Man and Girl in Spring, Sonata, Dulcinea, Apropos of Little Sister, Yvonne and Magdeleine (Torn) in Tatters, Portrait of Chess Players.*

The elaboration of a style, however, did not entirely satisfy his spirit of nonconformity, and his desire for new outlets led him to go counter to the current canons of subject matter as well. By November, 1911, his paintings included two heretical themes: the machine as well as the nude. This was the month of the *Coffee Mill*, Duchamp's first machine and the formal antecedent of the *Chocolate Grinder*. The nude found its first elaboration in the new style in *Sonata*, in the drawing *Once More to This Star* (a study for the *Nude Descending a Staircase*, in which the nude ascends rather than descends), and later in the two versions

of the *Nude Descending a Staircase*. Concentrating on the theme of the nude, Duchamp completed in succession some of his most important pictures: *The King and Queen Surrounded by Swift Nudes, The Passage from the Virgin to the Bride,* and finally the *Bride*. This painting may well be considered one of Duchamp's masterpieces—it is the end product of a series of stylistic revolutions that went hand in hand with the rejection of traditional subject matter. The extent to which the nude was considered heretical in avant-garde circles is sufficiently shown by Gleizes's request "at least to change the title" when Duchamp tried to exhibit his *Nude Descending a Staircase* at the Salon des Indépendants in 1912, and which caused him to withdraw the picture although it was already in the catalogue.

The Cubists realized perfectly well that the work embodied a break with their very concept of painting, and was heretical on more than one count. The kinetic preoccupations of the painting conflicted with the Cubist commitment to a static image. "My problem was kineticism—movement. . . . Cubism is nonmoving."[4] Duchamp was seeking something quite different. He was not concerned with the Futurists' attempts to create the illusion of movement, nor was he interested, like the Cubists, in an absolute lack of dynamism. He was interested in the relationship between the static medium and the dynamic subject. "My aim was a static representation of movement—a static composition of indications of various positions taken by a form in movement."[5] The concept that finally led Duchamp to the Large Glass was based on "a desire to break up forms—to 'decompose' them much along the lines the Cubists had done. But I wanted to go further—much further—in fact, in quite another direction altogether. . . ."[6] The suspicion that the Cubists harbored for Duchamp was mutual, as is clear from an interview in 1915, in which he stated: "Now, we have a lot of little Cubists, monkeys following the motion of the leader without comprehension of their significance. Their favorite word is discipline. It means everything to them and nothing."[7] One key word epitomizes the essence of the conflict: the Cubists were concerned with discipline. They were establishing a new school with a new

aesthetic program, and Duchamp was moving towards the opposite pole—to greater freedom, to individualism, to the rejection of programs and aesthetic categories. For the Cubists, Duchamp's conception, superficially identified with a kinetic brand of Cubism itself, was dangerously close to the theories of their rivals, the Italian Futurists. The suspicion was utterly groundless since, as Robert Lebel has already pointed out, the Futurists and the Cubists were both striving towards the same goal, the establishment of a new school.[8]

For the Futurists, kineticism was the point of departure for a pictorial recipe; for Duchamp it was the root of an intellectual speculation that led in the other direction—towards a liberation from the notion of paintings as objects meant to please the eye while leaving the mind alone. The essential difference between the attitudes of Duchamp and the Futurists with respect to movement holds for their other common interest as well, the machine. The Futurists' naive and vital drive was directed to the exaltation, the celebration of the machine; Duchamp meant to deride it. "Humor and laughter—not necessarily derogatory derision—are my pet tools."[9] But as Lebel has rightly observed, "Futurism, like Cubism, has no room for humor."[10] Moreover, it cannot even be said that Duchamp's attitude was a conscious reaction to the Futurists' point of view. He is on record as having said that he never knew them, and when he describes the events that may have aroused his interest in movement, the Futurists do not play a very large part in the account. "My interest in painting the *Nude* was closer to the Cubists' interest in decomposing forms than to the Futurists' interest in suggesting movement. . . ."[11]

Duchamp's fundamental goals were "to get away from the physical aspect of painting," and "to put painting once again at the service of the mind."[12] "I was interested in ideas—not merely in visual products. I wanted to put painting once again at the service of the mind. And my painting was, of course, at once regarded as 'intellectual, literary' painting. It was true I was endeavoring to establish myself as far as possible from 'pleasing' and 'attractive' physical paintings. That extreme was seen as literary.

. . . In fact, until the last hundred years all painting had been literary or religious: it had all been at the service of the mind. This characteristic was lost little by little during the last century. The more sensual appeal a painting provided —the more animal it became—the more highly it was regarded. It was a good thing to have had Matisse's work for the beauty it provided. Still, it created a new wave of physical painting in this century or at least fostered the tradition we inherited from the nineteenth-century masters. . . . This is the direction in which art should turn: to an intellectual expression, rather than to an animal expression. I am sick of the expression '*bête comme un peintre*—stupid as a painter.' "[13]

Duchamp's desire to escape from the physical aspects of painting also explains his intellectual rejection of the retinal. "I considered painting as a means of expression, not at all as a complete aim for life, the same as I considered that color is only a means of expression in painting. It should not be the last aim of painting. In other words, painting should not be only retinal or visual; it should have to do with the gray matter of our understanding instead of being purely visual. . . ."[14] Elsewhere Duchamp has stated: "[Impressionism] in a way was the beginning of a cult devoted to the material on the canvas—the actual pigment. Instead of interpreting through the pigment, the Impressionists gradually fell in love with the pigment, the paint itself. Their intentions were completely retinal and divorced from the classical use of paint as a means to an end. The last hundred years have been retinal; even the Cubists were. The Surrealists tried to free themselves, and earlier so had the Dadaists, but unfortunately these latter were nihilists and didn't produce enough to prove their point, which, by the way, they didn't have to prove—according to their theory. I was so conscious of the retinal aspect in painting that I personally wanted to find another vein of exploration."[15] Two of these other veins of exploration are the Ready-mades and the Large Glass itself. These two phenomena largely result from the rejection of the notion of the retinal. Duchamp never stopped emphasizing the necessity for the engagement of the mind as well as the eye.

In 1915 in New York these feelings on Duchamp's part were as strong as ever, even though his paintings had already provoked very favorable reactions among the advanced circles of the avant-garde at the time of the Armory Show in 1913. In September, 1915, his first interviewer was struck by the fact that Duchamp had "nothing but antipathy for the accepted sense of any of the terms of art."[16] Duchamp's irreverence is boundless. He thinks in terms of permanent revolutions rather than final resolutions. When, in 1922, Stieglitz circulated the inquiry "Can a Photograph Have the Significance of Art?" Duchamp wrote in reply, "I would like to see it make people despise painting until something else will make photography unbearable."[17] His fundamental notion that art is concerned with the intellect rather than the senses had in the meantime begun to shape the course of his activity.

The *Bride*, painted in August, 1912, is Duchamp's last conventional painting. It marks, indeed, his farewell to the concept of art as it was understood at the time. It is considered to be one of Duchamp's most perfect works. And, indeed, he must have felt that it would have been difficult for him to surpass it. He must have been sharply aware of the dangers of repeating himself, of yielding to the intoxicating power of sheer formalism, of accepting the monotony of a *genre*, a taste. The *Bride* was a triumph in both technique and sensualism, the highest point that he could attain through the use of the traditional means of painting as a medium. However, he had come to despise the "retinal," and he had not the least intention of committing creative suicide through repetition. Having exhausted the possibilities of renewing himself within the bounds of traditional painting on canvas, he began the conquest of a totally new concept of art, attempting "to put painting once again at the service of the mind." And when Duchamp uses the word "mind" here, he is thinking of the French word *esprit*, "*esprit* in all its meanings: intellect, spirit, wit."

Elsewhere I have tried to show that the Large Glass is not only Duchamp's most important work—a widely accepted fact—but also the focal point of his whole oeuvre, the point on which his most significant previous works con-

verge, and from which his most important later works descend. The picture that directly anticipated the basic theme of the Glass is *Young Man and Girl in Spring*, painted in 1911. This, as we have seen, is the year which witnessed a blossoming of Duchamp's personality and in which his individuation process was sharply accelerated. Duchamp must have sensed the importance that this painting's deeper motivations had in furthering the process of individuation since, a few months later, he attempted to make a larger version of the same theme. But the initial emotional shock responsible for *Young Man and Girl in Spring* had probably worn off, or could no longer be recaptured, and Duchamp, not satisfied with this second version, discarded it unfinished. Three years later he went back to this canvas and painted over it the *Network of Stoppages* (1914).

Young Man and Girl in Spring not only anticipates the theme of the Large Glass, but is second only to the latter in complexity. The theme is hinted at both in the double sense of the title—two young people in the "spring" of their life—and in the attitude that this Hero-Virgin pair has assumed in the painting—the two youngsters are sexually attracted to each other. We might note that the Young Man (the future Bachelor of the Large Glass) and the Young Girl (the future Bride) are barely differentiated sexually and both have their arms lifted to the sky in a Y-shaped figure, a position that is indicative of their common aspiration—immortality—and of their basic androgynous psychic patterns. This is the position of the shaman during the rituals in which he proclaims himself immortal,[18] and also of the Cosmic Man of esoteric tradition. The Y-sign embodies the concept of immortality through resurrection as well as the concept of the "double" androgynous personality. The two young people stand on two separate worlds, as is implied by the two semicircles from which they strive towards each other. The semicircle on which the Young Man stands emanates a yellowish light: it may well symbolize the Sun. The semicircle on which the Young Girl stands is darker and has a patch of silver white: the Moon.

Similarly, in the alchemical tradition the incestuous Brother-Sister pair is symbolized by the Sun-Moon pair.

Their union (*coniunctio oppositorum*) reconstitutes the original unity of the primordial being, the immortal Hermetic Androgyne (the Rebis). In the painting we may note how the meeting of the two young people appears to be both hindered and furthered by a tree whose branches grow between them. The tree as symbol conveys a great variety of meanings: here we will only remark that the tree is a symbol of the drive towards cosmic totality and also the prototype of the hermaphrodite, the synthesis of both sexes; and it may, as the *axis mundi*, act as a mediator between Earth (woman) and the Sky (man).[19] The tree in this painting grows from a circle, or rather from a transparent glass sphere that imprisons a sexless personage who closely resembles the Mercurius that is often represented in the alchemical vessel, and in fact, in this sphere, we might be tempted to recognize an alembic, the alchemical vessel. Finally, directly below the central transparent glass sphere, there is another character who rests on both the Bachelor's (Sun) world and the Bride's (Moon) world. This character participates in both worlds and is the mediator between them, reconciling in itself their contradictions.

This central personage epitomizes the meaning of this painting, which is the accomplishment, on the artistic level, of three primordial and only apparently contradictory aspirations finding gratification within the frame of the alchemical incest: the urge to reconstitute the original unity, the drive towards individuation, the wish for immortality. In the peculiar type of relationship between the two young people the real relationship of the Brother-Sister pair gradually replaces the mythical relationship of the Hero-Virgin pair. Incest is envisaged here as a means of resolving the contradictions of the male-female duality in the reconstituted androgynous unity of the primordial being, endowed with eternal youth and immortality. But it is equally important to remember that bisexuality is the archetypal quality of the creator, while the alchemical incest is the ideal mythical model for the state in which, after all contradictions have been resolved, individuation is achieved and creation becomes possible.

At this point we might call attention to the extra-

ordinary similarities between *Young Man and Girl in Spring* and its mythical model—the traditional representation of the philosophical androgyne (the Rebis or *Compositam de compositis*) as may be seen, for instance, in the illustration where the incestuous Brother-Sister pair again stand on the Sun and the Moon and where a tree grows between them once again dividing and uniting them.[20]

Even the puns conceived by Duchamp are revealing of secret and contradictory situations. Let us limit ourselves to a consideration of the most intimate one, contained in the title itself of the Large Glass. *La Mariée mise à nu par ses célibataires, même* contains a pun in which the whole theme of the work is hidden—an impossible love affair between a half-willing bride and an anxious bachelor. One has only to substitute for *même* the homophone *m'aime*, and the title reads: The Bride stripped bare by her bachelors is in love with me. In his preparatory notes for the Large Glass, and in certain puns published by Duchamp, there are allusions to a situation in which love and death are directly associated.

Not only does sexual intercourse never take place (as in the Large Glass), but the mere intention entails the most drastic of punishments—death. This is the pattern of one of the world's oldest and most widespread taboos—the taboo against incest.

In the Glass, the Bride is also called the Virgin, or *Pendu femelle*, and is indeed shown hanged from the sky. This would seem to indicate that the Bachelor's incestuous feelings are directed towards a sister rather than towards his mother, and this hypothesis may find further support if we remember that many primitive societies punish incest between siblings with death by hanging. Should we see Duchamp's punning activity as the verbal fulfillment of unconscious desires? In this case we might be willing to share Freud's point of view when he observes that "the pleasure in tendency-wit results from the fact that a tendency, whose gratification would otherwise remain unfulfilled, is actually gratified."[21]

To discover which of Duchamp's three sisters might have been the object of this unconscious incestuous love, we must return to the painting *Young Man and Girl in Spring*.

It would seem fairly obvious that this person must be the recipient of the picture. We have only to read the dedication on the back of the canvas to learn who the recipient is. Duchamp's dedication reads: *À toi ma chère Suzanne*; the painting was Duchamp's wedding gift to his sister Suzanne. In writing the dedication, he left an unusually large space between the words *chère* and *Suzanne*. Remembering Duchamp's love for puns, one cannot help wanting to substitute for the word *chère* (dear) its homophone *chair* (flesh). It thus reads as a reaffirmation of the indivisible physical unity of Marcel and Suzanne, who becomes, literally, Marcel's own flesh.

This picture expresses Duchamp's sentiments with regard to Suzanne's first marriage. She had been his playmate and favorite model. Some years later, when Suzanne married her second husband, the painter Jean Crotti, a friend of Duchamp's who vaguely resembled him, he found occasion again to express his state of mind after this second "betrayal" by Suzanne. Duchamp wrote to her from Buenos Aires giving her instructions to prepare what might be considered his wedding gift, the *Unhappy Ready-made* (1919). He thus entrusted her with the same power that he had, till then, reserved exclusively to himself, that of creating Ready-mades. But the identification process does not stop at the title, which states Marcel's unhappiness. The fate of this Ready-made is the same as the Bride's—to be destroyed by hanging. We recall, in fact, that the *Unhappy Ready-made* was a geometry book which was to be hung (hanged) from its corners *outside* Suzanne's home, on her balcony, where it would be destroyed by the weather. The geometry book is also, of course, a transparent allusion to school days, to their youth—in short, to a period in which Marcel and Suzanne were not separated by any intrusive third party. The latent significance of this gift must have been clear to Suzanne as well. The only record we have of this work is the painting Suzanne made of it to rescue it from material destruction and oblivion. Here we see once again the expiatory tendency present in cases of incest. Duchamp punishes himself for desiring his sister by hanging his work, with which he identifies. This detail helps us to

understand another striking fact: many of Duchamp's Ready-mades are to be hung (hanged).

After *Young Man and Girl in Spring*, practically all of Duchamp's works, until the end of the summer of 1912, were concerned with four essential themes: family portraits; nudes; the King and Queen (traversed or surrounded by swift nudes); and the Bride. The themes of these paintings are the formal expression of four major unconscious trends and aspirations: childhood recollections and reproaches; resentment and revenge; self-idealization (the portrait of the artist as a young man); and the elevation of a personal crisis into a mythical conflict—the Young Man and Girl grow up to become the Bachelor and the Bride. The extraordinary logical and formal continuity of the works of this period becomes clear when they are seen in the following light: the Young Man of the 1911 painting is, in fact, the Nude descending the staircase; the Nude is transfigured into the King traversed by swift nudes; and the King himself becomes the mythical Bachelor of the Large Glass. Similarly, we shall recognize the Young Girl of the 1911 painting in the Queen surrounded by swift nudes, who in turn is transformed first into the Virgin and then into the Bride whom we see in the homonymous painting and in the Large Glass as well.

Sonata (1911) is the first painting concerned with the theme of childhood memories. All the female components of Duchamp's family are reunited: his mother dominating his three sisters, Suzanne seated, Yvonne at the piano, and Magdeleine playing the violin. This is one of the last paintings in which a mild Cubist influence can still be seen. In contrast, however, to the static effect of Cubist paintings, in which the areas are rigidly delineated by straight lines, here each detail is part of a dynamic whole and the composition achieves a great harmonic effect enhanced by the subdued but dominant use of yellows. Music-making is a typical group activity that strengthens family ties—Suzanne's marriage was to break them. While Yvonne and Magdeleine play the piano and the violin, two symbolic substitutes for onanism,[22] Suzanne, who is about to be married, turns her back on her sisters.

In the same month that saw the conclusion of *Sonata*, Duchamp started the first of a series of studies that included the six sketches and one painting that led, in December, 1911, to the *Portrait of Chess Players*—his two brothers: Jacques Villon (right), and Raymond Duchamp-Villon. "You will observe, in the picture of the chess players, that a very intense absorption in the game is evinced," said Duchamp in a 1915 interview; "this is produced by a technique which must be visioned to be understood."[23] The technique to which Duchamp refers was the product of an experiment with lighting; instead of painting by daylight, he decided to paint this work by gaslight, which is greenish. As the artist explained: "While painting by gaslight you know that whatever you put on the canvas will be quite grayish next morning when you look at it in the daylight. It worked quite successfully, this painting has very subdued tones, which is also part of the Cubist theory of that time—as a reaction against Fauvism and violent colors." While *Sonata* reminded Suzanne of the family ties, the series of works dedicated to chess was to remind her of the frequent chess sessions that she had had with Marcel. The importance that chess was to have in Duchamp's life is well known; here it is sufficient to note that "chess" in French (*échecs*) is a homophone of "failure" (*échec*), and that Duchamp's interest in "failure" may be paralleled to the fact that he voluntarily failed to complete the Large Glass, his artistic progeny, just as he never cared to have any physical progeny.

In *Dulcinea* (1911) the same woman, detached and cold, is pictured five times in different planes. Three silhouettes—two of which are naked—appear along an ascending line, two on a descending line. In the background may be imagined, more than perceived, a clutter of nudes. Although no staircase is visible here, this work does in some way announce the two versions of the *Nude Descending a Staircase* which were painted a few months later. *Dulcinea* anticipates the fate of the Bride who, in the Large Glass, will also be stripped bare. Let us observe, however, that since climbing or descending is "indubitably symbolic of sexual intercourse,"[24] the significance of this painting, on the unconscious level, is perhaps less chaste than might at first be

assumed. At the conscious level, however, another correspondence may be noticed. *Dulcinea* is the portrait of a woman whom Duchamp had loved without ever having made her acquaintance, a girl from the neighborhood whom he had seen from time to time on an avenue in Neuilly. One is struck by the fact that in *Dulcinea*, as in the Large Glass, Duchamp's love object is unattainable and that in both cases his frustrated love finds fulfillment in a work of art in which voyeurism is the substitute for sexual intercourse.

Two works painted in quick succession shortly after Suzanne's marriage—*Yvonne and Magdeleine (Torn) in Tatters* (1911), and *Apropos of Little Sister* (1911)—are the ones that express Duchamp's vindictive feelings most aggressively. In the first of these two paintings we see Duchamp's two sisters in double profile—one in youth, the other in old age—"completely torn in tatters and spread around the canvas," as Duchamp remarked sadistically, then adding, as if to mitigate the violence of his words, "I wanted to get out of the canvas idea, which is an organization, a very technical organization that had been accepted for centuries, and that was my torture, because the canvas itself, which is a background to everything, gets mixed up with what you are painting on it, and that was not my cup of tea." That this "tearing to tatters" of Yvonne and Magdeleine may also have been an experiment dictated by formal reasons, and not by any conscious emotional ones, does not alter the significance of the title: the unconscious motives have indeed to be sublimated through the artistic creative process if they are to overcome the censor of the conscious and find expression. And these unconscious motives find expression also in the fact that Duchamp does not simply limit himself to spreading his sisters around the canvas; by portraying them in their old age he succeeds in making this painting tense with an atmosphere of tragedy. After Suzanne's marriage, when he was left with his other two sisters, Duchamp's reaction was typical. If he can no longer have Suzanne, then to hell with Yvonne and Magdeleine, who are, moreover, identified with Suzanne, whose betrayal has caused his misery. The displacement that leads to this identification is also typical.

In *Apropos of Little Sister*, which its author regards as "charming, very beautiful but not in my sense," the same vindictive feelings appear again: the typical attributes of femininity are cancelled out, in so far as the chest of the "little sister" is concave. To make things still clearer the following caption was written on the back of the painting: *Une étude de femme—Merde.*

Once More to This Star (1911) is one of three surviving drawings made to illustrate poems by Jules Laforgue. Here the nudes climb a staircase, and, in this respect, the sketch might be considered a preliminary study for the *Nude Descending a Staircase*. Duchamp's interest in Laforgue's homonymous poem dedicated to the sun—*Once More to This Star*—was far from accidental: Laforgue expresses towards the sun the same resentment that Duchamp feels for Suzanne, and as Duchamp in *Apropos of Little Sister* denies Suzanne her feminine attributes, Laforgue denies the sun its typical attribute of warmth.

The other two Laforgue poems which were illustrated in the same months are equally instructive. In *Mediocrity* (December, 1911), the misery of the individual assumes universal proportions, and the locomotive in the drawing seems to hint not only at the missed train trips implied in Laforgue's poem, but, more specifically, at Duchamp's own train trip which, in December, took him back to Rouen to visit Suzanne and his family. His feelings on this trip are revealed by the title of the self-portrait he painted on this occasion: *Sad Young Man in a Train*. In Laforgue's poem *Eternal Siesta*, illustrated by the 1911 drawing, some of Duchamp's secret feelings find an echo. The instruments of the musical gatherings evoked in *Sonata*, a piano and a violin, play a role in the poem as well as in the drawing for the evocation of dreams and recollections. The possession of the silky body which he adores becomes finally possible in the dream of the poet; when Duchamp wakes from the dream he finds himself, like the poet, alone in his bed, prostrate, as if in his grave, and with the wish for an eternal sleep.[25]

Coffee Mill (1911), a small oil, is Duchamp's first mechanomorphic painting, and anticipates the two versions

of the *Chocolate Grinder* and the *Glider Containing a Water Mill in Neighboring Metals,* both subjects that were finally incorporated in the Large Glass. This is also "Duchamp's earliest proto-Dada work, his first gesture of turning against the practices as well as the symbols of the traditional artist. Here, for the first time, he dissects the machine, and in exploring its parts, makes a new machine, showing in the process sardonic amusement with, and irreverence for, the power of the machine and the modern sanctities of efficiency and utility."[26] We may also say that in this process of dissection the *Coffee Mill* is "stripped bare," like the Bride, as its inner cogwheels and the heap of ground coffee are revealed. Lebel has noted in this representation of the rotation of the handle arm a figure astonishingly similar to the Mandala, by which he concludes: "We know that Jung sees the Mandala as a representation, common both to Indo-Tibetan mystics and to neurotics, of a struggle against psychic dissociation and of an effort toward unification in the attempt to organize forms around a common center. . . . It is thus not unimportant that the *Coffee Mill* should have appeared at a time when we believe we have detected in Duchamp the beginning of a crisis, manifested in a moral break with his environment."[27]

In *Young Man and Girl in Spring,* we noticed the relationship between Duchamp's themes and the alchemical tradition. We recognized in the glass sphere at the center of the painting a typical alchemic distilling apparatus—the alembic; now we meet in the *Coffee Mill* another typical alchemic instrument, the grinding mill. We may see in this the continuity of Duchamp's thought and the unitary organization of his symbols. Both instruments are refining instruments—the alembic acting chemically, the mill physically. They transmute raw materials into their sublimated form just as Duchamp sublimates his sexual drives into artistic drives. Grinding, which is still a colloquialism for having intercourse, has traditionally carried the same meaning. To Steefel, Duchamp admitted "that he was aware of the sensuous pleasure of synchronized grinding,"[28] and Steefel comments: "The female character of the machine could hardly escape him, both as a word gender, and as an

ironic reference to the clasping of the object, as one embraces a woman. . . . The *Coffee Mill,* then, might be interpreted as a celebration of self-fulfillment. . . ."[29] Indeed, if we remember that the *Coffee Mill* anticipates the *Chocolate Grinder* and that Duchamp's comment on the *Chocolate Grinder* is that "the Bachelor grinds his chocolate himself," we find a direct confirmation of the symbolic significance of this mill. The *Coffee Mill*'s significance is here overdetermined since it is also a symbolic substitute for both the Bachelor and the Bride and an anticipation of the mechanization of the Large Glass's two protagonists. This overdetermination of its symbolism is a manifestation of the unitary drive of Duchamp's psyche, which seeks to conciliate the conflicting personalities of Marcel and Suzanne in a symbol deriving its logic from the common traits of their characters. No wonder Duchamp was to declare that he regarded the *Coffee Mill* as "the key picture to his complete work."

The painting *Sad Young Man in a Train* (1911) is yet another point of departure and may be considered an unfinished preliminary study leading to the two versions of the *Nude Descending a Staircase.* The caption on the back of the painting—*Marcel Duchamp nu . . .*—leaves no doubt as to the identity of the sad young man in whom we are to recognize Duchamp naked.[30] Although his explanation of the title of this painting seems to deny it any emotional overtones, we cannot discard the obvious reference to a state of mind which the whole painting reflects: the deep brown hues of the painting unmistakably create a melancholic atmosphere that is enhanced by the fact that the painting is bordered with dark Prussian blue (which has become black with age). We notice for the first time a new technique that Duchamp calls elementary parallelism— "The reduction of a head in movement to a bare line seemed to me defensible. A form passing through space would traverse a line; and as the form moved, the line it traversed would be replaced by another line—and another and another."[31] Although the influence of chronophotography, at the time much in vogue (the artist was familiar with Marey's studies), can here be recognized, Duchamp's aim

was rather "a static representation of movement," using the image of a nude in the corridor of a moving train.

Nude Descending a Staircase, No. 1 (1911) is the intermediate stage between the *Sad Young Man* . . . and the final and larger version of the same theme, *Nude Descending a Staircase, No. 2,* painted in January, 1912. In *Nude . . . No. 1,* the right- and left-hand sides are again bordered with dark Prussian blue; the Nude appears cramped in space, as if repressed. On the contrary, in the final version of the *Nude . . .* the figure emerges triumphantly from the constricting shapes to affirm its expanded presence in a firework display of flesh colors. While in the preceding two versions the prevailing atmosphere is pessimistic as an introverted nude retires within itself, in the *Nude . . . No. 2* it is an optimistic and extroverted exhibitionist trend that prevails. A nude descending a staircase is clearly an exhibitionist, and exhibitionism "represents to perfection *a conflict of the will, a denial*"[32] (the emphasis is Freud's). We are well aware that Duchamp was indeed passing through a crisis as the unconscious incest drive conflicted with its moral condemnation. However, like every oneiric symbol this one too is ambivalent, and it is this very ambivalence that points the way out of this conflict. The state of nakedness also recalls: "This age of childhood, in which the sense of shame is unknown, [which] seems a paradise when we look back upon it later, and paradise itself is nothing but the mass-fantasy of the childhood of the individual. This is why in paradise men are naked and unashamed. . . ."[33] To paraphrase Freud, Duchamp could go back into that paradise, where the sense of guilt and of shame is unknown, whenever the pressure of the conflict increased to the point of requiring an outlet, either in a night dream or in a daydream that finds expression in a work of art. Duchamp confirmed that he was perfectly aware of the shock value of this painting as well as of the frustrated feeling it expressed.

From the very outset, *Nude . . . No. 2* was considered a real provocation. We have recalled how Duchamp was asked to withdraw it from the Salon des Indépendants in 1912. When it was first exhibited in New York at the Armory Show, the reaction was even more rabid; it "be-

came the focal point of the Exhibition . . . the great majority either laughed or were infuriated."[34] The violence of the reaction leads us to believe that the question involved was not merely an aesthetic one, and that a deeper psychological explanation is to be sought. If we realize that we all harbor, to a lesser or greater extent, self-assertive impulses that manifest themselves in more or less disguised exhibitionism, we can understand the deeper motivation for the widespread anger and irony which this painting provoked. Since it is the materialization, on the aesthetic plane, of exhibitionism, the *Nude . . .* could not fail to arouse in the onlooker a sense of gratification of his own unavowed desires. The gratification of a repressed desire is always accompanied by a sense of shame which culminates, as in this case, either in anger (in the puritan) or in irony (in the nonconformist).

The nude in the painting is clearly androgynous, as is suggested by the development of the chest and by the characteristic wood color; we know that wood is a symbolic substitute for woman. We recall that Duchamp liked to assume an androgynous appearance; he chose for himself a feminine pseudonym (Rose), and a woman's portrait as his "compensation portrait."[35] By assuming an androgynous personality in the *Nude Descending a Staircase,* he reinforced the compensatory virtues of this painting. His psyche's unitary drive was gratified, and incest was no longer a necessary step for the achievement of individuation. One more important aspect of this painting ought to be stressed; it can be regarded as the forerunner of the *Nine Malic Moulds* (1914–15), which were incorporated into the Large Glass. Indeed, the multiplication of Duchamp's representation in the series of nudes coming down the stairs is similar to the multiplication of the Bachelors in the *Nine Malic Moulds* where, as noted before, it is again Duchamp who is represented.

After finishing *Nude . . . No. 2,* two months elapsed before he returned to work. As the months went by, the shock of Suzanne's marriage was attenuated. In 1912 Duchamp painted only four pictures—admittedly among the most remarkable in his oeuvre—*Nude Descending a Staircase, No. 2,* which we have just discussed, *The King and Queen*

Surrounded by Swift Nudes, and the two works painted in Munich, *The Passage from the Virgin to the Bride* and the famous *Bride*. At this point we can follow the process by which the Young Man and Girl grow up to become the Bachelor and Bride. The theme of *The King and Queen* was prepared by three preliminary sketches, the first of which is entitled *Two Nudes: One Strong and One Swift*. We have no difficulty in recognizing the "Strong Nude" on the right as the Nude descending a staircase. The formal theme is similar and the androgynous nature of the Nude (again the development of the chest region) is even slightly accentuated, as if to placate the anxiety of the "Swift Nude" on the left in which the first draft of the *Bride*'s formal theme is clearly recognizable. In this drawing the Brother-Sister pair of *Young Man and Girl in Spring* become the Hero-Virgin pair, and they undergo still another transformation to become the King-Queen pair in the next two sketches, entitled *The King and Queen Traversed by Nudes at High Speed*, and *The King and Queen Traversed by Swift Nudes*. The King and Queen, in turn, undergo a final transfiguration as they evolve into the Bachelor and the Bride in the last sketch of this series: *The Bride Stripped Bare by the Bachelors*, which anticipates both the title and the theme of the Large Glass.

The stylistic continuity of the formal theme in those four sketches substantiates well enough our claim to recognize in the different characters of the sketches the same personages—Marcel and Suzanne. Let us also note that the King and Queen of chess are particularly well suited to stand for them symbolically. In fact, in chess the King is immortal: he can be checkmated but never killed, while the etymological root of the chess Queen can be traced back to the word "virgin." The fact that both the King and Queen in these sketches and the painting are traversed or surrounded by Nudes at high speed is indicative of their common erotic fantasies. The sexual symbolism of speed and flying nudes is too familiar to be insisted upon, and Duchamp had already emphasized the erotic aspect of these works in 1915. In the third drawing—*The King and Queen Traversed by Swift Nudes*—there appears for the first time the draft of a character embodying one of the two aspects of

Duchamp's psyche. This character is seen to split from the King, as if to represent, on a physical level, the split provoked in Duchamp's psyche as the narcissistic conservative trend conflicts with the impetus of the erotic trend which finally sees the realization of its drive towards the unification of opposites. The fact that the narcissistic trend prevails is shown by the fourth sketch, in which the union of the King with the Queen is no longer represented. The Queen, indeed, is seen standing between the two expressions of the King's split personality. The victory of the narcissistic trend is reflected also in the title of this sketch: *The Bride Stripped Bare by the Bachelors*, as well as in its caption: *Mécanisme de la pudeur/Pudeur mécanique*. Thus, sexual intercourse is again displaced from the physical to the mental level, and, as if to compensate for this loss of erotic tension, the pleasure derived from voyeurism is enhanced by the Bride's modesty.

The final picture, of an extraordinary aesthetic intensity, completes the series of the first three preliminary sketches. As Duchamp declared: "Personally, I find *The King and Queen Surrounded by Swift Nudes* just as interesting as the *Nude Descending a Staircase*, even though the public evidently doesn't. You know this was a chess King and Queen—and the picture became a combination of many ironic implications connected with the words 'king and queen.' Here 'the Swift Nudes,' instead of descending, were included to suggest a different kind of speed, of movement—a kind of flowing around and between the two central figures. The use of nudes completely removed any chance of suggesting an actual scene or an actual king and queen."[36]

"To me the execution of the King is very much more masculine than that of the Queen,"[37] remarked Duchamp in 1915, and he has since said to me, "I expected to render the idea of a strong king, or a male king and a feminine queen, a female queen. And the nudes were not anatomical nudes, rather things floating around the King and Queen without being hampered by their materiality."

The nudes here move from two different directions, a blue series hovers on the top above the Queen and a pink

series flows between the King and Queen. Blue is a color which occurs but rarely as a dominant in Duchamp's palette. It is, in fact, an essentially feminine color, associated, in some cases, with prostitutes. We may see, therefore, in the blue nudes above the Queen an expression of her own nudity, anticipating the "stripping bare" to which she will be subjected in the Large Glass. Pink stands for "love nuanced by constancy, composure, self-control and prudence,"[38] the very qualities which, at this stage, characterize the erotic feelings of the King for his Queen.

"Significantly," observes Lebel, "the final composition was executed on a canvas on the back of which Duchamp in 1910 had painted an *Adam and Eve in Paradise*. For anyone at all familiar with his symbolism there is more in that than simple coincidence. To the realistic and somewhat grotesquely paradisiacal Adam and Eve of a period still tenderly ironical he opposed the somber drama of the mechanized King and Queen surrounded or traversed by disquieting meteors."[39] We might also add that the King and Queen of this painting seem to realize in a mundane world the happiness of Adam and Eve in *Paradise* (this is the definitive title of the picture) since the theme of the King achieves full maturity here, while the Queen's austere beauty heralds the formal perfection of the next two pictures.

The Passage from the Virgin to the Bride (1912) was preceded by two preliminary studies, entitled *Virgin, No. 1* and *Virgin, No. 2*. In the first the formal theme of the Queen is isolated, while in the second this theme undergoes further elaboration; we find it fully developed in the left-hand side personage of the final version of the picture. Duchamp's ambivalent feelings regarding this Virgin, who is about to become an untouchable Bride contended for by numerous Bachelors, are well expressed by the title of these two sketches since in French, as in German, prostitute is euphemized in "girl" or in "virgin."[40] He considered *The Passage from the Virgin to the Bride* to be a study for the *Bride*, which for him "was more final and cleared." He was delighted with its ambiguous title, because "there should be, of course, a *double-entendre* there." Indeed, the "passage" refers not only to the fact that this painting is intermediate

between the two sketches of the *Virgin* which precede it and the painting of the *Bride* which follows, but also to the theme of the painting, which is a description of a young woman's passage from the virginal state to the bridal one. Thus, on the left-hand side of this painting, we clearly recognize the stylistic motif of the *Virgin,* which when passing to the right-hand side evolves into the structural formulation of the Bride. At that time, Duchamp conceived this painting within the cycle that should have culminated in an orthodox painting on canvas, and with the same title as the Large Glass. In the summer of 1912, he had still not conceived of *The Bride Stripped Bare by Her Bachelors, Even* as a work to be executed on glass.

The *Bride* (1912) is the painting which appropriately brings to a perfect aesthetic climax the series of paintings which had begun almost a year and a half before with *Young Man and Girl in Spring*. It is the culmination of that extraordinary stylistic continuity in the elaboration of the formal theme of the Bride which we have just examined. In turn, a morphological analysis of the Bride of the Large Glass will reveal that her features are derived from a reduction to an essential synthesis of the Bride's structure in the homonymous painting. A detail in this structure is of the greatest importance; right at the center we can recognize an alembic—the classical androgynous symbol in alchemy. The androgynous nature of the Bride is further confirmed by another fact; Duchamp writes that the spinal column of the Bride is arbor-type, and we may recall again that the tree is a typical symbol of bisexuality. The Bride in this painting thus embodies the realization of the wishes of the protagonists of *Young Man and Girl in Spring*, the initial work that revealed them. Another detail of this painting may lend further support to this hypothesis: we may notice that a streamlet of liquid is entering the opening of the alembic. In the alchemic tradition, this operation stands for the alchemical marriage—the union of the Brother-Sister pair. The alchemical marriage is similarly represented in many old alchemical prints, and even in Hieronymus Bosch's famous painting *The Millennium*, where we may note in a detail a "hooded crow pouring out from a little

phial in its beak a glimmering fluid that flows down into the ovary." Fränger comments that this is "a process that in Bosch's metaphorical language indicates the celebration of an alchemical marriage."[41]

As Duchamp stated: "From Munich on, I had the idea of the Large Glass. I was finished with Cubism and with movement—at least movement mixed up with oil paint. The whole trend of painting was something I didn't care to continue. After ten years of painting I was bored with it. . . ."[42] Thus it was on Duchamp's return to Neuilly, in September, 1912, that the idea of the Large Glass as such began to crystallize. The first hint of the use of glass is to be found at the beginning of a series of notes that he devoted to this work. Here, although the Large Glass is still envisaged as "a long canvas, upright," Duchamp started to consider the use of glass elements for the "cooler," which was to consist of three parallel plates of glass, perpendicular to the canvas, and separating the Bride's Domain from the Bachelor Apparatus, exactly as in the final Glass. The passage from theoretical speculations to actual execution may have come from a banal everyday experience. "The idea came from having used a piece of glass for a palette, and looking through at the colors from the other side. That made me think of protecting the colors from oxidation, so there wouldn't be any of that fading and yellowing you get on canvas."[43]

The dislike Duchamp had for canvas as a background may also account for his choice. Finally, the choice is symptomatic from still another point of view. At one and the same time glass is both one of the hardest extant materials (only diamond and hydrofluoric acid attack it) and one of the most fragile. It thus reconciled two conflicting trends in his psyche: one that led him to make a work that would defy time, and another that led him to expose it to destruction in order to prevent the spectator from discovering its significance.

The wish to differentiate himself from other painters led Duchamp to consider creating a four-dimensional work, and the project led him to consider the use of unconventional colors and techniques to create unconventional characters. We are able to retrace the development of Duchamp's thought thanks to the notes he wrote, some of which were collected in *The Box of 1914*, and subsequently in the *Green Box* of 1934; they were completed by a third collection published in 1966 and entitled *À l'Infinitif*. Examination of this final series reveals a great number of notes devoted to the fourth dimension, which are not to be found in the ones published previously. *À l'Infinitif* thus allows us to know his intellectual interests during the second decade of the century. In it, Duchamp explains that his interest in the fourth dimension was the result of his wish to escape the banality of routine: "I thought of art on a broader scale. There were discussions at the time of the fourth dimension and of non-Euclidean geometry. But most views of it were amateurish. . . ."[44] He also clarifies his conception of the relationship between the fourth dimension and the Bride of the Glass. "Anything that has three-dimensional form is the projection in our world from a four-dimensional world, and my Bride, for example, would be a three-dimensional projection of a four-dimensional bride. All right. Then, since it's on the glass it's flat, and so my Bride is a two-dimensional representation of a three-dimensional Bride, who also would be a four-dimensional projection on a three-dimensional world of the Bride."[45] The process that led Duchamp from abstract speculation to the concreteness of this concept in the Glass can be grasped and followed by reading his notes.

The starting point is a note where Duchamp quotes Jouffret's *Géometries à 4 dimensions* to the effect that "the shadow cast by a 4-dimensional figure on our space is a 3-dimensional shadow." This concept, of course, is not remarkable for its originality. It is surely as old as Plato. Little wonder however, that Duchamp, involved in cold cerebral speculations in reaction to the romantic sensualism of painting, was attracted by this fresh scientific approach to an old metaphysical problem. Essentially, he himself was involved in the parallel process of replacing the aesthetically old and subjective with something newer and more objective. He has often emphasized that this new objectivity was a way of escaping "from the conventional expression in

painting," adding that the mechanical technique was one of the means by which the escape was effected, the means of avoiding the dangers of indulging in taste—"a mechanical drawing has no taste in it."[46]

For the establishment of a four-dimensional perspective, he first thought of using "two 'similar' objects, i.e., of different dimensions, but one being the replica of the other. . . ." But this crude plastic translation of the old Platonic concept that our world is but the microcosm of an elsewhere existent macrocosm was, of course, not sufficient for him. He found himself in more fertile territory when it occurred to him that the two-dimensional surface of a mirror could serve as the practical translation of the notion of a three-dimensional infinity, and this led him to the thought that the four-dimensional *continuum* is essentially the mirror of a three-dimensional *continuum*. And from here it was only a short step to the decision to use transparent glass and the mirror for the four-dimensional perspective. This same notion of representing a higher dimension through and in terms of a lower one lies at the base of the optical experiments to which he was later to devote himself, creating three-dimensional effects with two-dimensional objects.

Having made up his mind about the materials which would serve his purposes, he was still uncertain about the ways in which to use them. But one thing was perfectly clear: that the still to be executed Large Glass had to mark a final and decisive break with all past convention. It was his objective to succeed "in no longer thinking that the thing in question is a picture." He thought of defining it as a "'delay in glass' as you would say a poem in prose or a spittoon in silver." And the subtitle which he chose for the Glass was in keeping with this frame of mind. He associated *The Bride Stripped Bare by Her Bachelors, Even* with an "agricultural machine."

To define the Large Glass as an agricultural machine will appear less paradoxical in light of the following considerations: first of all, there is an obvious reference to the traditional concept of agriculture as the symbolic marriage of Earth and Sky; ploughing is thus connected with sowing and the sexual act. And again it is natural that Duchamp, in another note, should call this work "a world in yellow." Within the esoteric tradition, yellow is the symbol of both gold and the Sun; the Sun, in turn, is symbolic of Revelation. And in general, when revelation is involved, gold and yellow become the symbol of the state of the initiate. And since it is in the nature of archetypes, yellow as symbol is, of course, ambivalent. Sulphur is associated with both guilt and the devil. This is the color of both marriage and cuckoldry, wisdom and betrayal, the ambivalent couple and the hermaphrodite.[47] It should be noted, however, that Duchamp was unaware of the archetypal symbolic value of yellow, and that his use of it was entirely unconscious.

From 1913 onwards, Duchamp expanded the notion of unconventional materials to be used as coloring matter. From the beginning the idea of the glass is accompanied by a reference to such materials as "liquids. Colored pieces of wood, of iron, chemical reactions." He thought about testing the possibilities of ground glass, transparent glass, and colored glass. As far as liquids were concerned, he considered the possibility of a transparent colorless juice, and planned all sorts of experiments for many other materials, from the most elementary to other more complex and unconventional mixtures. In 1915 he even thought of cultivating immaterial colors in a greenhouse, each color being "in its optical state: Perfumes (?) of reds, of blues, of greens or of grays." This idea led him to "breed" dust and use it as a coloring material, as he did in the Large Glass in the region of the Sieves.

From his early theoretical speculations to their subsequent practical realization in the Large Glass, Duchamp strove to incorporate as many new means of expression as possible. In the Bride's Domain, the Top Inscription (also called the Milky Way) was to have had the appearance of shaving cream. In order to obtain "on a flat surface a conventional representation of the *3 Draft Pistons*," Duchamp hung a square piece of gauze in front of an open window and photographed it as it assumed different shapes and formed chance images in the current of air. In the once popular "barrel game," he saw "a very fine '*sculpture*' of

skill," and this induced him to introduce the element of skill for determining the positions of the nine holes which are drilled in the Glass, just below the Top Inscription in the area of the Nine Shots; these holes correspond to the points at which the Glass was struck by matches dipped in fresh paint and fired from a toy cannon. Finally, the stripping of the Bride was conceived of as being accomplished by means of an imaginary quality of electricity—its width.

In the Bachelor Apparatus, unconventional materials and techniques occur with even greater frequency. The outline of the Capillary Tubes leading the gas from the Malic Moulds to the Sieves was again determined, as with the Draft Pistons, by chance; they were drawn along various segments of the Standard Stoppages, each of which had been made according to the configuration taken by a meter length of thread stretched horizontally and dropped from the height of a meter. The unconventional quality of the techniques and materials is fully shared by the characters in the work. Among the actors in the Large Glass, Duchamp mentions an Inspector of Space, a Revolver Chewer, and a Handler of Gravity.

That the characters as well as the colors and techniques of the Glass are unconventional implies that similarly classified principles must govern them. And, in fact, one of Duchamp's earliest notes states that the Glass is subject to the rules of the "*Regime of gravity—Ministry* of coincidences" or, conversely, the "Regime of Coincidence—Ministry of gravity." He then specifies that the main active principles of the Glass are three: wind, skill, and weight (gravity). "Wind—for the Draft Pistons/Skill—for the holes/Weight—for the Standard Stops." The movements of the Handler of Gravity and the Bride were conceived of as being governed by the "Principle of subsidized symmetries." The Bachelor obeys the "Adage of spontaneity" and grinds his chocolate by himself. At the Bride's base "is a reservoir of love gasoline" the purpose of which was to fuel "the motor with quite feeble cylinders," whose strokes control "the clockwork machinery, graphic translation of the blossoming into stripping by the bachelors" as well as of her "electrical stripping." These new laws, principles, and

phenomena derive from having conceived the Glass as the representation of "a *reality which would be possible by slightly distending* the laws of physics and chemistry"—a distension which demands the invention of a "playful physics." Even space and time are subject to different laws. Space, as already mentioned, is four-dimensional, and the unit of measure is the Standard Stop; it can be stretched. As for time, the "clock *in profile*" measures a duration endowed with two or three dimensions. Duchamp fully vindicates his desire to succeed "in no longer thinking that the thing in question is a picture."

Four distinct stages may be recognized in the genesis and the development of the Large Glass, which was conceived in Neuilly, anticipated in Munich and Paris, and elaborated in New York. The first stage begins in Neuilly, early in 1911, with *Young Man and Girl in Spring* and ends in Munich, in the summer of 1912, with the *Bride*; both the plot of the Large Glass and the formal structure of its *dramatis personae* take shape. The second stage starts in Munich, in the summer of 1912, where Duchamp jots down the first of a long series of notes concerning the Large Glass, and ends in New York in 1920 with the *Oculist Witnesses*. During these eight years, each element of the Glass was the object of one or more preliminary studies, ranging from summary sketches to fully elaborated and independent works. The third stage saw the actuation of the projects, studies, and notes of the preceding years—hence the elaboration of the Large Glass itself, begun in the autumn of 1915 in New York and abandoned, unfinished, in 1923. Finally, the fourth stage of the Large Glass saw its projection in works which, from 1913 on, developed, commented, and expanded upon ideas and elements of this work. This period is the longest, since it continued until the artist's death. Let us now follow the stages that in eight years saw the construction of the work.

The lower part of the Large Glass, known as the Bachelor Apparatus, was the first part of the Glass to be planned. An oil on cardboard, executed early in 1913 but since lost, is its first draft. Soon afterwards the plan and elevation of the

Bachelor Apparatus (1913) were laid down with great precision. All the elements find a precise collocation according to classical perspective. Also in 1913, in a pencil drawing with the same title as the Glass, *The Bride Stripped Bare by Her Bachelors, Even,* Duchamp drafted the first complete layout of the Large Glass, this time including the upper half, the Bride's Domain, as well. The following year this small pencil drawing was expanded into two successive compositions, both of which, unfortunately, have been either damaged or lost. The first of these compositions showed the Large Glass on a scale half its actual size. The other, double the size of the former composition, and thus equal to the Glass itself, was executed by Duchamp on the wall of his new studio in Paris. In 1914 Duchamp also selected the first collection of notes regarding the Large Glass which he "published" in a limited edition of three examples, known as *The Box of 1914.*

In June, 1915, he abandoned Paris for New York, where he could count on the friendship of Walter Pach, who had selected his paintings for the Armory Show, and of Walter and Louise Arensberg, his first patrons. The pleasure of discovering New York in the first months made him abandon all painting activity, but with the arrival of winter he set to work: "I bought two big plate glass panes and started at the top, with the Bride. I worked at least a year on that. Then in 1916 or 1917 I worked on the bottom part, the Bachelors. It took so long because I could never work more than two hours a day. You see, it interested me, but not enough to be *eager* to finish it. I'm lazy, don't forget that. Besides, I didn't have any intention to show it or sell it at that time. I was just doing it, that was my life."[48] Another reason for the slow pace at which the work proceeded was that it was no longer really creative work, but an exact and faithful execution of preliminary sketches.

In the iconographic development of the Bride's Domain (in the upper part of the Large Glass), the first element we meet is the Bride. On the right of the Bride is the Top Inscription; a note explains that this element is a "kind of Milky Way *flesh color* surrounding unevenly densely the 3 Pistons." The latter are three square apertures, called Draft Pistons or Nets, and allow the Top Inscription to be ob-

tained. As discussed above, these were worked out by Duchamp by taking "three photos of a piece of white cloth." A square piece of gauze was hung before an open window and, as the air penetrated the room, the cloth was "accepted and rejected by the draft." The result of these photos (taken in 1914) was a series of chance images of the deformations of the square, which were recorded photographically in order to obtain "on a flat surface a conventional representation of the 3 Draft Pistons." Duchamp chose a piece of gauze because its wide-meshed regular texture helped him "avoid any play of light." Originally, he had planned to glue the three squares of gauze, frozen in the shape which the photos had revealed, directly onto the glass. It was, however, impossible to stick the gauze onto the glass, and he resolved to record on the glass only the external shapes of the three squares, or rather their photos.

The last element in the Bride's Domain is to be found to the right of the Top Inscription, which it partly overlaps, in an area delimited by a rectangle perforated by nine holes. This area is known as that of the Nine Shots because Duchamp, using a toy cannon, fired a "match with a tip of fresh paint" at a "target" from three different points three times each. Each match left a trace of paint on the glass at the point of impact; at these points the Glass was then perforated. "The figure thus obtained will be the projection *(through skill)* of the principal points of a 3-dimensional body. With maximum skill, this projection would be reduced to a point (the target). With ordinary skill this projection will be a demultiplication of the target. . . . In general, the figure obtained is the *visible* flattening (a stop on the way) of the demultiplied body" whereas the "target in short *corresponds* to the vanishing point (in perspective)."

The first element of the Bachelor Apparatus (in the lower part of the Glass), symmetrically situated with respect to the Bride above, is the Bachelor as represented by the Nine Malic Moulds. *Cemetery of Uniforms and Liveries, No.1* (1913) is the first draft to materialize this concept; this pencil sketch names and outlines the position of eight of the Nine Malic Moulds. This plan was further developed the following year in the *Cemetery of Uniforms and Liveries, No. 2*(1914),

a full-size blueprint in which the nine personages appear in reverse order with respect to the positions they will occupy in the final version. This third version, known as the *Nine Malic Moulds* (1914–15), is, in turn, the preliminary study for the similarly titled element of the Large Glass. Malic is a neologism coined by Duchamp and derived from "male," to emphasize that the moulds were quite "malish," since their ambiguous shapes could be of no help to distinguish their sex. Here is Duchamp's explanation for the fact that the Malic Moulds find themselves in a cemetery: "I gave this title to the first two studies because at the end it looked like a cemetery. It is not that I intended it to be a cemetery, but at the same time the Malic Moulds were not the forms themselves, those are inside it. The Moulds were rather a sort of *catafalco* or coffin. . . . For the sake of simplifying things, I did not want to detail every form very closely and it was a good idea to use gas which would take the shape of a thing that I did not have to draw materially, because the idea of the thing was more important than the actual design, and the actual design of a very detailed policeman would have taken too much time. . . . "

The shapes of the Capillary Tubes, the communicating channels of the Malic Moulds, were derived from the *3 Standard Stoppages* (1913–14). The Capillary Tubes had a double function, first to lead the Gas to be cast into the Malic Moulds and then out of them to the opening of the first of the seven Sieves. The shape of these tubes was, on the one hand, strictly accidental, and, on the other hand, just as strictly planned, combining a "painting of precision" with the "beauty of indifference." Here we encounter once again that combination of chance and determinism to which Duchamp often had recourse. Indeed chance plays an important role in the iconography of the Large Glass. It determines the shape of the Draft Pistons, as well as that of the Capillary Tubes, and the position of the Nine Shots. Formerly, Duchamp had already expressed the desire to "make a picture of *lucky or unlucky chance.*" For him, chance was a highly personal matter; in the apparently complete objectivity of chance he paradoxically saw a kind of subjective determinism. Of equal importance is the complex role played by the number

3 in the Glass, where it recurs, as Duchamp remarked, "as a refrain in duration." There are three main elements that govern the Glass (wind, skill, weight), and three principles that regulate it (stretching in the unit of length, the adage of spontaneity, the principle of oscillating density); in turn, each element is tributary to the number 3, above all by its component parts. "The number 3 interested me because I used it as a kind of architecture for the Glass." When I asked Duchamp the reason for his predilection for this number, he commented, "For me it is a kind of magic number, but not magic in the ordinary sense. As I said once, number 1 is the unity, number 2 is the couple, and 3 is the crowd. In other words, twenty millions or three is the same for me."

The *3 Standard Stoppages*, the work that led to the Capillary Tubes, is indeed nothing but "canned chance." Duchamp considers this work to be one of the turning points of his life. "In itself it was not an important work of art, but for me it opened the way—the way to escape from those traditional methods of expression long associated with art." Indeed, nothing could be more divorced from the traditional concept of art. Duchamp took a long rectangular canvas and painted it uniformly with Prussian blue. He then cut three one-meter-long lengths of white thread of the type used for invisible mending (*stoppage* in French, hence the title of this item). Placing himself above the canvas, and stretching the thread, he let it fall on the canvas from the height of one meter. The shape which the thread took on touching the canvas was preserved by fixing it with varnish. The experiment was repeated three times. Duchamp then cut the canvas into three rectangular strips each with its thread, and glued the strips to three plates of glass. The *3 Standard Stoppages*, defined by Duchamp as "the meter diminished," had a twofold purpose: to create "a new image of the unit of length," and to obtain a specimen of "canned chance." The accidental shapes taken by the three threads were projected onto the *Network of Stoppages* (1914), constructed with nine lines. These lines, i.e., one thread for each of the Malic Moulds, furnished the outlines used to trace the shapes of the nine Capillary Tubes on the Glass.

The idea of creating a new image of the unit of length

fits into the project to organize the laws and principles of the Glass into a "playful physics," according to which the Glass could exist as "a *reality which would be possible by slightly distending* the laws of physics and chemistry." Regarding his second goal—the creation of canned chance—Lebel sums up the issue very well when he observes that here "Duchamp . . . takes the offensive against logical reality. Duchamp's attitude is always characterized by his refusal to submit to the principles of trite realism, and if this refusal is expressed in a mocking fashion the revolt is all the more effective. . . . By opposing laws imbued with humor to laws supposedly serious he indirectly casts doubts upon the absolute value of the latter."[49]

The Sieves are the only elements that were not preceded by important studies, but only by two pencil sketches. They led, however, to one of Duchamp's most unusual and interesting experiments, *Dust Breeding* (1920), executed in collaboration with Man Ray. This work materializes one of Duchamp's projects, "For the Sieves in the Glass—allow dust to fall on this part, a dust of three or four months." Accordingly, he allowed the back of the Bachelor Apparatus to collect dust for a few months in his New York studio and then called in Man Ray to photograph the result. Once the photo was shot, the dust was carefully wiped away from the glass, except for the region of the Sieves, where varnish was run over the dust to fix it and perpetuate the color effect it had on the other side of the glass. This placed the emphasis on one aspect of dust, its connection with the concept of the flow of time. Marcel Jean acutely reminds us: "In the *Notebooks* of Leonardo da Vinci, one finds the same humorous idea of the utilization of the fall of dust as a measure of time; Duchamp's procedure is almost identical to that which Leonardo formulated. . . ."[50]

Several notes and two studies anticipated the Oculist Witnesses, which derive their formal theme from oculist charts, transferred onto the Glass by silvering it. He first envisaged obtaining the "silvered effect" by using "ground glass behind which one lays mat black paper." Some time later, to test the possibility of silvering glass, he planned to "make a mirrored wardrobe . . . for the silvering." Later

he also envisaged the use of rust and of a magnifying glass. Finally, in a letter of 1919, he mentions for the first time his intention to use oculist charts in a work of art. It was in this period, during his nine-month stay in Buenos Aires, that Duchamp realized the small glass *To Be Looked at (from the Other Side of the Glass) with One Eye, Close to, for Almost an Hour* (1918) in which the four elements of his earlier speculations—oculist charts, silvered glass, rust, magnifying glass—all entered into the composition.

Even though the *Boxing Match* (1913) was the first element, with the *Chocolate Grinder,* to be planned for inclusion in the Large Glass—it should have been inserted on top of the Oculist Witnesses—it never found its way there, either because Duchamp was dissatisfied with it, or because he never finished the Glass. The graphic abstractness of this item clearly exemplifies Duchamp's intention after his Munich experience to substitute the impersonal and dry "mechanical drawing" for the complacent sensuous artist's touch. After the *Bride* of the preceding year, he was well aware of the danger that the aesthetic result might produce complacency in the artist and thus lead to repetition. The *Boxing Match* was the graphic expression of Duchamp's ironic attitude towards this kind of danger. Notwithstanding the exhaustive, but nonsensical, caption which describes the phases of the match, the viewer is left free to imagine the development of this unusual mechanical ballet in which the solitary and robot-like protagonist anticipates science fiction's most pessimistic forecasts of a fully mechanized future. This pessimism, however, is relieved by the introduction of a feeling which is strictly human—eroticism—since the lonely fighter does not aim here at knocking out a nonexistent foe, but at stripping bare the Bride, as is hinted by the caption of this item. This may perhaps account for Duchamp's defining this match as "a romanticization of an actual fight."

The *Glider Containing a Water Mill in Neighboring Metals* (1913–15) is the only antecedent of the Glider of the Large Glass. It is also Duchamp's first work on glass. With the *Glider* . . . Duchamp had a chance to rehearse practically all the techniques that he later used in the Large Glass.

His first attempt to engrave the lines of his design on the glass by coating it with paraffin and etching it with hydro-fluoric acid was unsuccessful. Later he explained: "I found that by stretching a fine lead wire I could obtain a perfect straight line. Lead, being very malleable, was very easy to work with, and the results I obtained were much closer to my expectations." This work is one of the first examples of Duchamp's interest in achieving as impersonal a form of expression as possible. From the theoretical point of view, it is probably the most faithful to Duchamp's austere intents, and from the formal standpoint, the most finished.

The Chocolate Grinder was the first element to be executed for the Glass. It was preceded by two paintings: *Chocolate Grinder, No. 1* (1913), and *Chocolate Grinder, No. 2* (1914). Shortly after his return from Munich, Duchamp went to visit his parents in Rouen, and in a shop window of that city saw a chocolate grinder. The sight fascinated him: "The mechanical side influenced me then, or at least that was also the point of departure of a new technique. I couldn't go into the haphazard drawing or the paintings, the splashing of the paint. I wanted to go back to a completely dry drawing, a dry conception of art, and the mechanical drawing for me was the best form of that dry form of art . . . I was striving towards accuracy and precision, no more handwork . . . I was beginning to appreciate the importance of chance . . . this was the real beginning of the Large Glass."[51]

The break that this painting represented with the preceding ones was more than conceptual—embodying as it did a complete renunciation of the subjective, romantic approach. It also repudiated the Cubist reduction of forms into geometrical patterns and the dynamic organization of these patterns. "The *Chocolate Grinder* was completely static, although it might move if you let it move. But it was a reversal of the Cubist concept of movement."[52] The differences which we may notice in the two versions give us a measure of the evolution of Duchamp's concepts, which, in the brief span of a year that separates the first from the second version, made giant strides towards dry accuracy and precision.

In *Chocolate Grinder, No. 1,* the canvas is still entirely painted; traditional perspective is used; shadows and lights "interpret" the subject. The only effort to stress the anonymity of the painting was to have its title printed in gold letters on a black ribbon which was stuck in the upper right-hand corner of the canvas. If we bear in mind that this is the first work that he painted after the *Bride,* the progress is remarkable. In *Chocolate Grinder, No. 2,* the label is again used to liken the painting to something commercial and mass-produced, but all shadows are eliminated in favor of a flat "mechanical rendering of the subject." Duchamp's concept that the work of art must become a "painting of precision" endowed only with the "beauty of indifference" is well embodied here. The concept that most frequently recurs in the notes dedicated to the *Chocolate Grinder* is "exactitude"; exactitude is requested for the elaboration of each of the details of this element. In *Chocolate Grinder, No. 2,* thread was sewn to the canvas at each intersection of the lines of the rollers; a sketch of the Grinder's leg shows how the proposed Louis XV style envisaged for this leg could be reduced to a dry scheme. Some of the projects to enhance the beauty of the Grinder, such as that of having one of its details, the necktie, "resplendent in color," or to have it in "aluminum foil with brilliant shimmering stretched and stuck down," were abandoned in favor of the more severe concept that the "beauty" of the Grinder must emanate from its inner essence. In the second version, Duchamp consciously limited himself to copying the model, in an effort to represent the physical quality of the actual machine and restore its presence as objectively as possible.

In February, 1923, Duchamp left for Europe and definitely abandoned the Large Glass. "I never finished the Large Glass, because after working on it for eight years I probably got interested in something else; also I was tired. It may be that subconsciously I never intended to finish it, because the word 'finish' implies an acceptance of traditional methods and all the paraphernalia that accompany them."[53] But it is also important to remember that Duchamp did not, at a certain date, make a conscious decision to stop working on the Glass; rather, he began to lose

interest in it, once the concern had worn off. "It never was a decision, I can paint tomorrow if I wish. I don't find painting, or the idea of painting, or the painter or the artist today as suiting my attitude toward life. In other words, painting for me was a means to an end, but not an end in itself. . . . Painting was only a tool. A bridge to take me somewhere else. Where, I don't know. I wouldn't know, because it would be so revolutionary in essence that it couldn't be formulated."[54] It is difficult to accept Duchamp's explanation completely, and very likely his abandonment of the work was also based on unconscious motivations. The four missing elements (Toboggan, Boxing Match, Juggler of Gravity, and Picture of Cast Shadows) have, in fact, a common characteristic: they are all concerned with the Bachelor. We know that Duchamp's psyche is here engaged much more in repressing the active drives of the Bachelor than those of the Bride.

Despite his intention to discontinue work on the Large Glass, Duchamp went back to it in the spring of 1936 to repair it. The work had been badly damaged in 1927 on its return from the Brooklyn Museum to the home of Katherine Dreier, who had bought it from the Arensbergs. The whole Glass was splintered, and the upper right part, including the end of the Top Inscription and the region of the Nine Shots, was literally smashed to pieces, probably on account of the nine holes which had weakened the structure of the Glass. "But the more I look at it," said Duchamp, "the more I like the cracks, because they are not like shattered glass. They have a shape. There is a symmetry in the cracking, the two crackings are symmetrically disposed, and there is more; I see in it almost an intention, a curious intention that I am not responsible for, in other words, a readymade intention that I respect and love."[55] Duchamp first saw the broken Glass in October, 1933, but it was only three years later, when he returned to New York on the occasion of the second Brancusi exhibition, which he had helped to organize, that he set himself to the task of repairing it. The right end part of the Top Inscription and the area of the Nine Shots, which had been practically destroyed, had to be remade completely on a new piece of glass that was then joined to the splintered glass. This explains why the lines of the splinters, which run across the Glass from left to right, stop abruptly at a certain point. Duchamp even considered the idea of continuing the lines of the splinters across the new portion of glass using silver paper to simulate the cracks. Another element of the Glass which was completely smashed and which he had to remake was the Bride's Garment. In the original version this was composed of three parallel strips of glass running across the whole width of the Glass, separating the Bride's Domain from the Bachelor Apparatus. When he repaired the Glass a solid steel frame was substituted for the fragile glass Garment of the Bride. However, to remind the viewer of the way things stood originally, three strips of glass were again used, on top, in the middle, and below the metal frame. To hold together the two panes of splintered glass and the new inserted section, Duchamp had them clamped between two panes of glass and the whole was bound in a heavy steel frame. This is the condition in which this extraordinary work, donated by Katherine Dreier in 1954 to the Philadelphia Museum of Art, may be seen today.

Let us briefly examine the mechanics of the Large Glass, the functioning of its elements. In the Bride's Domain (the upper half of the Glass), the Bride transmits her commands, in a triple cipher, to the Bachelors (whose expression is the Gas) through the 3 Draft Pistons. The 3 Draft Pistons are surrounded by the Milky Way, which is the graphic expression of the Bride's three "blossomings." The area known as that of the Nine Shots is where the Bride's desires meet the expression of the Bachelor's. The latter's desires

THE BRIDE'S DOMAIN (upper half of the Glass) : ▶

1. *Bride* (or *Pendu femelle, Virgin, Skeleton*). 2. *Bride's Garment*. 3. *Region of the Gilled Cooler* (isolating plates). 4. *Horizon*. 5. *Top Inscription* (or *Milky Way*). 6. *Draft Pistons* (or *Nets*). 7. *Nine Shots*. 8. *Region of the Picture of Cast Shadows*. 9. *Region of the Mirror Image of the Sculpture of Drops*. 10. *Juggler of Gravity* (also called the *Trainer, Handler*, or *Tender of Gravity*).

THE BACHELOR APPARATUS (lower half of the Glass) :

11. *Nine Malic Moulds* (or *Eros's Matrix*) forming the *Cemetery of Uniforms and Liveries*. 11a *Cuirassier*. 11b *Gendarme*. 11c *Flunkey*. 11d *Department Store Delivery Boy*. 11e *Bus Boy*. 11f *Priest*. 11g *Undertaker*. 11h *Station Master*. 11i *Policeman*. 12. *Capillary Tubes*. 13. *Region of the Waterfall*. 14. *The Water Mill*. 14a *Water Wheel*. 14b *Chariot* (or *Sleigh*, or *Glider*). 14c *Runners Sliding in a Groove*. 15. *Chocolate Grinder*. 15a *Louis XV chassis*. 15b *Rollers*. 15c *Necktie*. 15d *Bayonet*. 15e *Scissors*. 16. *Sieves* (or *Parasols*, within are the *Drainage Slopes*). 17. *Region of the Butterfly Pump*. 18. *Toboggan* (or *Corkscrew*, or *Slopes of Flow*). 19. *Region of the three Crashes* (or *Splashes*). 20. *Mobile Weight with nine holes*. 21. *Oculist Witnesses*. 21a, b, c, *Oculist Charts*. 21d [*Mandala*] (should have been a magnifying glass to focus the Splashes). 22. *Marble*. 23. *Boxing Match*. 23a *First Ram*. 23b *Second Ram*. 24. *Region of the Sculpture of Drops*. 25. *Region of the Wilson-Lincoln effect*.

THE ELEMENTS IN GRAY WOULD HAVE BEEN INCLUDED IN THE LARGE GLASS HAD IT BEEN COMPLETED.

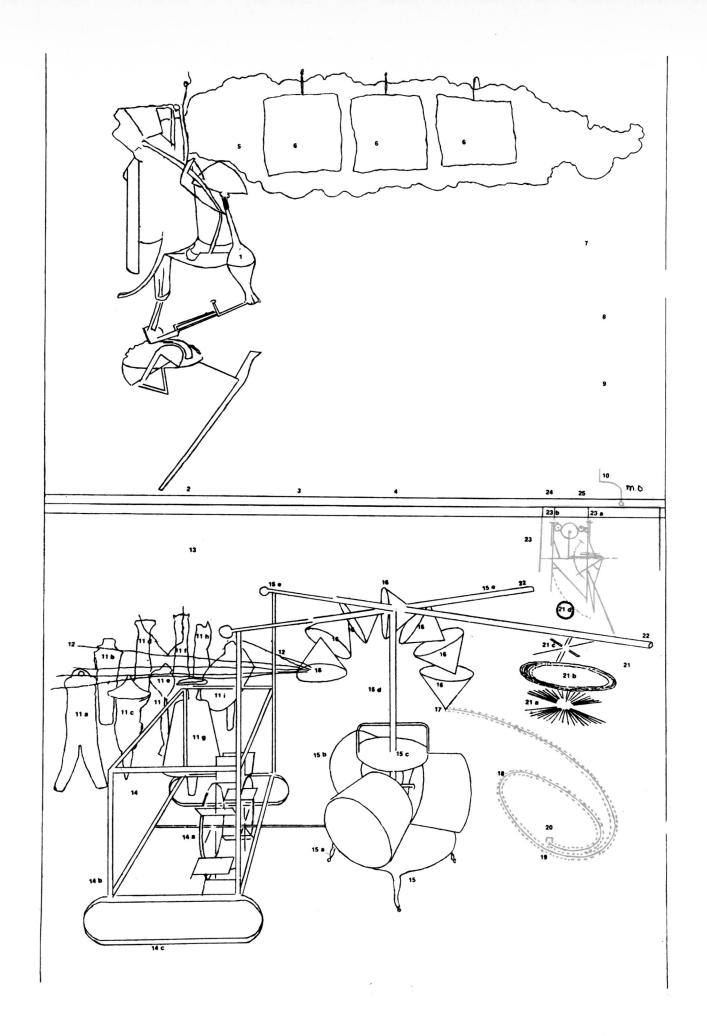

should have found their graphic expression in a Picture of Cast Shadows formed by the mirrored return of the Sculpture of Drops.

In the lower half of the Glass, termed by Duchamp the Bachelor Apparatus, a gas (whose origin is unknown) is cast in the Malic Moulds into the shapes of nine bachelors. The Gas escapes from the Moulds through the Capillary Tubes, where it is frozen and cut into spangles and then converted into a semi-solid fog. The Capillary Tubes lead the Spangles to the opening of the first Sieve. Sucked by the Butterfly Pump, the Spangles pass through the seven Sieves, and in the process they condense into a liquid suspension. This liquid suspension falls into the Toboggan and "crashes" at its base.

The splashes formed by the fall of the liquid suspension are channelled into a stream by a Mobile Weight with nine holes which directs the stream of Splashes to the Oculist Witnesses. The Scissors control the impetus of the Splashes as they issue from the Oculist Witnesses. Some of these Splashes will then form a Sculpture of Drops which will undergo the Wilson-Lincoln effect. The reflection of the drops passes through the Bride's Garment and is mirrored upwards towards the Bride's Domain to form the Picture of Cast Shadows mentioned above. The kinetic energy of the other Splashes is transformed into light energy when the Splashes are dazzled through the Oculist Charts, the last element of which should have been a lens whose position in the Glass is, however, merely indicated by a circle.

This lens was to have focused the beam of light energy toward the Combat Marble, which was to have been struck by it, and forced to rise, finally colliding at the summit and thus setting in motion the clockwork mechanisms of the Boxing Match, whose two Rams move up and down lifting and unfastening the Bride's Garment and actuating her striptease.

The Juggler of Gravity, whose three legs rest on the Bride's Garment, finds his equilibrium upset by the Bride's striptease and experiences difficulty in stopping the fall of a ball balanced on the tray he is holding. The Bride's Garment, in addition to acting like a prism which deflects upwards the reflection of the drops, also functions as a Gilled Cooler which restrains the Bachelor's warm attentions; the Garment further indicates the ideal Horizon of the Glass.

The Water Mill is activated by a Waterfall, while the Chariot is set in motion also by a series of complicated mechanical devices. In its seesaw movement the Chariot controls the action of the Scissors and sings the litanies which are heard in the Cemetery of Uniforms and Liveries by the Bachelor Gas as it is being cast in the Malic Moulds.

The Chocolate Grinder, whose Bayonet supports the Scissors, illustrates one of the main traits of the personality of the Bachelor, who "grinds his chocolate himself." At the end of the blades of the Scissors, a marble was to have been poised as a pendant to the circles at the end of the Scissors' handles.

The complex meaning of all these elements is especially accentuated by the fact that they are ambivalent, the mechanical aspect of the Bride is everywhere emphasized, and the analogy with a motorcar often recurs. Her Garment, the transparency of which enhances its erotic quality, fulfills three related functions in the Glass: at the left-hand end it acts as the "cooler" we have just discussed; at the right-hand end it is responsible for the Wilson-Lincoln effect in the Oculist Witnesses; in the middle it indicates the Horizon of the Glass. This last allows Duchamp to subvert the laws of classical perspective, leaving the space of the Glass indeterminate. The stripping of the Bride is the result of a "blossoming" which thus involves three distinct stages, namely, the stripping by the Bachelor, the Bride's imaginative stripping, and the collision of the Bachelor's and Bride's desires—the collision of the former two rituals. As for the Top Inscription, it is not only a means by which the Bride transmits "commands, orders, authorizations" through the flow of letters that make up her messages to the Bachelor; its secondary title, the Milky Way, recalls its resemblance to clouds, which are a combination of water and gas, and which indicate the androgynous nature and conciliatory role of this element, as is confirmed by other details. The function of the 3 Draft Pistons (or Nets) is to transmit the Bride's messages only after they have been set

in "a sort of triple 'cipher'. . . . " Their role might be compared to that of the censor which, in the dream process, disguises the unconscious, repressed wishes that seek fulfillment. The last element of the Bride's Domain is the area of the Nine Shots, which brings to a conclusion the voyage of the Bride's desires. The exercise of aiming at a target with a toy cannon clearly implies that the target is identified with the Bride, and the region aimed at—her Domain—leaves no doubt as to the identity of the person shot at. A complex mechanism governs the meeting of the Bride and the Bachelor, and ensures that no contact can take place between them.

If the Bride's wishes have had to overcome many obstacles before reaching the region where they confront the wishes of the Bachelor, the journey of the latter is even more tormented. A note by Duchamp admirably characterizes the psychology of the Nine Malic Moulds, and reveals that the Bachelor has strong narcissistic inclinations (a mirror reflects his own complexity back to him) and a castration complex (he is cut off by an imaginary plane at what Duchamp calls the point of sex). Like the Bride, the Malic Moulds are also invested with mythical implications; in fact, their second name is Eros's Matrix, and Eros has always been represented in traditional iconography as androgynous. A matrix may also be understood as the "negative" from which a "positive" cast is obtained; matrix and cast are antithetical just as, in mythology, Eros and Narcissus are. Moreover, the number of the Moulds, nine, points to the ambivalent character of the Bachelor, nine being a symbol of fertility (related to the number of months in the human gestation period), while we know that the Moulds are all headless, and thus castrated. In the course of his voyage from his birthplace, the Eros's Matrix where Illuminating Gas is cast into an image of Narcissus, we see that the Bachelor not only forfeits his "malic" character, but loses, in addition, his physical state and condition, since only his mirrored image will finally meet the Bride.

The Capillary Tubes and the Sieves have basically the same function, that of conducting the Illuminating Gas, and in both cases, the Gas meets castration during or at the end of the journey. In the Capillary Tubes, the "malic" identification is counterbalanced by castration, just as in the Sieves the Gas is transformed into a "dense liquid" and into vapor, again a combination of Air (Narcissus) and Water (Bride). All this suggests that these elements also have the function of obstructing the Bachelor's journey. Finally, the Capillary Tubes—which are to be identified with the threads of the *3 Standard Stoppages*—are not hollow, and it would be almost impossible for the Gas to travel through them; the Tubes should allow the Gas to pass through easily, but they are either solid or too narrow. As for the Sieves, they collect the Gas liberated at the mouth of the Tubes, which "tends to rise." They also "force the Spangles to take a direction which they would otherwise not have followed," Duchamp observes; "the Spangles coming out of the Capillary Tubes would have tended to rise toward the Bride . . . probably too rapidly!" By alternating holes and solids, the Sieves constitute a channel that is neither entirely free nor entirely stopped up. Finally, in passing through the Sieves, the Gas is deprived of most of its characteristics, and yet the reverse process of helping it recover its personality simultaneously takes place; in fact, the Gas, in its passage, undergoes the same process of identification, since the holes of the Sieves "should give in the *shape of a globe* the *figure* of the eight Malic Moulds." The Sieves, at this point, like the Malic Moulds, are matrices. Other elements, including some of the missing ones, are intended to help the Bachelor to recover his original personality.

In the Oculist Witnesses the basic contradictions of the Bachelor's psyche are reconciled after first being accentuated Here the Bachelor's journey comes to an end; it is from here that the Gas can witness the Bride stripped bare and eventually reach her domain, even if only as a reflected image. This complex mechanism is also based on the ambivalent functions and actions of the Bride's Garment, which, on the one hand, separates the Bride from the Bachelor, and on the other, is responsible for their meeting. In this respect, the Bachelor's journey also appears to be motivated by the effort of the dissociated psyche to regain its own unity. We cannot fail to note that Oculist Witnesses also stand for Eye

Witnesses, and that the Eye Witness is, of course, a transparent disguise for the voyeur. Scoptophilia (sexual gazing) and exhibitionism are two antithetical aspects of the same ambivalent trend.

The whole mechanism actuating the stripping of the Bride contributes to setting in motion the clockwork machinery of the Boxing Match, thus connecting the stripping with time. Duchamp has emphasized the importance of the element of time in referring to his Ready-mades; one cannot fail to be struck by his analogy between the Ready-made and the love act—in both cases, the "important thing" is time. Duchamp called the Glass a "Delay in Glass," and the Ready-made can also be looked for, created "with all kinds of delays." Finally, the Glass is also the story of a rendezvous between the Bride and the Bachelor just as the Ready-made is a rendezvous between its creator and the creation. It seems as if Duchamp wishes to equate the two creative acts involved in love and art. The title of a phallic-shaped sculpture made in 1951 epitomizes this concept; the sculpture is entitled *Objet-Dard* (Dart-Object), which also reads *Objet d'Art* (Art Object).

The ambivalence of all the elements in the Glass is not merely the expression of the real structure of the psyche—a structure dominated by polarity—nor does it reflect here only the conflict between repression and wish-fulfillment. Rather we should see in this ambivalence a fundamental characteristic of all myths and of their therapeutic virtues. The repetition we have met of the same fundamental theme is one of the essential features of the cathartic function of myth. Duchamp's mythopoeic ability, which finds its highest achievement in the Glass, has given us one of the most useful works of occidental thought. "We like to imagine that something which we do not understand does not help us in any way," observes Jung, "but that is not always so. . . . Because of its numinosity the myth has a direct effect on the unconscious, no matter whether it is understood or not."[56]

Tu m', painted in 1918, confirms the importance of the role played by the unconscious in Duchamp's work. It is his largest painting. Its unusual size and shape were determined by the fact that it was commissioned by Katherine Dreier to fill a space above some bookshelves in her library. Duchamp never really liked the painting very much. "It is a kind of inventory of all my preceding works, rather than a painting in itself. . . . I have never liked it because it is too decorative; summarizing one's works in a painting is not a very attractive form of activity." This last remark may account for the title of the painting. Although the pronoun *m'* in the title could be followed by any verb at all so long as its first letter is a vowel, the phrase is really a polite contraction for the French colloquialism *tu m'em-merdes* (you bore me), a feeling which could perhaps be referred both to the tedium involved in making the work and to the person who commissioned it. But notwithstanding Duchamp's severe judgment, this painting has many interesting features. It is probably the realization of his project to make, after finishing the Large Glass, a picture using "shadows cast by 2, 3, 4 Ready-mades." The picture was to be executed "by means of luminous sources, and by drawing the shadows on these planes, simply following the *real* outlines projected." In fact, the painting shows the shadows cast by three Ready-mades: at the left the *Bicycle Wheel,* in the center the *Corkscrew,* and to the right the *Hat Rack* (i.e., three of his well-known works). Duchamp's account of his procedure in realizing the painting is also in accordance with the contents of his notes. "I had found a sort of lantern which made shadows easily enough; I projected the shadow and then traced it by hand onto the canvas." Starting from the center and vanishing towards the upper left-hand corner, there can be seen a series of overlapping, diamond-shaped paint samples that Duchamp had copied from a catalog of oil paints. The first sample is secured by a real bolt—a metaphor of the relationship of fantasy (painting) and reality.

The choice of the three Ready-mades is by no means accidental. The latent motivation of this choice can be traced back to a note in *The Green Box* and to a drawing in *The Box of 1914.* On his way to the Bride, the Bachelor was to land on the Slopes of Flow of the Toboggan and these are in the shape of a Corkscrew. The drawing which was to

illustrate those Slopes of Flow as a "commentary" shows a man (Duchamp) riding a bicycle uphill. The *Hat Rack* (which is identified with Duchamp) is hung from the ceiling and seems to symbolize Duchamp's fate for having committed an act—incest—punished by hanging. The sequence in which these three Ready-mades are found in the painting reflects the logical sequence of the story: the Bachelor rides his bicycle uphill (the Slopes of Flow), corkscrewwise towards the Bride (the Bride's Domain is the top part of the Glass), and, after meeting her, he is hanged! The other details of this painting complete the story. At the lower left can be seen the outline of the three templets of the *Standard Stoppages.* We recall that, in the Large Glass, the three plates of glass of the *Standard Stoppages* find their equivalents in the three strips of glass which divide the Bride's Domain from the Bachelor's, a detail of the Glass which stands for the Bride's Garment. It appears, therefore, that in *Tu m'* the Bride has shed her garments, abandoning them in the lower left-hand corner of the painting. Right in its center, a *trompe l'oeil* tear in the canvas is mended by three real safety pins. From a hole in the tear a bottle brush, securely fastened to the stretcher, projects towards the spectator. The symbolism of this detail is clear—it is a transparent allusion to coitus, while the three safety pins that repair the tear may refer to a clumsy attempt to cancel out the consequences of the sexual intercourse. After having shed her garment, the Bride finally meets the Bachelor.

This interpretation finds confirmation in the fact that in the note describing the original project for this painting Duchamp mentions that it was indeed to be made "for the upper part of the glass included between the horizon and the 9 holes," that is to say, in the very region where the Bride's and the Bachelor's desires meet in the Large Glass. The fact that the rip in the canvas is *simulated,* while the safety pins are *real,* has a very clear meaning: the Bride must remain a virgin for Duchamp. This double precautionary measure finds further motivation in the strength of the taboo which is about to be broken. The taboo is so strong that the mere intention of infringing it is first rendered impossible for the Bride and then drastically punished. The

absurdity of the situation finds a parallel in the dream-work, which creates composite formations of conflicting situations, completely ignoring the logic of waking life. A hand in the lower center of the canvas pointing to the right end of the canvas draws our attention to this region which in execution recalls Kandinsky. To understand its significance we only have to read Duchamp's comments on Kandinsky's work: "In tracing his lines with ruler and compass, Kandinsky opened to the spectator a new way of looking at painting. It was no more the lines of the unconscious, but a deliberate condemnation of the emotional: a clear transfer of thought on canvas."[57] Indeed, for Duchamp, *Tu m'* is again a clear transfer of his repressed thoughts onto canvas. His very condemnation of the unconscious motivations in painting is the clearest proof of the strength of the defense mechanism and hence of the determining role of the unconscious in Duchamp's oeuvre, a fact that, on other occasions, he has freely acknowledged. Finally, Duchamp's deprecatory judgment of this painting seems to be directed to its author rather than to the work, through the well-known process of displacement.

The same impulse which led Duchamp to a rejection of conventions in painting led him even farther abroad and into speculations and revisions that had to do with social convention and language. The first stage of his language reform was concerned with the creation of an alphabet, the letters of which were first conceived of as elementary signs like the dot, the line, and the circle. Their significance was to vary as a function of position. But then he came upon the idea of discarding the alphabet altogether and of replacing it with films that would convey the significance of groups of sentences or words; the creation of "letters" was to be followed by "the search for 'prime words.'" Thus for Duchamp the word began to exist as an entity separate from its meaning; he thought of words as photographic details of large-sized objects, or he might have recourse to chance to find words whose "personality" would vary according to the intentions of those who used them. My conversations with Duchamp have brought to light the fact that he was led by the desire "to transfer the significance of language from

words into signs, into a visual expression of the word, similar to the ideogram of the Chinese language."

His theoretical speculations about language found an important outlet in his playing and working with words on a phonetic level—his preoccupation with the pun. In fact, Duchamp's very earliest published pun (in Picabia's *391,* July, 1921) reveals the intimacy of the connection for him between the renewal of language and the exploitation of the word as sound. It gives a concrete example of the way in which the new grammatical relations were to be phonetically structured. "If what you want is a grammatical rule: the verb agrees with the subject in consonance; for instance, *le nègre aigrit, les nègresses s'aigrissent ou maigrissent, etc.*" In Duchamp's activity, puns and Ready-mades are expressions of a single psychological attitude; in his puns he redeems the word from the commonplace and displays its beauty through a more-or-less abstract displacement. For André Breton's magazine, *Littérature,* Duchamp conceived a pun that attacked the idea of literature by equating it to beds and erasures: *Lits et Ratures.* In this case, the word is removed from its ordinary logical context and unexpectedly placed in juxtaposition to something else.

The same process of displacement is likewise at the bottom of Duchamp's attitude toward commonplace objects (Ready-mades). Here again, the process may be concerned either with the physical, or more abstractly, with the logical context of the object. Displacement from *physical* context is achieved by changing the visual angle from which the object is ordinarily perceived and by isolating it from its ordinary surroundings. This is the principle at work in the 1913 *Bicycle Wheel* (the fork is upside down and screwed to a kitchen stool), the 1914 *Bottle Dryer* (to be viewed hanging from the ceiling like the 1917 *Hat Rack*), and the 1917 *Trap* (a coat rack designed for the wall but nailed to the floor).

Displacement from ordinary *logical* context is achieved by renaming the object, the new title having no obvious relationship to the object as ordinarily understood. This process is exemplified in the 1914 *Pharmacy* (a commercial print of a winter landscape to which Duchamp added two minute figures); in *In Advance of the Broken Arm* (1915, an ordinary snow shovel); in the 1915 *Pulled at 4 Pins* (an unpainted tin chimney ventilator); and in *Fountain* (1917, a urinal).

Duchamp theorized this process when he spoke of the necessity of finding new titles and inscriptions for a Ready-made. He has also told me that the practice of naming Ready-mades derived from his desire to add a verbal color to the object. He has explicitly stated, "For me the title was very important." The relationship between puns and the Ready-mades becomes even clearer when it is remembered that the Ready-made is sometimes a pun in three-dimensional projection. *Trap (Trébuchet)* is then an example not only of physical displacement, but of logical displacement as well since the word itself is a pun on the phonetically identical chess term *trébucher,* the French word meaning "to stumble over." The pun is also used in the titles of *Apolinère Enameled* (1916–17); the 1919 bearded and moustached *Mona Lisa, L.H.O.O.Q.* (when read in French this becomes "she has a hot bottom"); and in *Fresh Widow* (1920), a pun on French window. Puns, like poetry, undermine the basic suppositions of a static and immutable reality, since they are concerned with the equating of two different realities.

After achieving results on the verbal level, Duchamp began to look for something that would lead to results on the physical level. He first formulated the question by asking himself how one could succeed in losing *"the possibility of recognizing* (identifying) *two similar objects"*; and this possibility was first envisaged as purely mental. From undermining the recognizability of *similar,* he passed on to undermining the recognition of *opposite* categories, thus abolishing traditional polarities such as right and left, or interior and exterior. An embodiment of these theoretical notions can be seen in *Why Not Sneeze Rose Sélavy?* (1921), a birdcage filled with 152 lumps of marble sawn in the shape of sugar cubes. On lifting the cage, one is shocked to find it much heavier than expected.

This same attitude of indifference, first toward similar categories and then toward opposite categories, led Du-

champ to a noncommittal position as regards the aesthetic approach to a work of art, for which he asks the "beauty of indifference," and to his more general attitude of non-involvement and suspension of judgment. This implies an absolute lack of dogmatism, which Duchamp has expressed perfectly in the formula: "There is no solution because there is no problem."[58] We find this thought expressed by Ludwig Wittgenstein: "In reality, the deepest problems are not problems at all" since "the solution of the problem of life is seen in the disappearance of this problem."[59]

André Breton recalls a remarkable anecdote that demonstrates the way in which Duchamp was actually prepared to live by what he thought: "I have seen Duchamp do an extraordinary thing, toss a coin up in the air and say, 'Tails I leave for America tonight, heads I stay in Paris.' *No* indifference about it, it is certain that he infinitely preferred to go or to stay. . . ."[60]

In 1913, Duchamp's doubts led him to pose the question "Can one make works which are not works of 'art'?" He gave himself an affirmative answer by designing a variety of projects for works endowed with the "beauty of indifference." Thus, he made plans for the use of the *width* of electricity in a work of art and the plan found fulfillment in the stripping of the Bride. The enigmatic project for a "painting *of frequency*" brought him to think in terms of "*plastic* duration," rather than in terms of plastic aesthetics, and this could be looked upon as a prelude to his speculations about music and the possibilities of a musical sculpture. In spite of the abstractness of these ideas, they apparently led Duchamp to the *Musical Erratum* of 1913. This work, a musical composition, was his first implementation of chance; his theory was Lewis Carroll's, with musical intervals taking the place of words. In 1914, less than a year after having asked himself whether one could make works which are not works of art, Duchamp set out afresh to check on the notion of "pictorial Nominalism"—the concept that the existence of the definition does not imply the existence of the defined—in this case, that the existence of the word art does not imply the existence of art itself. He made notes on the relationship between the Large Glass and the Ready-made, in which the Glass is used as a touchstone for the differentiation of the Ready-made from the common *objet-trouvé*. As an extension of and corollary to the rejection of identical and opposite categories, he finds it important that neither the Ready-made nor the Glass is a "found object." Their similarity lies in the fact that both possess the same negative quality.

The first Ready-made was chosen in 1913; the year of the application of chance in the *Musical Erratum* and of the extension of this principle to the *3 Standard Stoppages* was also the year of the *Bicycle Wheel*. The word "Ready-made" was not coined until 1915, shortly after Duchamp's arrival in New York. The discovery of this new means of expression, or nonexpression, did not, however, cause Duchamp to lose any of his powers of self-criticism. He was well aware of the trap of facility. "But I realized very soon the danger of repeating indiscriminately this form of expression and decided to limit the yearly production of Ready-mades to a small number." This limitation was only one of the rules which he established in order to restrict his liberty of production. The Ready-made had to be planned "for a moment to come (on such a day, such a date, such a minute). . . . It is a kind of rendezvous." Furthermore, the Ready-made had to bear an inscription that "instead of describing the object like a title, was meant to carry the mind of the spectator towards other regions, more verbal."[61]

A caption was, in fact, the first thing that Duchamp set out to discover when he decided, in January, 1916, to consider the Woolworth Building a Ready-made. Since, however, for one reason or another, he never actually found the phrase he was looking for, the Woolworth Building can be considered no more than a *latent* Ready-made. The *Comb* received its name in 1916, one year after the artist had conceived a plan to "classify combs by the number of their teeth." In 1915 he again proposed to use the comb as a "proportional control . . . on another object made up also of smaller elements," and to investigate the possibility of a geometric projection of the comb in space; the title of this note, *Rattle,* foreshadows the Semi-Ready-made of 1916 entitled *With Hidden Noise.* Duchamp returns

to this theme some years later with a plan to "make a Ready-made with a box containing something unrecognizable by its sound and solder the box." Other notes develop ideas later to be also formulated by Christo in his storefronts and by Arman in his accumulations. Duchamp planned to make accumulations of "similar things (stretcher keys)" or of sponges; his idea of making "a sick picture or a sick Ready-made" is related to the *Unhappy Ready-made* of 1919, the geometry book that was to be hung from her balcony by his sister Suzanne. His projects to "buy a pair of ice-tongs as a Ready-made" and to experiment with the cutting qualities of razor blades were never carried out.

This rapid digression on the Ready-mades fittingly closes with a dialectical return to its point of origin and a final desecration of the notion of art. The trip from the canvas to the Ready-made was only the first half of a round trip ticket. Duchamp now thinks of the "reciprocal Ready-made"—"use a Rembrandt as an ironing board." This idea was the fruit of a desire "to expose the basic antinomy between art and Ready-mades." And to close the circle, he remarks, "Since the tubes of paint used by an artist are manufactured and ready-made products, we must conclude that all paintings in the world are Ready-mades Aided."[62] But to return to the Rembrandt, a final remark must be made in the light of Duchamp's notion of the "beauty of indifference" and in the light of his attitude of radical non-commitment. If the work of art and the work of "nonart" are essentially the same, and if the common object can be elevated and pulled into timelessness through the choice of the artist, the reverse must also be true. An equally valid operation would be to take a Rembrandt or any other work of art down from the wall and to transform it into something ordinary—something subject to use, change, and ultimate destruction.

The notion reveals some of the quality of the humor that is constantly active in Duchamp's work. And let it not be forgotten that true humor—in the words of Nimzovich, a great chess theoretician like Duchamp himself—"often contains more inner truth than the most serious seriousness."[63] Nimzovich's revolution in chess strategy has been defined as both neo-Romantic and hypermodern—two adjectives that could be just as appropriately applied to Duchamp's revolution in the visual arts.

Duchamp's optical works, the experiments for which always explored many lines of research at the same time, were the resumption of his idea of representing a higher dimension in terms of a lower one. The first of these attempts to create three-dimensional effects with two-dimensional means was made in Buenos Aires in 1918. Duchamp used two stereopticon slides of a seascape on which he had drawn a pyramid and its mirror image; seen through a viewer, they give a striking three-dimensional effect in which the pyramid seems to float above the surface of the sea. In New York, in 1920, he collaborated with Man Ray for the production of a 3-D film based on the anaglyphic process—the process which involves the use of red and green colored glasses for the discrimination of two separate images to be combined by the retina of the eye—the same process that had a short-lived commercial success in the thirties. In Duchamp's case, however, the experiment was not wholly successful, and this led him to redirect his attention elsewhere. He decided to exploit the principle according to which the eye retains an image for a fraction of a second after the image has actually disappeared. His work with this principle led him to the building of his first optical machine, the *Rotary Glass Plates (Precision Optics)* (1920). Segments of a circle were painted on five glass plates, and as the blades were set spinning, they produced the illusion of a series of continuous circles.

In 1924, Duchamp drew up plans for his *Rotary Demisphere (Precision Optics)*, an experiment with 3-D effects that was realized in the following year. In this second optical machine the impression of depth was obtained by rotating a white demisphere on which he had painted black spirals. In the following years, he pursued his experiments in this direction and drew variations on the spiral theme on ten cardboard discs. When these discs were set revolving at the speed of 30/33 revolutions per minute, they gave a striking impression of three-dimensional depth. This gave him the idea of again trying his hand at producing a 3-D film. This

time, instead of trying to obtain the effect of depth with the anaglyphic process, he simply filmed the rotating discs. In 1926, he thus produced *Anémic Cinéma*—Anémic is an anagram of Cinéma. The contrast between the 3-D effect and ordinary cinematic vision is accentuated by alternating the spiral discs with verbal discs inscribed with alliterative puns, discs which were to give no 3-D effect.

These experiments were taken up once again in 1935, in the *Rotoreliefs (Optical Discs)*, a series of twelve designs printed on six discs with spirals and concentric circles; when the discs were set to rotate, the desired effects were obtained. *Fluttering Hearts* (1936) was another experiment in this direction. This time he dispensed with motion as before he had dispensed with glasses. *Fluttering Hearts* obtained its effect by means of the creation of strong contrasts between bordering zones of color. Three paper hearts, two blue and one red, each larger than the one before, were pasted one upon the other with the colors alternating, and they seem to detach themselves from the surface of the paper and to flutter towards the spectator. Duchamp may be considered the precursor of Op art and Kinetic art, although he never identified himself with any single line of experiment.

"Not to be engaged in any groove is very important for me," asserts Duchamp. "I want to be free, and I want to be free for myself, foremost."[64] If any one idea is embodied in the Large Glass, this is it. And if any one statement characterizes Duchamp's Weltanschauung, this is it again. This demanding and imperious yearning for freedom conditioned a lifelong attitude of tolerance, of noncommitment, of happily accepted inconsistency. Kolakowski has observed that it is thanks only to inconsistency that humanity has survived.[65] To be perfectly consistent with oneself, in all circumstances, leads to intolerance and fanaticism. Inconsistency is the source of tolerance. It is tantamount to an awareness of the contradictions of the world. Inconsistency as an individual human attitude is simply a sum of uncertainties held in reserve in the consciousness. The world of values is not a world of polaristic logic; and the refusal to make a choice once and for all between mutually exclusive values, and thus to prejudice the future, is exactly what inconsistency stands for. Generally, inconsistency is practiced more than proclaimed. It is a way of life—Duchamp's. Inconsistency is an attempt constantly to deceive life. In fact, life continuously places us between alternative situations, between two doors both of which are marked Entry, but neither Exit. Having once entered we are compelled to go on to the bitter end. But Duchamp has invented the door which is neither open nor closed. When Korzybski advocates a non-Aristotelian attitude, this implies a realization that oppositions cannot be reconciled in any harmonizing synthesis. A reasoned inconsistency does not attempt a synthesis between extremes, because this synthesis does not exist. If a contradiction disappears, it is only to give birth to a new contradiction, and thus no universal synthesis is possible. Duchamp's inconsistency exalts contradictions, and derives its dynamism from their tension.

"To attain his truth man must not be tempted to dissipate the ambiguity of his being," observes Simone de Beauvoir, "but on the contrary, accept its realization." And she continues; "The first implication of such an attitude is that an authentic man will never consent to recognize an extraneous absolute; when a man projects into the sky this impossible synthesis of the for-me and the in-me which is called God, this is because he wishes the attention of this existing being to change his existence into being; but if he accepts not to be, in order to exist authentically—he will abandon the dream of an inhuman objectivity; he will realize that the point is not to be right before God, but before himself."[66] Thus Duchamp recalls that "God is created in man's image. He is the final end of man's use of causal systems—the product of the desire for the absolute. . . ."[67] When asked whether he believed in God, Duchamp answered, "No, not at all. Don't say that! For me, the question does not exist. . . . I do not want to say that I am either atheist or believer, I don't even want to discuss it."[68] And elsewhere: "The term 'atheist' (in opposition to the word 'believer') does not even interest me. . . . For me there is something else in addition to *yes, no,* and *indifferent*— that is, for instance, *the absence of investigations of that type*."[69]

As Duchamp once explained to me: "You see, I don't want to be pinned down to any position. My position is the lack of a position, but, of course, you can't even talk about it, the minute you talk you spoil the whole game. I also mean that words are absolutely a pest as far as getting anywhere. You cannot express anything through words." "How can you express yourself then?" Duchamp answered, "You don't *have* to express yourself. Love does not express itself through words. It is just love. The feelings have no equivalent in words; we think they have, but that is not so." Then, going on to discuss art, "The content or the value of a painting cannot be evaluated in words. You cannot find any language to speak about painting. Painting is a language of its own. You cannot interpret one form of expression with another form of expression. To say the least, you will distort completely the original message, whatever you say about it."

In a short lecture, "The Creative Act," delivered in April, 1957, at the Convention of the American Federation of Arts, in Houston, Duchamp discussed his concept of art more comprehensively. Given the two poles of artistic creation, on the one hand the artist, and on the other the spectator, he stated: "To all appearances, the artist acts like a mediumistic being. . . . If we give the attributes of a medium to the artist, we must then deny him the state of consciousness on the aesthetic plane about what he is doing or why he is doing it. . . . I know that this statement will not meet with the approval of many artists who refuse this mediumistic role and insist on the validity of their awareness in the creative act—yet, art history has consistently decided upon the virtues of a work of art through considerations completely divorced from the rationalized explanations of the artist. . . ." To clarify his listeners' understanding of the word "art," Duchamp went on: "What I have in mind is that art may be bad, good or indifferent, but, whatever adjective is used, we must call it art, and bad art is still art in the same way as a bad emotion is still an emotion. Therefore, when I refer to 'art coefficient,' it will be understood that I refer not only to great art, but I am trying to describe the subjective mechanism which produces art in a raw state—*à l'état brut*—bad, good or indifferent. In the creative act, the artist goes from intention to realization through a chain of totally subjective reactions. His struggle toward the realization . . . cannot and must not be fully self-conscious, at least on the aesthetic plane. The result of this struggle is a difference between the intention and its realization. . . . Consequently, in the chain of reactions accompanying the creative act, a link is missing. This gap, representing the inability of the artist to express fully his intention, is the personal 'art coefficient' contained in the work."

Commenting on the importance of the "art coefficient," Duchamp told me, "What art is in reality is this missing link, not the links which exist. It's not what you see that is art, art is the gap. I like this idea and even if it's not true, I accept it for the truth." With Sweeney, Duchamp insisted, "I believe that art is the only form of activity in which man as man shows himself to be a true individual and is capable of going beyond the animal state, because art is an outlet towards regions which are not ruled by time and space. To live is to believe, that's my belief."[70] This peculiar mixture of belief and unbelief, of affirming the necessity of art the better to deny its utility, of relying on one's ability to express oneself while realizing that what is important remains unexpressed is, of course, fully consistent with Duchamp's inconsistency. Even the negative side of Duchamp's statement—that art is to be identified with the failure or the inability of the artist to express it—takes on a positive value if we consider that while failure generates emotional disturbance and is an incentive for living, success only leads to ataraxic self-complacency—to immobility.

It is the recognition of life's paradoxes that accounts for Duchamp's rejection of absolutes in every field. And humor is his favorite weapon for the undermining of these absolutes. "Seriousness is a very dangerous thing. . . . The only serious thing which I might consider is eroticism . . . because that is serious! . . ."[71] Thus humor, for Duchamp, is another way to reaffirm his freedom, to defend individualism; through humor he abolishes the difference between what possesses an aesthetic quality and what

doesn't. The "ironism of affirmation" leads to the "beauty of indifference"; and by being as "unaesthetic as possible, I would be poetic after all."[72] For Duchamp, being a poet is at least as important as being an artist. He has embodied more consistently than anybody else the concept of the *homo faber* in its fullest connotation of poet and artist, and has succeeded in transcending both into the demiurge who through his sole decision can rescue from banality the common, ready-made object and raise it to the level of a work of art. His greatest contribution resides perhaps in his effort to make us aware of the beauty that surrounds us, if only we will open our eyes and our minds to it.

Teeny Duchamp once remarked to me that time was her husband's palette. Indeed, what Oscar Wilde tried to accomplish, Duchamp realized. However, Duchamp's egocentrism is but a reflection of his interest in the individual: "Art doesn't interest me. Artists interest me."[73] "My interest has always been with the individual, rather than the group. The greatest aspect of man is his imagination. Nothing important has ever been done by a group."[74] This intransigent defense of individualism has as its corollary the rejection of a technological society, in which man is but a cog in a machine. Conversing with Brian O'Doherty, he emphasized the idea of art as secondary to life, important only as a way of staying alive in the interstices of organized society's shrinking mesh. Duchamp's individualism may also account for the preference he always showed for remaining a bachelor. Speaking about marriage, he observed, "I carefully avoided all this until I was 67 years old. I married a woman who, because of her age, could not bear a child. I too did not feel like having one, simply to keep down expenses." But we are inclined to believe that he is more interested in defending himself against the servitude of a family. "The family which forces you to abandon your real ideas and exchange them for something accepted by itself, society, and the whole show!"[75]

I still have in my ears the sound of Bachelard's voice when, twenty years ago, he explained that "alchemy is a science only for men, for bachelors, for men without women, for initiates isolated from the community, working in favor of a masculine society,"[76] and I remember that I immediately thought of Duchamp. If in a world as rationalist, prosaic, and fragmented as ours an irrational, poetic, and humanistic adventure can still be attempted, nobody but Duchamp could be its hero. No work but the Large Glass could embody the unattainable transparence of the Philosopher's Stone. The story of the quest of the Philosopher's Stone is a story of failures. But the men who bravely fail teach us more than those who briefly succeed.

In chess one may arrive at a position with no way out, in which neither of the two opponents can impose a victory. One of the opponents is in a state of perpetual check with but one move available to escape, to a square where he will be checked again and forced to return to his point of departure. For Duchamp, this insoluble situation came to be a metaphor of his entire relationship with life. Probably his most beautiful endgame.

The evening had been an especially pleasant one—he had dined at home in Neuilly with Man Ray and Robert Lebel. A fitful close for a busy and eventful day. In the morning he had received my letter with the news that the abridged paperback edition of his monograph had just come out in Italy. Teeny remembers that this made him happy the whole day. The Librairie Vuibert called later that morning—the red and blue colored glasses he had been hunting for weeks to accompany the drawing to be included in the French edition were finally available. After lunch he went out immediately to get them. "He has always been like this, impatient like a child," commented Teeny.

It happened suddenly and peacefully, a little while after the guests had left. He was about to retire and his heart simply stopped beating. It was five past one a.m., Wednesday, October 2, 1968.

The following morning I found him resting on his bed, fully dressed, and wearing his favorite tie. Beautiful, noble, serene. Only slightly paler than usual. A thin smile on his lips. He looked happy to have played his last trick on life by taking French leave. No better ending to no better life. His last masterpiece.

Notes

1 Letter of January 28, 1951, in the Archives of the Francis Bacon Foundation, Claremont, California.

2 G. Rachel Levy, *Religious Conceptions of the Stone Age* (1948), (New York and Evanston: Harper Torchbooks, 1963), p. 121.

3 Lawrence D. Steefel, Jr. in "The Position of La Mariée mise à nu par ses célibataires, même (1915–1923) in the Stylistic and Iconographic Development of the Art of Marcel Duchamp," unpublished Ph.D. dissertation, Princeton University, 1960, pp. 82, 85.

4 William C. Seitz, "What's Happened to Art? . . . ," *Vogue* (New York), n. 4 (February 15, 1963), p. 112.

5 James Johnson Sweeney, "Eleven Europeans in America," *The Museum of Modern Art Bulletin* (New York), XIII, nn. 4–5 (1946), p. 20.

6 *Ibid.,* p. 19.

7 "A Complete Reversal of Art Opinions . . . ," *Arts and Decoration* (New York), V, n. II (September, 1915), p. 428.

8 Robert Lebel, *Marcel Duchamp,* with chapters by Marcel Duchamp, André Breton, and H. P. Roché. Translation by George H. Hamilton (London and Paris: Trianon Press, 1959; New York: Grove Press; Cologne: DuMont Schauberg Verlag), p. 7.

9 Katharine Kuh, *The Artist's Voice* (New York: Harper & Row, 1962), p. 90.

10 Lebel, *op. cit.,* p. 7.

11 Sweeney, *op. cit.,* p. 20.

12 *Ibid.,* p. 20.

13 *Ibid.,* pp. 20, 21.

14 From "A Conversation with Marcel Duchamp and James Johnson Sweeney," interview at the Philadelphia Museum of Art, constituting the sound track of a 30-minute film made in 1955 by NBC. Excerpts adapted and translated into French by Michel Sanouillet in *Marchand du Sel* (Paris: Le Terrain Vague, 1959), pp. 149–61.

15 Kuh, *op. cit.,* p. 89.

16 "A Complete Reversal of Art Opinions . . . ," *loc. cit.,* p. 427.

17 *Manuscripts* (New York), n. 4 (December, 1922), p. 2.

18 Mircea Eliade, *Le Chamanisme et les techniques archaïques de l'extase* (Paris: Payot, 1949), pp. 122–25.

19 See Mircea Eliade, *Patterns in Comparative Religion* (1949), (Cleveland: Meridian Books), pp. 265–330, and Gilbert Durand, *Les Structures anthropologiques de l'imaginaire* (Paris: Presse Universitaires de France, 1963), pp. 365–72.

20 See ill. 36.

21 Sigmund Freud, *Wit and Its Relation to the Unconscious* (1905), (London: Kegan Paul, Trench, Trubner & Co., n.d.), p. 177.

22 Freud, *A General Introduction to Psychoanalysis* (1917), (New York: Washington Square Press, 1952), p. 164.

23 Frederick Macmonnies, "French Artists Spur on an American Art," *New York Tribune,* October 24, 1915, IV, p. 3.

24 Freud, *A General Introduction . . . , op. cit.,* p. 165.

25 *Oeuvres complètes de Jules Laforgue, I, Poésies* (Paris: Mercure de France, 1947), p. 21.

26 Harriet and Sidney Janis, "Marcel Duchamp, Anti-Artist," in *View* (New York), Marcel Duchamp Number, V, n. 1 (March, 1945), p. 24.

27 Lebel, *op. cit.,* pp. 74–75.

28 Steefel, *op. cit.,* p. 123.

29 *Ibid.,* pp. 123–24.

30 Lebel writes that "Duchamp admits that he recognizes himself on the train to Rouen" (Lebel, *op. cit.,* p. 9); and to Pierre Cabanne, Duchamp confirmed that the nude is smoking a pipe to indicate his identity (Pierre Cabanne, *Entretiens avec Marcel Duchamp.* Paris: P. Belfond, 1967, p. 55).

31 Sweeney, "Eleven Europeans . . . ," *op. cit.,* p. 20. See also Kuh, *op. cit.,* p. 83.

32 Freud, *The Interpretation of Dreams* (1900), (London: G. Allen & Unwin Ltd., 1937), p. 240.

33 *Ibid.,* pp. 238–39.

34 Milton W. Brown, *The Story of the Armory Show* (New York: The Joseph H. Hirshhorn Foundation, 1963), p. 109.

35 See the catalog *First Papers of Surrealism,* Coordinating Council of French Relief Societies, Inc., New York, October 14–November 7, 1942, unpaged.

36 Kuh, *op. cit.,* pp. 83–88.

37 Macmonnies, *loc. cit.*

38 René-Lucien Rousseau, *Les Couleurs / Contribution à une philosophie naturelle fondée sur l'analogie* (Paris: Flammarion, 1959), pp. 47, 48, 161.

39 Lebel, *op. cit.,* p. 13.

40 Durand, *op. cit.,* p. 116.

41 Wilhelm Fränger, *The Millennium of Hieronymus Bosch* (London: Faber and Faber, 1952), p. 138.

42 M. D. quoted by Calvin Tomkins in *The Bride and the Bachelors* (New York: The Viking Press, 1965), p. 24.

43 *Ibid.,* pp. 29–30.

44 Sweeney, "Eleven Europeans . . . ," *op. cit.,* p. 21.

45 "Marcel Duchamp Speaks," interview by George H. Hamilton and Richard Hamilton, with brief comments by Charles Mitchell, broadcast by the Third Programme of the BBC, in the series "Art, Anti-Art," in 1959.

46 "A Conversation with Marcel Duchamp and James Johnson Sweeney," interview *cit.*

47 Marianne Verneuil, *Dictionnaire pratique des sciences occultes* (Monaco: Les Documents d'Art, 1950), pp. 227–28.

48 Tomkins, *op. cit.,* p. 38.

49 Lebel, *op. cit.,* p. 29.

50 Marcel Jean, *The History of Surrealist Painting* (London: Weidenfeld & Nicolson, 1960), p. 101.

51 "A Conversation with Marcel Duchamp and James Johnson Sweeney," interview *cit.*

52 "Marcel Duchamp Speaks," interview *cit.*

53 M.D. quoted by Kuh, *op. cit.,* p. 81.

54 M.D. quoted by Seitz, *op. cit.,* p. 113.

55 "A Conversation with Marcel Duchamp and James Johnson Sweeney," interview *cit.*

56 Jung, "On the Psychology of the Trickster Figure," *The Trickster* by Paul Radin (New York: Bell Publishing Company, 1956), p. 207.

57 From the catalog *Collection of the Société Anonyme: Museum of Modern Art 1920,* with 33 critical notes compiled by Duchamp, p. 2.

58 Quoted by H.P. Roché in his article "Souvenirs sur Marcel Duchamp," *La Nouvelle N.R.F.* (Paris), I, n. 6 (June, 1953), p. 1136.

59 *Tractatus Logico-Philosophicus,* 4003.

60 André Breton, "Marcel Duchamp," *Littérature* (Paris) N.S., n. 5 (October 1, 1922), p. 9.

61 The first draft of this lecture was published in *Art and Artists* (London), I, n. 4 (July, 1966), p. 47. My quotations are taken from the definitive unpublished text given to me by Duchamp.

62 *Ibid.*

63 Quoted by Philip Hereford in Aron Nimzovich, *My System* (London: G. Bell & Sons, 1929), p. 6.

64 "Marcel Duchamp Speaks," interview *cit.*

65 This paragraph synthesizes Leszek Kolakowski's "Éloge de l'inconséquence," in *Arguments* (Paris), XXVII–XXVIII, 1962, pp. 1–6.

66 Simone de Beauvoir, *Pour une morale de l'ambiguïté* (1947), (Paris: Gallimard, 1962), pp. 18, 19, 20.

67 Interview with Duchamp by Laurence S. Gold, in appendix to "A Discussion of Marcel Duchamp's Views on the Nature of Reality and Their Relation to the Course of His Artistic Career," unpublished, Princeton University, May, 1958, p. ii.

68 M.D. quoted by Cabanne, *op. cit.,* p. 204.

69 "Une lettre de Marcel Duchamp" (to André Breton), *Medium* (Paris), n. 4 (January, 1955), p. 33.

70 "A Conversation with Marcel Duchamp and James Johnson Sweeney," interview *cit.*

71 M.D. quoted by Alain Jouffroy, in *Une révolution du regard* (1961), (Paris: Gallimard, 1964), p. 118.

72 M.D. quoted by Steefel, *op. cit.,* p. 16.

73 M.D. quoted by William C. Seitz, *op. cit.,* p. 129.

74 Gold, *op. cit.,* pp. i–ii.

75 Cabanne, *op. cit.,* p. 143.

76 Gaston Bachelard, *La Psychoanalyse du feu* (1949), (Paris: Gallimard, 1965), p. 90.

Bibliography

WRITINGS BY DUCHAMP

"A Complete Reversal of Art Opinions . . . ," *Arts and Decoration* (New York), V, No. 11 (September, 1915), pp. 427–28, 442.

"The," *The Rogue* (New York), II, No. 1 (October, 1916), p. 2. Reprinted in *Marchand du Sel,* Bibl. 78.

"The Richard Mutt Case," *The Blind Man / P.B.T.* (New York), No. 2 (May, 1917), p. 5.

Puns in *Littérature* (Paris), N.S., No. 5 (October 1, 1922), pp. 1, 7, 13, 15, 16, 24.

"Can a Photograph Have the Significance of Art?" *Manuscripts* (New York), No. 4 (December, 1922), p. 2.

"Leçons du soir et du matin," *Littérature* (Paris), N.S., No. 10 (May, 1923), p. 10.

La Mariée mise à nu par ses Célibataires même [*The Green Box*]. Paris: Édition Rrose Sélavy, 1934.

"Rendez-vous du Dimanche 6 Février 1916," *Minotaure* (Paris), III, No. 10 (Winter, 1937), unnumbered page.

Rrose Sélavy. Paris: GLM, April, 1939.

"Quand la fumée . . . ," *View* (New York), Marcel Duchamp Number, V, No. 1 (March, 1945), back cover.

"Jurors Are Always Apt to Be Wrong . . . ," *The Temptation of St. Anthony.* Washington: The American Federation of Arts, 1946, p. 3.

"Ombres Portées," *Instead* (New York), No. 1 (February, 1948), inside unnumbered page.

Excerpts from "The Western Round Table on Modern Art" (1949), *Modern Artists in America.* First Ser., ed. BERNARD KARPEL, ROBERT MOTHERWELL, AD REINHARDT. New York: Wittenborn Schultz, Inc., 1951, pp. 27–37.

[33 critical notes.] *Collection of the Société Anonyme: Museum of Modern Art 1920.* New Haven: Yale University Art Gallery, for the Associates in Fine Arts, 1950.

"Piston (de courant d'air)," *Medium* (Paris), N.S., No. 2 (February, 1954), p. 12.

"Une lettre de Marcel Duchamp" [to André Breton], *Medium* (Paris), No. 4 (January, 1955), p. 33.

"The Creative Act," *Art News* (New York), LVI, No. 4 (Summer, 1957, contents wrongly dated Summer 1956), pp. 28–29.

Lettre de Marcel Duchamp (1921) à Tristan Tzara. Alès (Gard): PAB, 1958.

Possible. Alès (Gard): PAB, 1958.

Marchand du Sel: Écrits de Marcel Duchamp, ed. MICHEL SANOUILLET. Bibliography by POUPARD-LIEUSSOU. Paris: Le Terrain Vague, 1959.

"Rendez-vous du Dimanche 6 Février 1916" (first draft), *Marchand du Sel,* Bibl. 78.

Quatre inédits de Marcel Duchamp. Alès (Gard): PAB, 1960.

The Bride Stripped Bare by Her Bachelors, Even. A typographic version by RICHARD HAMILTON of MARCEL DUCHAMP'S *The Green Box.* Translated by GEORGE HEARD HAMILTON. London: Percy Lund, Humphries & Co.; New York: Wittenborn, 1960.

"Where Do We Go from Here?" Unpublished talk delivered at the Philadelphia Museum College of Art, March 20, 1961.

"Apropos of Readymades." Unpublished talk delivered at The Museum of Modern Art, New York, 1961. First draft published in *Art and Artists* (London), I, No. 4 (July, 1966), p. 47.

À l'Infinitif [*The White Box*]. Translated by CLEVE GRAY. New York: Cordier & Ekstrom, 1967.

Notes and Projects for The Large Glass. Selected, ordered and with an Introduction by ARTURO SCHWARZ. New York: Harry N. Abrams, 1969.

WRITINGS ON DUCHAMP

APOLLINAIRE, GUILLAUME. *Les Peintres Cubistes.* Paris: Eugène Figuière, 1913.

ARAGON, LOUIS. *La Peinture au défi.* Paris: Galerie Goemans, 1930.

ASHTON, DORE. "An Interview with Marcel Duchamp," *Studio International* (London), Vol. 171, No. 878 (June, 1966), pp. 244–47.

BRADY, FRANK R. "Duchamp, Art and Chess," *Chess Life* (New York), XVI, No. 6 (June, 1961), pp. 168–69.

BRETON, ANDRÉ. "Marcel Duchamp," *Littérature* (Paris), N.S., No. 5 (October 1, 1922), pp. 7–10.

———. "Les Mots sans rides," *Littérature* (Paris), N.S., No. 7 (December 1, 1922), pp. 12–14.

———. *Le Surréalisme et la peinture* (1928). New York: Brentano's, 1945.

———. "Phare de la Mariée," *Minotaure* (Paris), II, No. 6 (Winter, 1935), pp. 45–49. English translation published in *View* (New York), Marcel Duchamp Number, V, No. 1 (March, 1945), pp. 6–9, 13.

BUFFET-PICABIA, GABRIELLE. "Coeurs Volants," *Cahiers d'Art* (Paris), XI, Nos. 1–2 (1936), pp. 34–43. English translation in *View* (New York), Marcel Duchamp Number, V, No. 1 (March, 1945), pp. 14–16, 23.

CABANNE, PIERRE. *Entretiens avec Marcel Duchamp*. Paris: Pierre Belfond, 1967.

CARROUGES, MICHEL. *Les Machines célibataires*. Paris: Arcanes, 1954.

CHARBONNIER, GEORGES. *Entretiens avec Claude Lévi-Strauss*. Paris: Plon-Juillard, 1961.

COWAN, ROBERT. "Dada," interview in *Evidence* (Toronto), No. 3, Autumn, 1961.

DORIVAL, BERNARD. *Les Duchamps*. Rouen and Paris: Musée des Beaux-Arts and Musée d'Art Moderne, 1967.

DROT, JEAN-MARIE. "Jeu d'échecs avec Marcel Duchamp." Unpublished interview constituting the sound track of a film made for the ORTF, 1963.

GOLD, LAURENCE S. "A Discussion of Marcel Duchamp's Views on the Nature of Reality and Their Relation to the Course of His Artistic Career." Unpublished Senior Thesis, Princeton University, 1958. Pp. xviii, 54.

GREELEY-SMITH, NIXOLA. "Cubist Depicts Love in Brass and Glass . . . ," *The Evening World* (New York, April 4, 1916), p. 3.

HAHN, OTTO. "Passport No. G255300." Interview in *Arts and Artists* (London), I, No. 4 (July, 1966), pp. 7–11.

HAMILTON, GEORGE H.; RICHARD HAMILTON. "Marcel Duchamp Speaks." Unpublished interview, with brief comments from CHARLES MITCHELL, broadcast by the BBC Third Programme in the series "Art, Anti-Art," 1959.

HAMILTON, RICHARD. "Duchamp," *Art International* (Lugano), VII, No. 10 (December, 1963–January, 1964).

———. *The Almost Complete Works of Marcel Duchamp*. Catalog for exhibition at the Tate Gallery, London, June 18 to July 31, 1966. With iconographic notes on the Large Glass and a Descriptive Bibliography by ARTURO SCHWARZ. London: Arts Council, 1966.

HEECKEREN, JEAN VAN. "La Porte de Duchamp," *Orbes* (Paris), II, No. 2 (Summer, 1933), pp. XIV-XV.

HOPPS, WALTER. *By or of Marcel Duchamp or Rrose Sélavy*. Catalog for the retrospective exhibition at the Pasadena Art Museum, October 8 to November 3, 1963.

JANIS, HARRIET and SIDNEY. "Marcel Duchamp, Anti-Artist," *View* (New York), Marcel Duchamp Number, V, No. 1 (March, 1945), pp. 18–19, 21, 23–24, 53–54. Reprinted in Bibl. 202, pp. 306–15.

JEAN, MARCEL. *The History of Surrealist Painting*. Translated by GORDON WATSON-TAYLOR. London: Weidenfeld & Nicolson, 1960.

JOUFFROY, ALAIN. Interview in *Une révolution du regard*. Paris: Gallimard, 1964, pp. 111–24.

KREYMBORG, ALFRED. "Why Marcel Duchamps [*sic*] Calls Hash a Picture," *Boston Transcript* (September 8, 1915), p. 12.

KUH, KATHARINE. "Marcel Duchamp." Interview in *The Artist's Voice: Talks with Seventeen Artists*. New York and Evanston: Harper & Row, 1962, pp. 81–93.

LEBEL, ROBERT. *Marcel Duchamp*. With chapters by MARCEL DUCHAMP, ANDRÉ BRETON, and H.-P. ROCHÉ. Translation by GEORGE HEARD HAMILTON. London & Paris: Trianon Press; New York: Grove Press; Cologne: DuMont Schauberg Verlag, 1959.

LEIRIS, MICHEL. "Arts et Métiers de Marcel Duchamp," *Fontaine* (Paris), No. 54 (Summer, 1946), pp. 188–93.

LÉVESQUE, JACQUES-HENRY. "Marcel Duchamp," *Orbes* (Paris), II, No. 4 (Summer, 1935), pp. 1–2.

MACMONNIES, FREDERICK. "French Artists Spur on an American Art." Article, quoting an interview, in the *New York Tribune* (October 24, 1915), IV, pp. 2–3.

MASSOT, PIERRE DE. "Lu le soir," *Orbes* (Paris), II, No. 2 (Summer, 1933), pp. 12–17.

———. "La mariée mise à nu par ses célibataires, même," *Orbes* (Paris), II, No. 4 (Summer, 1935), pp. XVII-XXII.

————. *Marcel Duchamp, propos et souvenirs*. Milan: Schwarz, 1965.

PAZ, OCTAVIO. *Marcel Duchamp ou le Château de la pureté*. Paris: Galerie Givaudan, 1968.

RAY, MAN. "Bilingual Biography," *View* (New York), Marcel Duchamp Number, V, No. 1 (March, 1945), pp. 32, 51.

RICHTER, HANS. *Dada: Art and Anti-Art*. London: Thames and Hudson, 1965.

ROCHÉ, HENRI-PIERRE. "Souvenirs sur Marcel Duchamp," *La Nouvelle N.R.F.* (Paris), I, No. 6 (June, 1953), pp. 1133–1138.

————. "Vie de Marcel Duchamp," *La Parisienne* (Paris), No. 24 (January, 1955), pp. 63–69.

ROUGEMONT, DENIS DE. "L'Amérique en guerre," *Journal des deux mondes*. Paris: Gallimard, 1947. Revised edition: *Journal d'une époque, 1926–1946*. Paris: Gallimard, 1968.

————. "Marcel Duchamp mine de rien," *Preuves* (Paris), XVIII, No. 204 (February, 1968), pp. 43–47.

SANOUILLET, MICHEL. "Dans l'atelier de Marcel Duchamp." Interview in *Les Nouvelles Littéraires* (Paris), No. 1424 (December 16, 1954), p. 5.

SCHUSTER, JEAN. "Marcel Duchamp, vite." Interview in *le surréalisme, même* (Paris), No. 2 (Spring, 1957), pp. 143–45.

SCHWARZ, ARTURO. *Marcel Duchamp / Ready-mades, etc. (1913–1964)*. With an Introduction by WALTER HOPPS and a chapter by ULF LINDE. Milan: Galleria Schwarz; Paris: Le Terrain Vague, 1964.

SEITZ, WILLIAM C. "What's Happened to Art? . . . ," Interview with Duchamp in *Vogue* (New York), No. 4 (February 15, 1963), pp. 110–13, 129–31.

STEEFEL, LAWRENCE D., JR. "The Position of La Mariée Mise à Nu par Ses Célibataires, Même (1915–1923) in the Stylistic and Iconographic Development of the Art of Marcel Duchamp." Unpublished Ph.D. dissertation, Princeton University, 1960.

STEEGMULLER, FRANCIS. "Duchamp: Fifty Years Later." Interview in *Show* (New York), III, No. 2 (February, 1963), pp. 28–29.

SWEENEY, JAMES JOHNSON. Untitled interview in "Eleven Europeans in America," *The Museum of Modern Art Bulletin* (New York), XIII, Nos. 4–5 (1946), pp. 19–21.

————. "A Conversation with Marcel Duchamp. . . . ," Interview at the Philadelphia Museum of Art, constituting the sound track of a 30-minute film made in 1955 by NBC, first shown on American television in the program Elderly Wise Men, January, 1956.

TOMKINS, CALVIN and the Editors of Time-Life Books. *The World of Marcel Duchamp*. New York: Time, Inc., 1966.

List of Illustrations

60. *The King and Queen Traversed by Nudes at High Speed.* 1912. Watercolor and gouache, 19 1/4 × 23 1/4″. Philadelphia Museum of Art. Louise and Walter Arensberg Collection

61. *The King and Queen Traversed by Swift Nudes.* 1912. Pencil, 10 3/4 × 15 3/8″. Philadelphia Museum of Art. Louise and Walter Arensberg Collection

62. *The Bride Stripped Bare by the Bachelors.* 1912. Pencil and wash, 9 3/8 × 12 5/8″. Cordier & Ekstrom Gallery, New York

63. *The King and Queen Surrounded by Swift Nudes.* 1912. Oil on canvas, 45 1/8 × 50 1/2″. Philadelphia Museum of Art. Louise and Walter Arensberg Collection

64. *Virgin, No. 1.* 1912. Pencil, 13 1/4 × 9 7/8″. Philadelphia Museum of Art. A. E. Gallatin Collection

65. *Virgin, No. 2.* 1912. Watercolor and pencil, 15 3/4 × 10 1/8″. Philadelphia Museum of Art. Louise and Walter Arensberg Collection

66. *The Passage from the Virgin to the Bride.* 1912. Oil on canvas, 23 3/8 × 21 1/4″. The Museum of Modern Art, New York

67. *Bride.* 1912. Oil on canvas, 35 1/4 × 21 5/8″. Philadelphia Museum of Art. Louise and Walter Arensberg Collection

68. *Bachelor Apparatus (Plan).* 1913. Black and red ink, 10 1/2 × 13 7/8″. Marcel Duchamp Collection, New York

69. *The Bride Stripped Bare by Her Bachelors, Even.* 1913. Pencil on tracing cloth, 13 × 11″. Collection Jeanne Reynal, New York

70–71. *The Box of 1914.* 1913–14. Kodak photographic box containing 16 photos of manuscript pages and one of the design *To Have the Apprentice in the Sun,* 9 7/8 × 7 1/4″. Collection Arturo Schwarz, Milan

72. *To Have the Apprentice in the Sun.* 1914. India ink and pencil on music paper, 10 3/4 × 6 3/4″. Philadelphia Museum of Art. Louise and Walter Arensberg Collection

73. *The Bride* (detail of the Large Glass). 1965. Wash study on handmade paper for the second state of the etching of the same subject, 13 1/4 × 7 7/8″. Galleria Schwarz, Milan

74. *Draft Piston.* 1914. Photograph, 23 1/8 × 19 3/4″. Suzanne Crotti Estate, Neuilly

75. *The Top Inscription* (detail of the Large Glass). 1965. Wash study on handmade paper for the second state of the etching of the same subject, 13 3/4 × 15 7/8″. Galleria Schwarz, Milan

76. *Cemetery of Uniforms and Liveries, No. 1.* 1913. Pencil, 12 5/8 × 15 7/8″. Philadelphia Museum of Art. Louise and Walter Arensberg Collection

77. *Cemetery of Uniforms and Liveries, No. 2.* 1914. Pencil, ink, and watercolor, 26 × 39 3/8″. Yale University Art Gallery, New Haven. Société Anonyme Collection, Katherine S. Dreier Bequest

78. *The Nine Malic Moulds* (detail of the Large Glass). 1965. Wash study on handmade paper for the second state of the etching of the same subject, 13 1/4 × 7 7/8″. Galleria Schwarz, Milan

79. *Nine Malic Moulds.* 1914–15. Oil, wire, and glass, 21 1/8 × 39 3/4″. Collection Teeny Duchamp, New York

80–83. *3 Standard Stoppages.* 1913–14. Semi-Ready-Made: Three threads, one meter in length, dropped from a height of one meter and glued, to preserve their outline, onto a canvas painted Prussian blue, cut into three strips, 47 1/4 × 5 1/4″, in turn glued onto three glass panels, 49 3/8 × 7 1/4″. Three flat wooden strips 47 × 2 3/8″, 42 7/8 × 2 1/2″, and 43 1/2 × 2 1/2″ cut to repeat the curves of the threads. The whole is enclosed in a wooden box 50 7/8 × 11 × 9 1/8″. The Museum of Modern Art, New York. Katherine S. Dreier Bequest

84. *Network Stoppages.* 1914. Oil on canvas, 58 1/8 × 77 5/8″. Collection Mary Sisler, New York

85. *Sieves, or Parasols.* 1914. Colored pencil, pencil, and ink, 27 7/8 × 20 7/8″. Collection Mary Sisler, New York

86. *The Sieves* (detail of the Large Glass). 1965. Wash study on handmade paper for the second state of

the etching of the same subject, 13 1/8 × 7 7/8″. Galleria Schwarz, Milan

87. *Dust Breeding*. 1920. Photograph taken by Man Ray of dust in the region of the *Sieves* on the Large Glass, 9 1/2 × 12″. Galleria Schwarz, Milan

88. *To Be Looked at (from the Other Side of the Glass) with One Eye, Close to, for Almost an Hour*. 1918. One glass sheet, oil paint, lead, rusted metal, magnifying glass, and silver scratching mounted between two glass plates, 20 1/8 × 16 × 1 3/8″. The Museum of Modern Art, New York. Katherine S. Dreier Bequest

89. *Oculist Witnesses*. 1920. Pencil on the reverse of a carbon paper, 19 3/4 × 14 3/4″. Philadelphia Museum of Art. Louise and Walter Arensberg Collection

90. *The Witnesses* (detail of the Large Glass). 1965. Wash study on handmade paper for the second state of the etching of the same subject, 13 1/2 × 7 7/8″. Galleria Schwarz, Milan

91. *Boxing Match*. 1913. Pencil and crayon, 16 1/2 × 12 1/8″. Philadelphia Museum of Art. Louise and Walter Arensberg Collection

92. *The Water Mill* (detail of the Large Glass). Wash study on handmade paper for the second state of the etching of the same subject, 13 1/8 × 7 7/8″. Galleria Schwarz, Milan

93. *Glider Containing a Water Mill in Neighboring Metals*. 1913–15. Oil and lead on glass, mounted between two glass plates, 57 7/8 × 31 1/8″. Philadelphia Museum of Art. Louise and Walter Arensberg Collection

94. *Chocolate Grinder, No. 1*. 1913. Oil on canvas, 24 3/8 × 25 5/8″. Philadelphia Museum of Art. Louise and Walter Arensberg Collection

95. *Chocolate Grinder, No. 2*. 1914. Oil and thread on canvas, 25 5/8 × 21 1/4″. Philadelphia Museum of Art. Louise and Walter Arensberg Collection

96. *The Chocolate Grinder* (detail of the Large Glass). 1965. Wash study on handmade paper for the second state of the etching of the same subject, 13 3/4 × 15 7/8″. Galleria Schwarz, Milan

97. *The Bride Stripped Bare by Her Bachelors, Even* (The Large Glass). 1915–23. Oil, varnish, lead foil and wire, and dust on glass mounted between two glass panels, 9′ 1 1/4″ × 5′ 9 1/4″. Philadelphia Museum of Art. Katherine S. Dreier Bequest

98. *The Large Glass Completed*. 1965. Colored etching on japan vellum, 19 3/4 × 13″. Galleria Schwarz, Milan

99–100. Two views of Duchamp's studio, New York. 1918. Photos courtesy of Mr. Arnold Fawcus, Trianon Press, Paris

101. *Bicycle Wheel*. 1964 version (original 1913, lost). Assisted Ready-made: A bicycle fork with its wheel screwed upside down onto a kitchen stool painted white, height 50″. Galleria Schwarz, Milan

102. *Bottle dryer*. 1964 version (original 1914, lost). Ready-made: Galvanized iron, height 25″. Galleria Schwarz, Milan

103. *Pharmacy*. 1914. Rectified Ready-made: Commercial print of a winter landscape with two small personages added in gouache, one red and one green, alluding to the bottles in a pharmacy window, 10 1/4 × 7 5/8″. Collection William N. Copley, New York

104. *In Advance of the Broken Arm*. 1964 version (original 1915, lost). Ready-made: Wood and galvanized iron snow shovel, height 52″. Galleria Schwarz, Milan

105. *Pulled at Four Pins*. 1964. Etching of the lost 1915 Ready-made of a tin chimney ventilator. Etching on handmade paper, 25 1/4 × 18 1/4″.

106. *Comb*. 1916. Ready-made: Gray steel comb, 1 1/4 × 6 1/2″. Philadelphia Museum of Art. Louise and Walter Arensberg Collection

107–108. *With Hidden Noise*. 1916. Semi-Ready-made: Ball of twine containing a small "secret" object added by Walter Arensberg, pressed between two brass plates 5 1/8 × 5 1/8″, which are joined by four screws, length 4 1/2″. Philadelphia Museum of Art. Louise and Walter Arensberg Collection

109. *Traveller's Folding Item.* 1964 version (original 1916, lost). Ready-made: Underwood typewriter cover, height 9 1/8″. Galleria Schwarz, Milan

110. *Apolinère Enameled.* 1916–17. Ready-made: Cardboard and painted tin advertisement for Sapolin brand of enamels, 9 5/8 × 13 3/8″. Philadelphia Museum of Art. Louise and Walter Arensberg Collection

111. *Fountain.* 1917 (photo of lost original). Assisted Ready-made: Urinal turned on its back, 1964 version, height 24 5/8″. Galleria Schwarz, Milan

112. *Trap.* 1964 version (original 1917, lost). Assisted Ready-made: Coat rack nailed to the floor, 4 5/8 × 39 3/8″. Galleria Schwarz, Milan

113. *Hat Rack.* 1964 version (original 1917, lost). Assisted Ready-made: Hat rack suspended from the ceiling, height 9 1/4, diameter at base 5 1/2″. Galleria Schwarz, Milan

114. *Sculpture for Travelling.* 1918 (destroyed). Strips cut from bathing caps differently colored, cemented together at random intersections, tied to strings which were then attached to the corners of Duchamp's studio at 33 West 67th Street

115–116. *L.H.O.O.Q.* 1919. Rectified Ready-made: Reproduction of the *Mona Lisa* to which Duchamp has added a moustache and beard in pencil, 7 3/4 × 4 7/8″. Collection Mary Sisler, New York

117. *Tzanck Check.* 1919. Preliminary sketch. Pencil, black and red ink, 14 7/8 × 20 7/8″. Collection Vera and Arturo Schwarz, Milan

118. *Tzanck Check.* 1919. Imitated Rectified Ready-made: Enlarged manuscript version of a check, 8 1/4 × 15 1/8″. Collection Mary Sisler, New York

119. *Paris Air.* 1919. Ready-made: Glass ampoule, height 5 1/4″. Philadelphia Museum of Art. Louise and Walter Arensberg Collection

120. *Unhappy Ready-made.* 1919 (destroyed). Assisted Ready-made: Geometry textbook hung from the window by Duchamp's sister Suzanne

121. *Marcel's Unhappy Ready-made.* 1920. Painted by Suzanne Duchamp after Duchamp's *Unhappy Ready-made.* Oil on canvas, 31 7/8 × 23 5/8″. Collection Vera and Arturo Schwarz, Milan

122. *Fresh Window.* 1920. Semi-Ready-made: French window, painted light green, with black leather covering the glass panes, 30 1/2 × 17 3/4″. The Museum of Modern Art, New York. Katherine S. Dreier Bequest

123. *Belle Haleine, Eau de Voilette (Beautiful Breath, Veil Water).* 1921. Assisted Ready-made: Perfume bottle, height 6″. Cordier & Ekstrom Gallery, New York

124–125. *The Brawl at Austerlitz.* 1921. Miniature window with painted brickwork, 24 3/4 × 11 1/4 × 2 1/2″. Collection William N. Copley, New York

126. *Why not Sneeze Rose Sélavy?* 1921. Semi-Ready-made: 152 marble cubes with thermometer and cuttlebone in small birdcage, 4 1/2 × 8 5/8 × 6 1/4″. Philadelphia Museum of Art. Louise and Walter Arensberg Collection

127. *L'Oeil cacodylate.* 1921. Painting by Francis Picabia, 57 1/4 × 44 7/8″, with the signature of Marcel Duchamp, Rrose Sélavy

128. *WANTED / $2,000 REWARD.* 1923 (lost). Rectified Ready-made: Photographs on paper, 19 1/2 × 14″

129. *Monte Carlo Bond.* 1924. Imitated Rectified Ready-made: Collage of color lithograph with photo by Man Ray of Marcel Duchamp's soap-covered head, 12 3/8 × 7 3/4″. Galleria Schwarz, Milan

130. *Door: 11, rue Larrey.* 1927. Three-dimension pun: A door which permanently opens and shuts at the same time, 86 5/8 × 24 3/4″. Collection Arman, New York

131. *Handmade Stereopticon Slides.* 1918–19. Rectified Ready-made: Two views of a seascape on which Duchamp has drawn, in pencil, the projection of a pyramid and its mirror image, 2 1/4 × 2 1/4″. The Museum of Modern Art, New York. Katherine S. Dreier Bequest

132–133. *Rotary Glass Plates (Precision Optics).* 1920. Motorized optical device: Five glass plates, painted with black segments of circles, turning on a metal axis

powered by an electric motor and forming continuous circles when seen in motion, 47 1/2 × 72 1/2". Yale University Art Gallery, New Haven. Société Anonyme Collection, Katherine S. Dreier Bequest

134. *Rotary Demisphere (Precision Optics)*. 1925. Motorized optical device: White demisphere painted with black eccentric circles, fixed on a flat disc covered with black velvet, with copper and glass dome, and electric motor, height 54 1/8"; diameter of disc, 23 7/8". Collection Mary Sisler, New York

135–142. *Discs Inscribed with Puns*. 1926. White letters pasted on nine black cardboard discs, diameter 11 3/4". Collection William N. Copley, New York

143–166. *Anémic Cinéma*. 1925–26. Film made in collaboration with Man Ray and Marc Allégret. Ten optical discs alternate with nine discs with puns

167–178. *Rotorelief (Optical Discs)*. 1935. Set of six discs, with a drawing on each side printed in color by offset lithography, diameter 7 7/8":

 167. *No. 1 Corolles*
 168. *No. 2 Oeuf à la coque*
 169. *No. 3 Lanterne chinoise*
 170. *No. 4 Lampe*
 171. *No. 5 Poisson japonais*
 172. *No. 6 Escargot*
 173. *No. 7 Verre de Bohême*
 174. *No. 8 Cerceaux*
 175. *No. 9 Montgolfière*
 176. *No. 10 Cage*
 177. *No. 11 Éclipse totale*
 178. *No. 12 Spirale blanche*

179. *Fluttering Hearts*. 1936. Cover for *Cahiers d'Art*, Paris. Paper collage, 12 3/8 × 9 5/8"

180. *The Bride Stripped Bare by Her Bachelors Even* [The Green Box]. 1934. One colorplate and ninety-three documents boxed in a green suede-covered case, 13 1/8 × 11 × 1". 300 copies signed and numbered

181. *From or by Marcel Duchamp or Rrose Sélavy* [The Box in a Valise]. 1941–68. Cardboard box containing eighty-three miniature replicas and color reproductions of works by Duchamp, limited to 300 copies

182–183. *1200 Coal Bags Suspended from the Ceiling Over a Stove*. 1938. Layout for the Exposition Internationale du Surréalisme, Galeries Beaux-Arts, Paris

184. *In the Manner of Delvaux*. 1942. Collage of photo, tinfoil, and cardboard, 13 3/8 × 13 3/8". Collection Vera and Arturo Schwarz, Milan

185. *Pocket Chess Set*. 1943. Rectified Ready-made: Leather pocket chessboard, celluloid, and pins, 6 1/4 × 4 1/8"

186–187. *Sixteen Miles of String*. 1942. Layout for the exhibition *First Papers of Surrealism*, organized by André Breton, at the Coordinating Council of French Relief Societies, New York

188. Cover for *View*, March, 1945. Vol. V, No. 1. 12 × 9 1/8"

189. *Genre Allegory (George Washington)*. 1943. Assemblage: Cardboard, gauze, and paint, 20 7/8 × 15 7/8". André Breton Estate, Paris.

190. *Lazy Hardware*. Window display for André Breton's *Arcane 17*. 1945

191. Cover for the exhibition catalogue, *Le Surréalisme*. 1947. Paperback, 9 1/4 × 8 1/8"

192. *Given the Illuminating Gas and the Waterfall*. 1948–49. Painted relief of cowhide, paint and plaster, 19 3/4 × 12 1/4". Collection Maria Martins, Rio de Janeiro

193. *Female Fig Leaf*. 1950. Galvanized plaster, 3 1/2 × 5 1/2 × 4 7/8". Collection Mary Sisler, New York

194. *Objet-Dard (Dart-Object)*. 1951. Galvanized plaster with inlaid lead, 3 × 8 × 2 3/8". Collection Mrs. Marcel Duchamp, New York

195. *Wedge of Chastity*. 1954. Sculpture of two interlocking parts, galvanized plaster for the wedge and dental plastic for the base, 2 1/4 × 3 3/8". Collection Teeny Duchamp, New York

196. *Jacket*. 1956. Pen and ink drawing, 10 5/8 × 8 1/8". Harriet Janis Estate, New York

197. *Moonlight on the Bay at Basswood*. 1953. Pen, pencil, talcum powder, and chocolate on blue blotter,

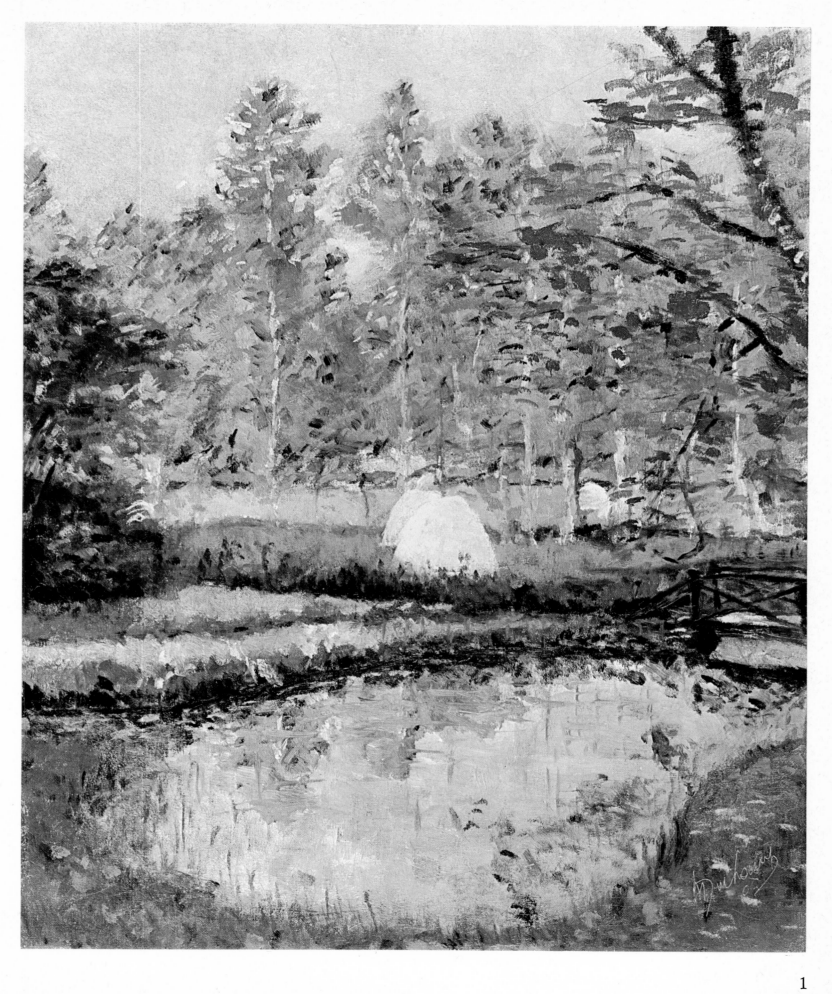

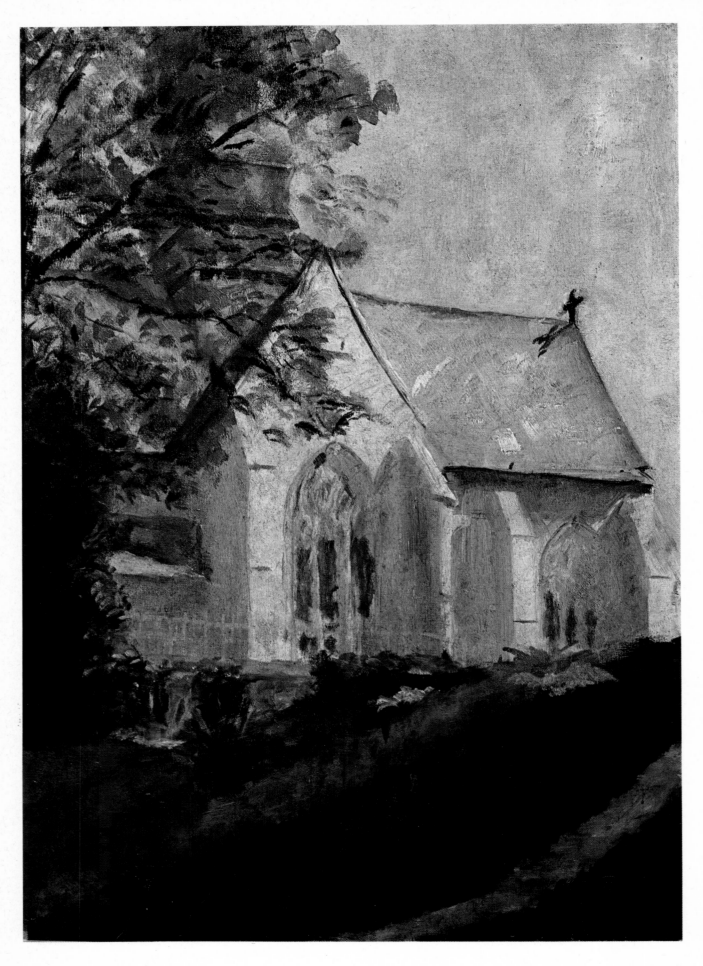

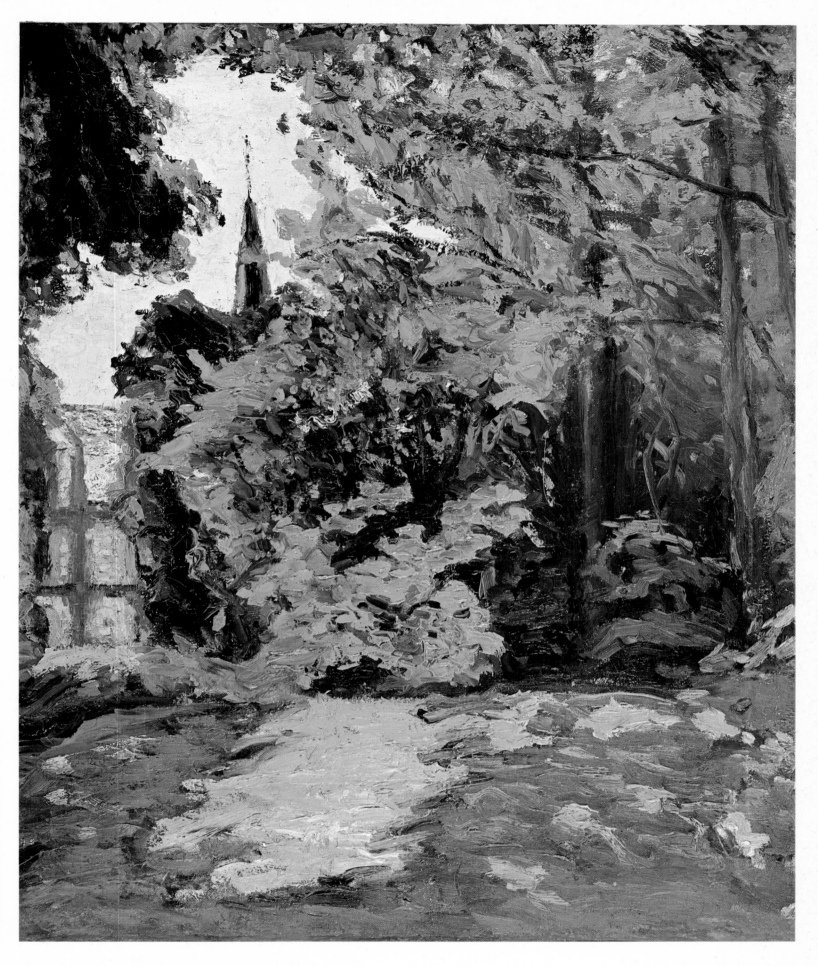

4

5

6 7 8

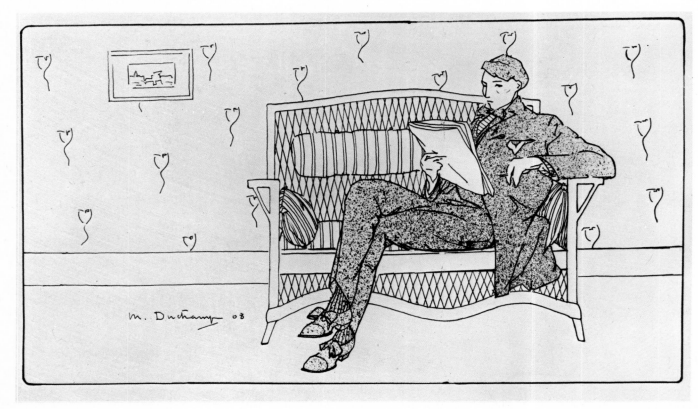

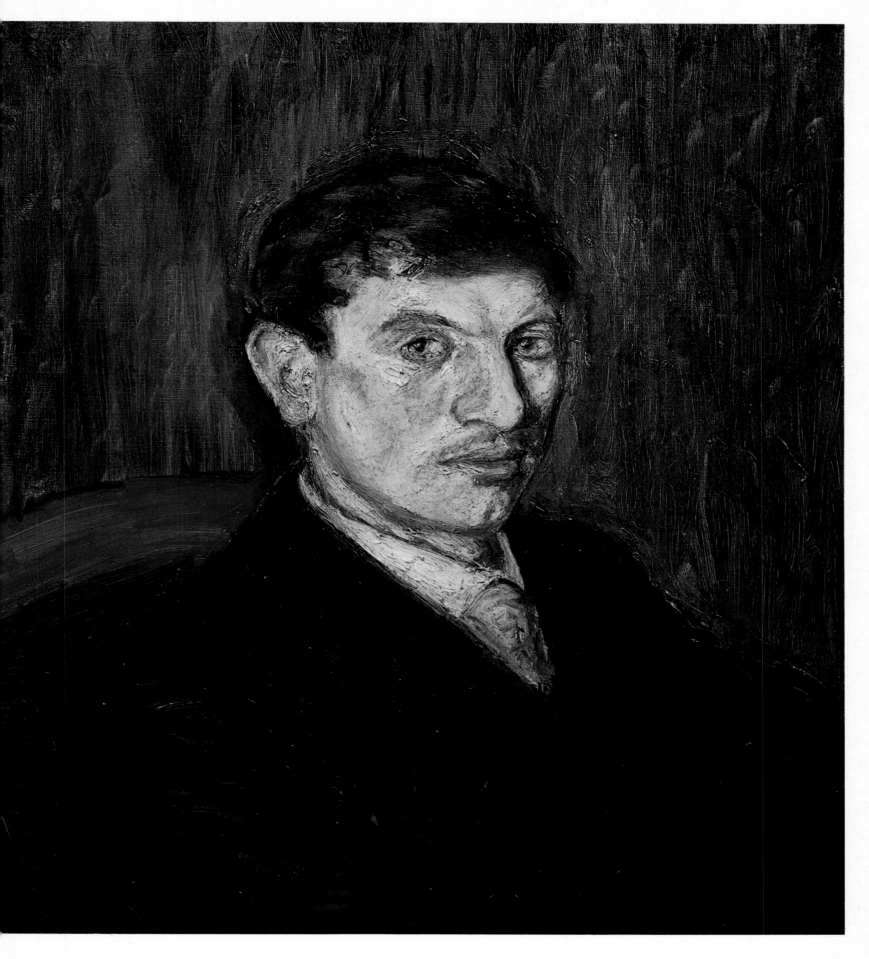

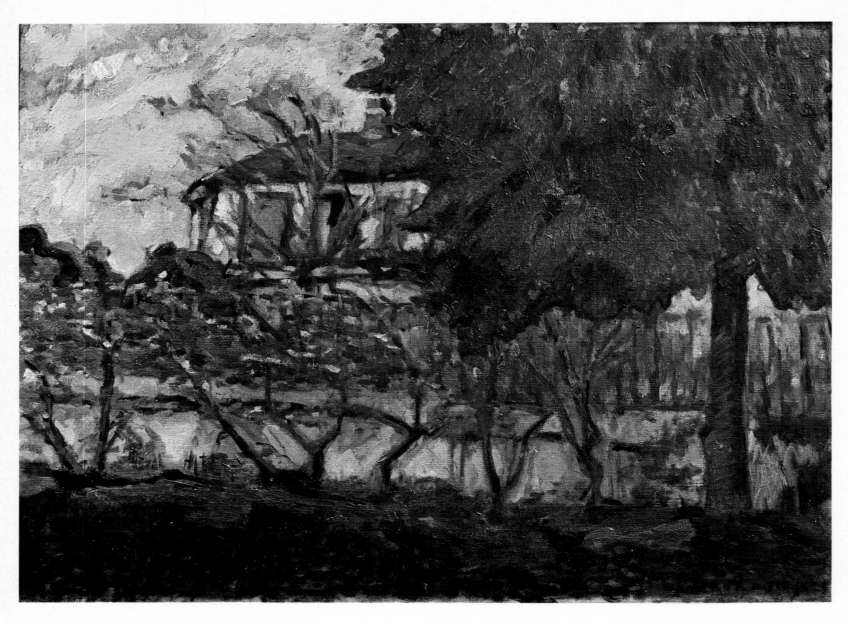

13

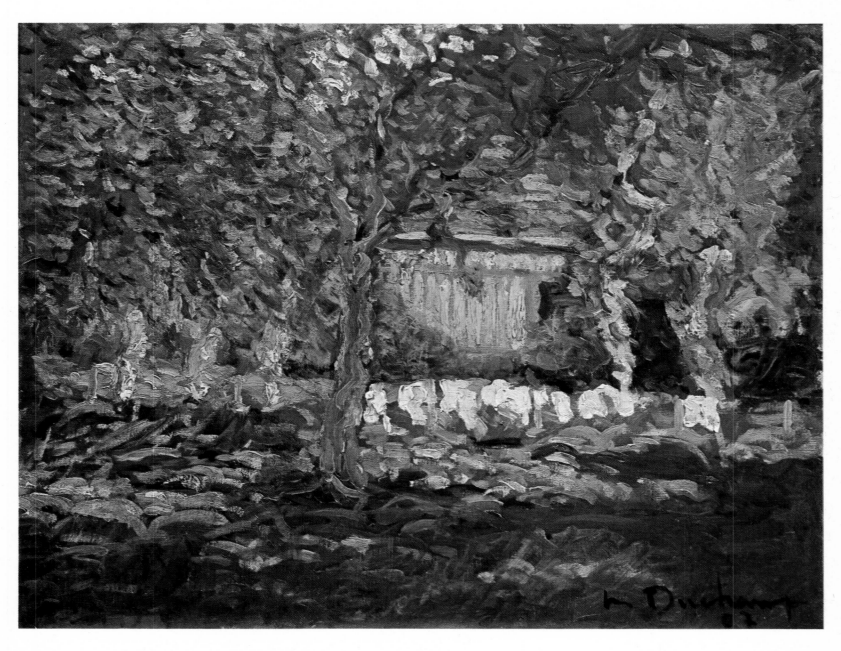

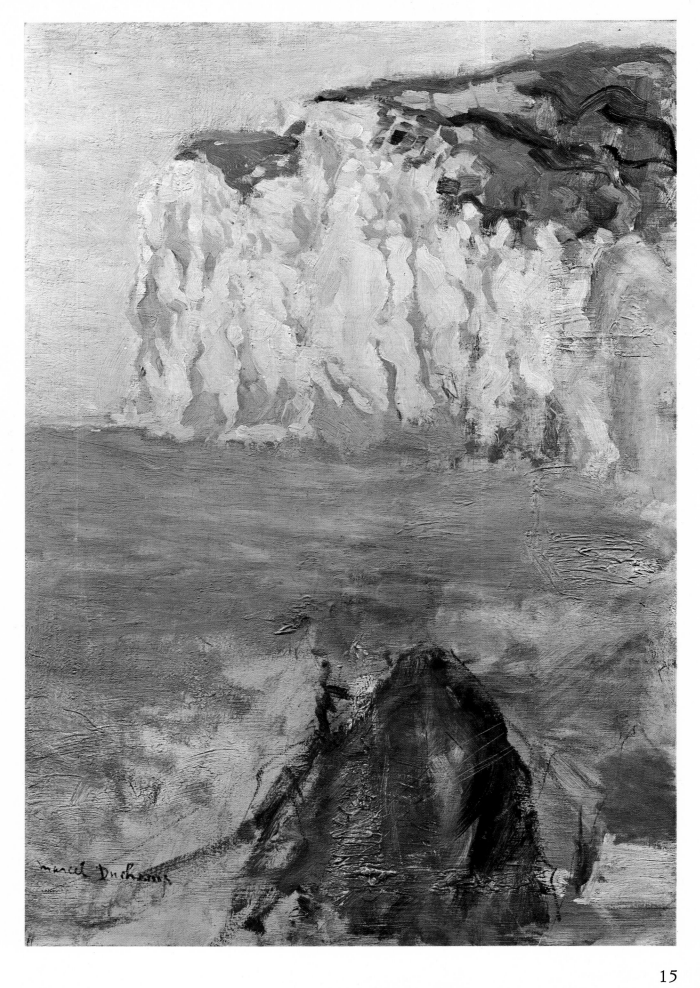

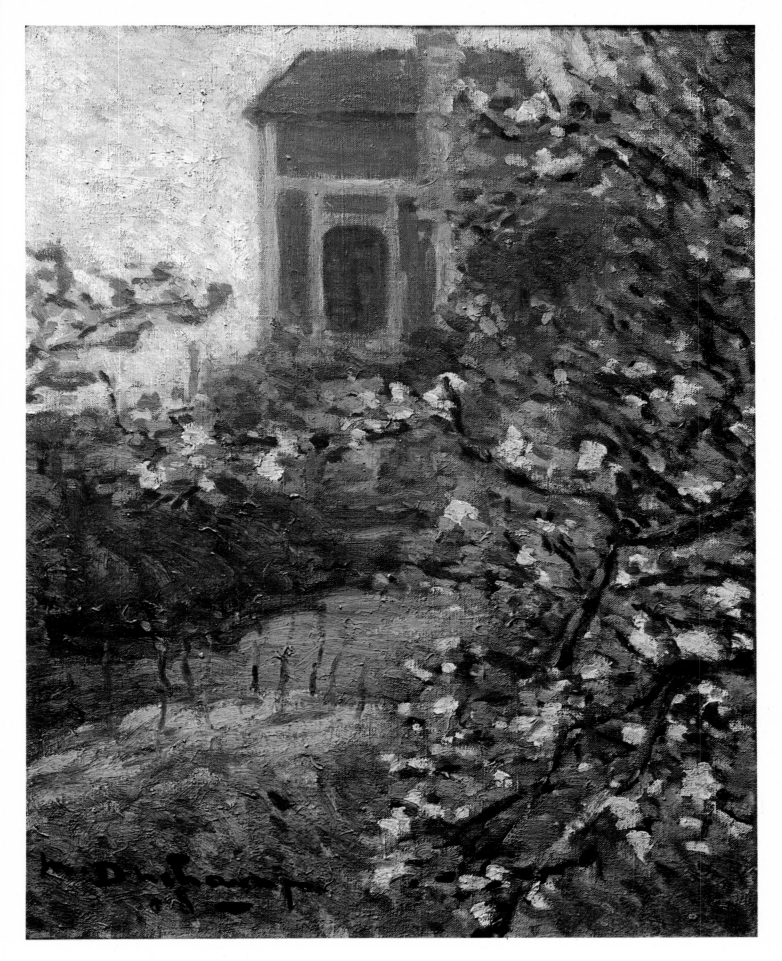

16

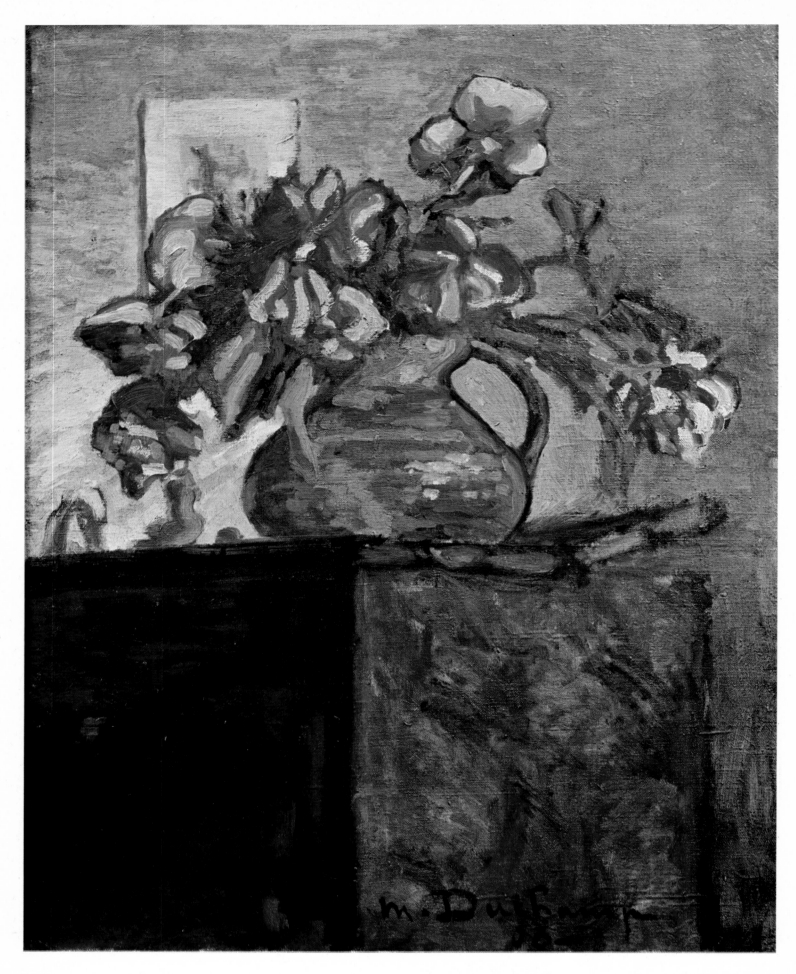

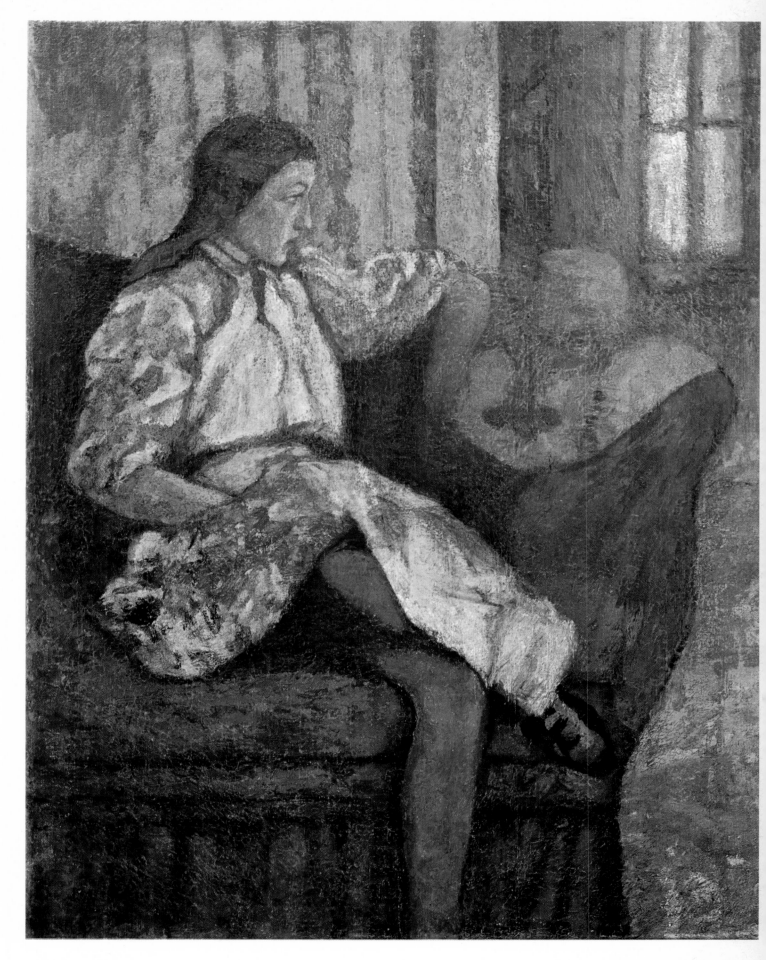

19

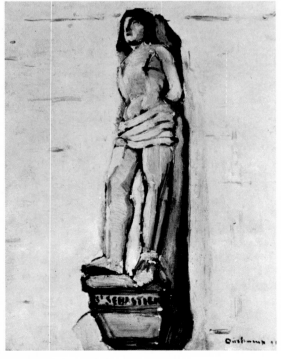

20

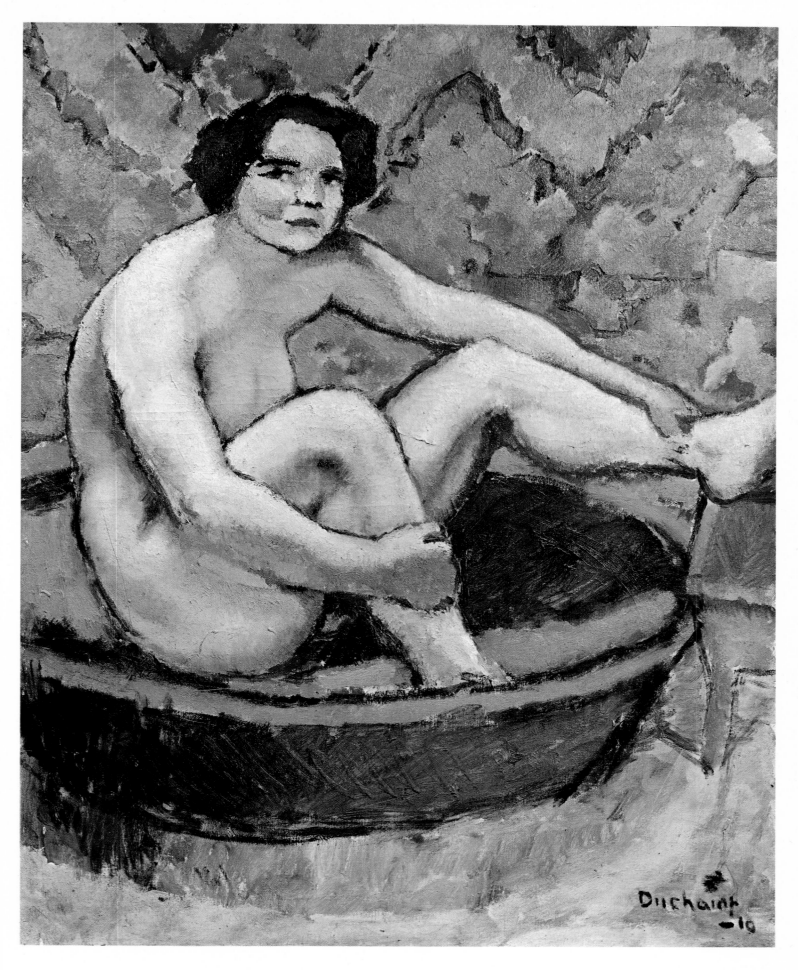

21

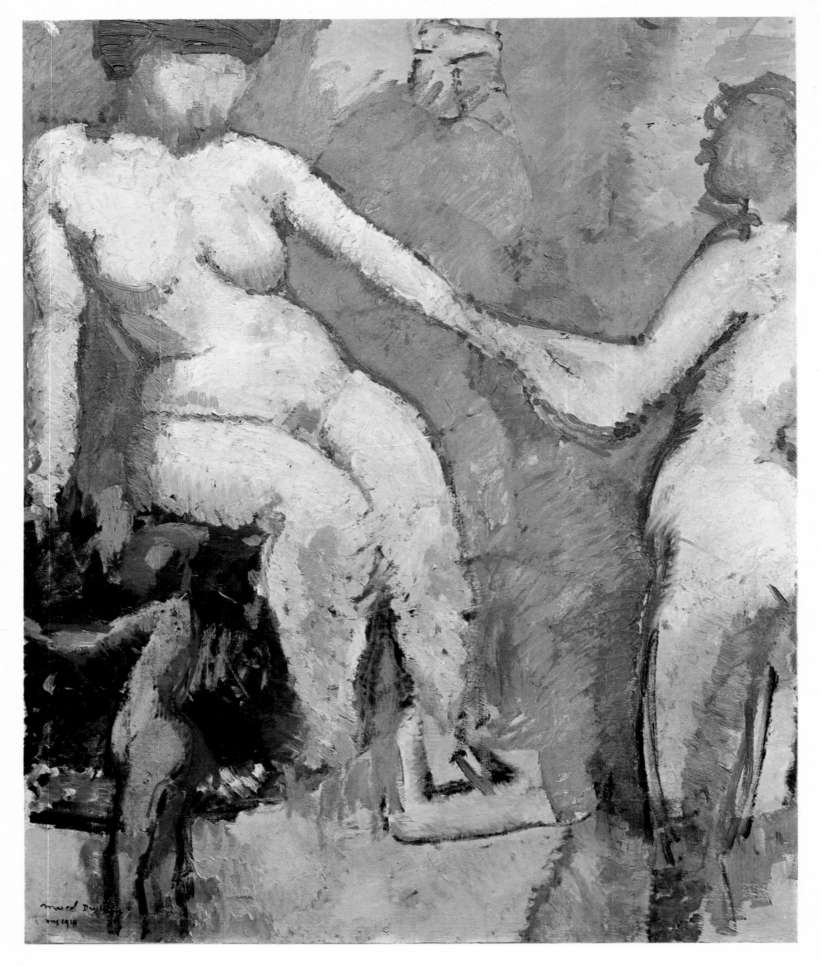

22

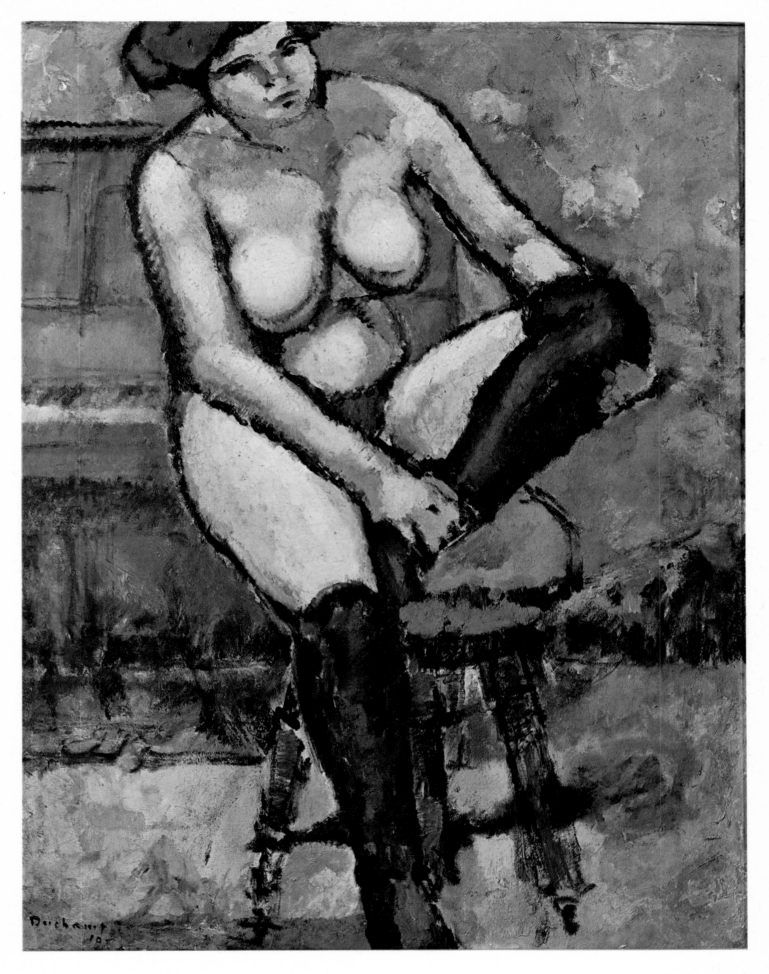

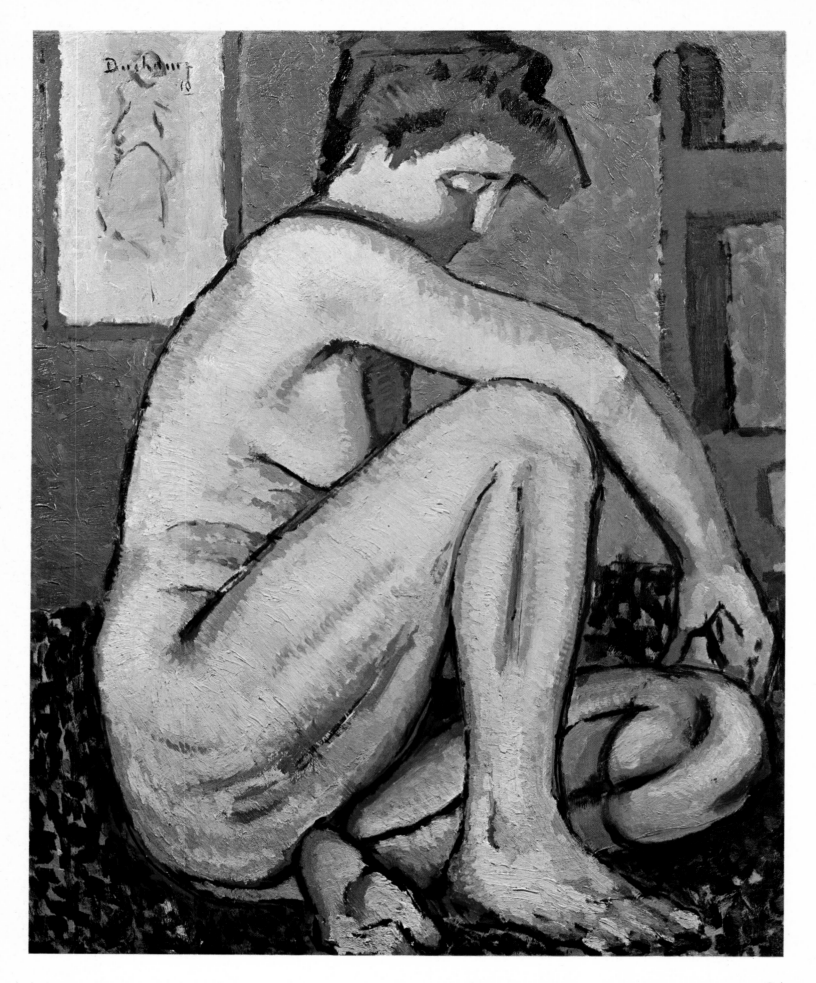

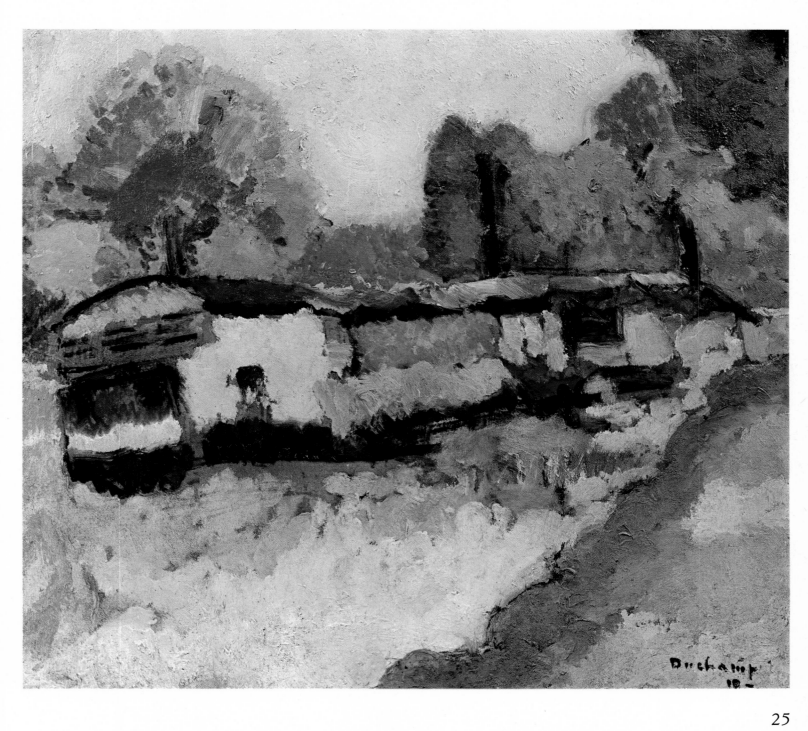

25

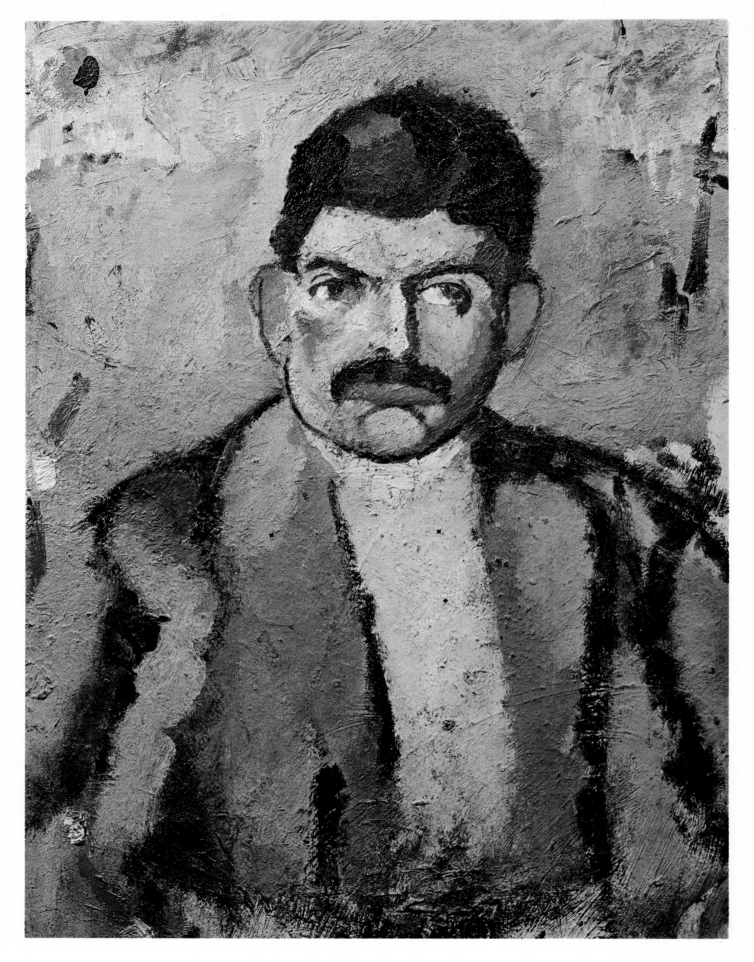

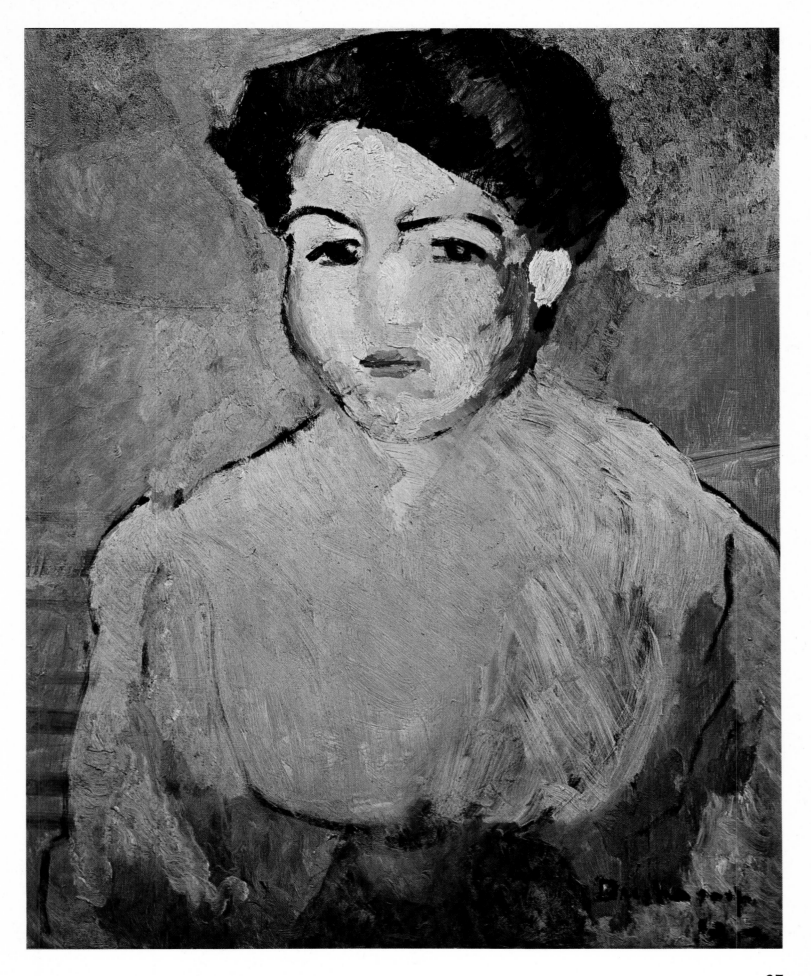

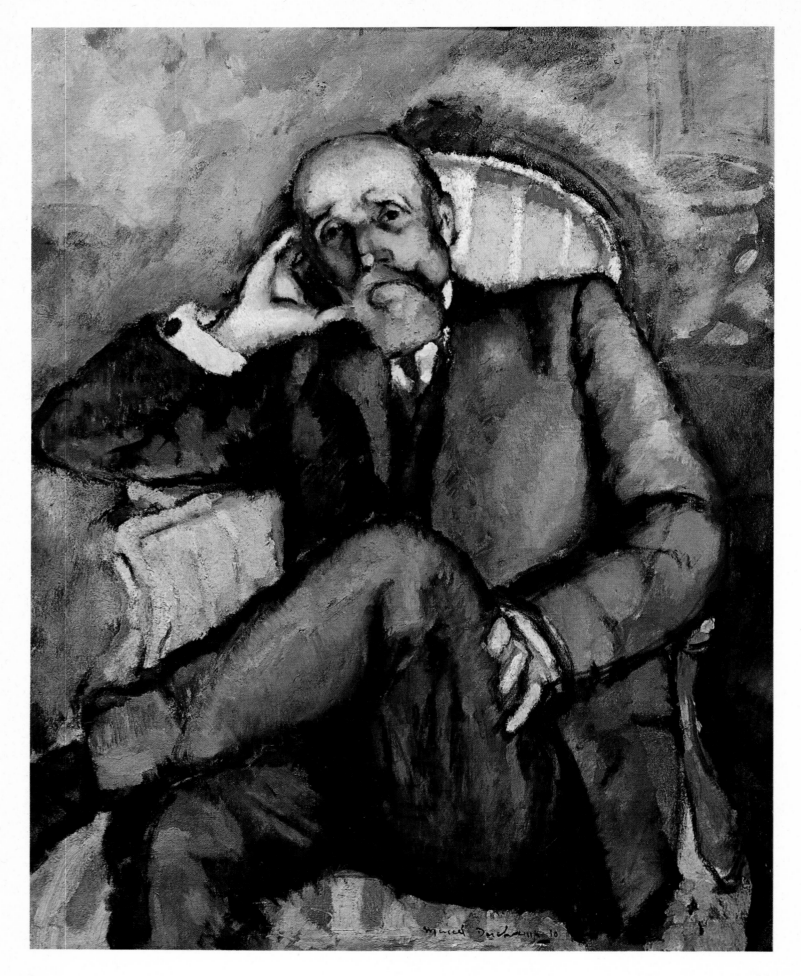

28

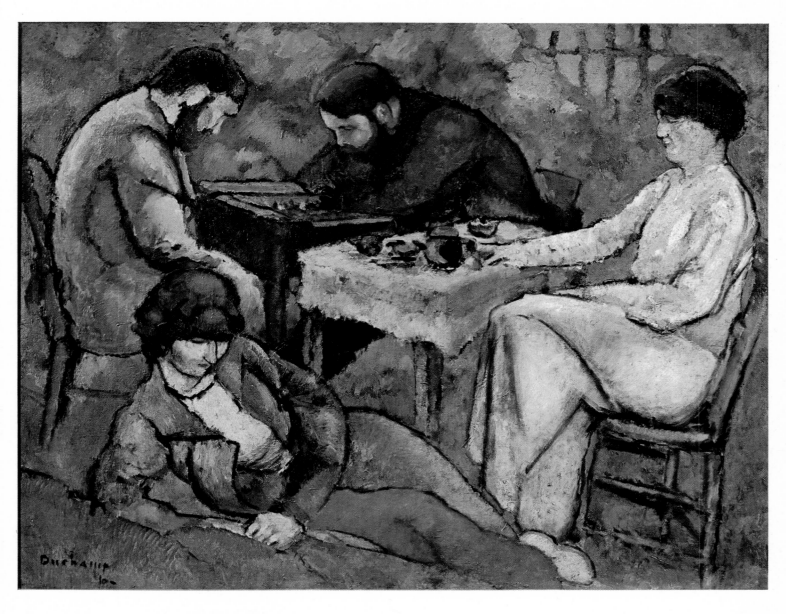

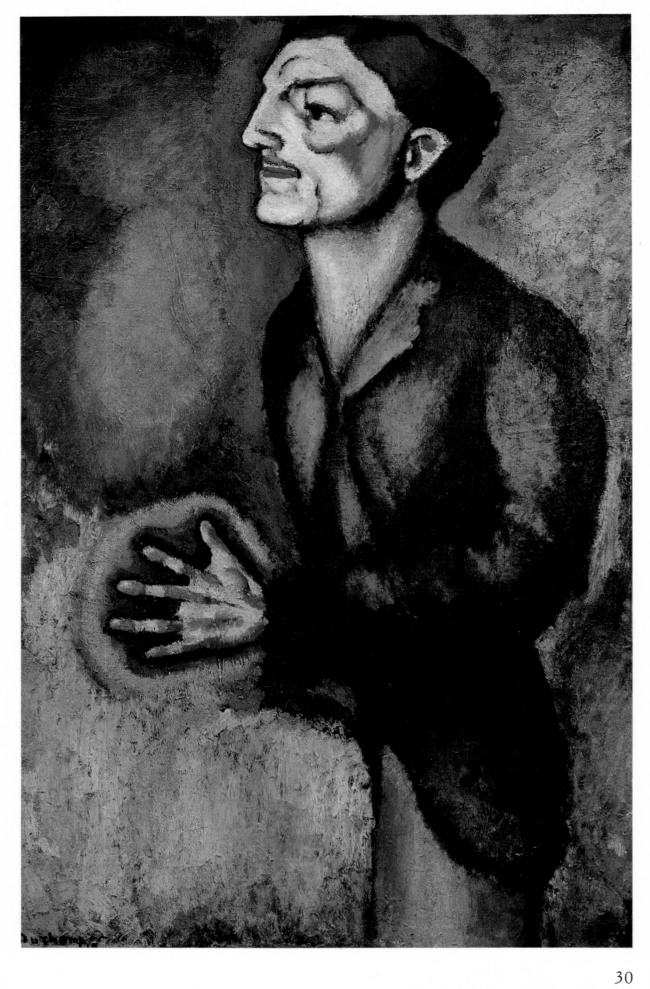

30

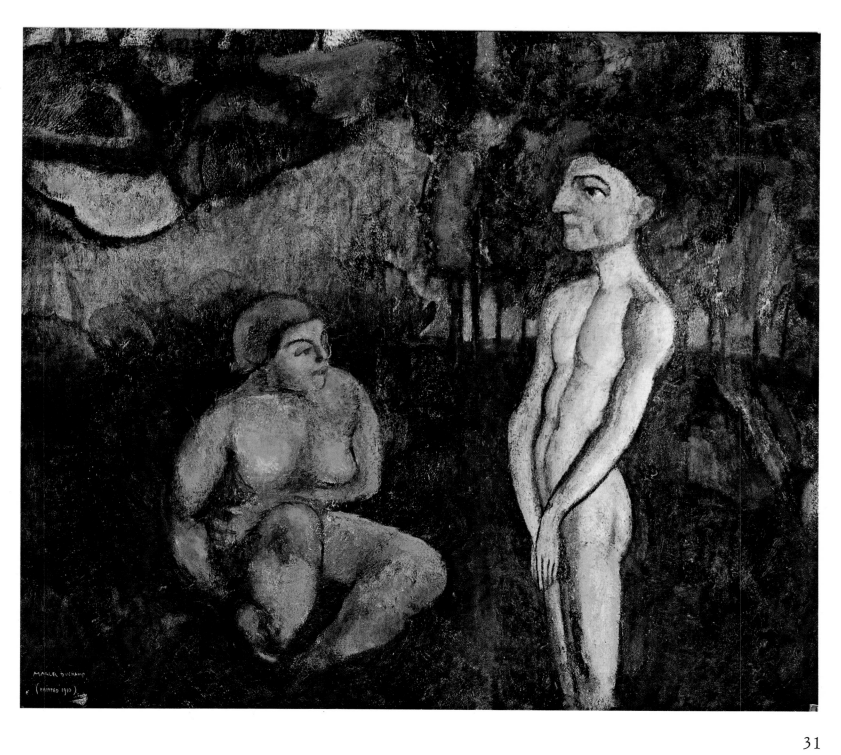

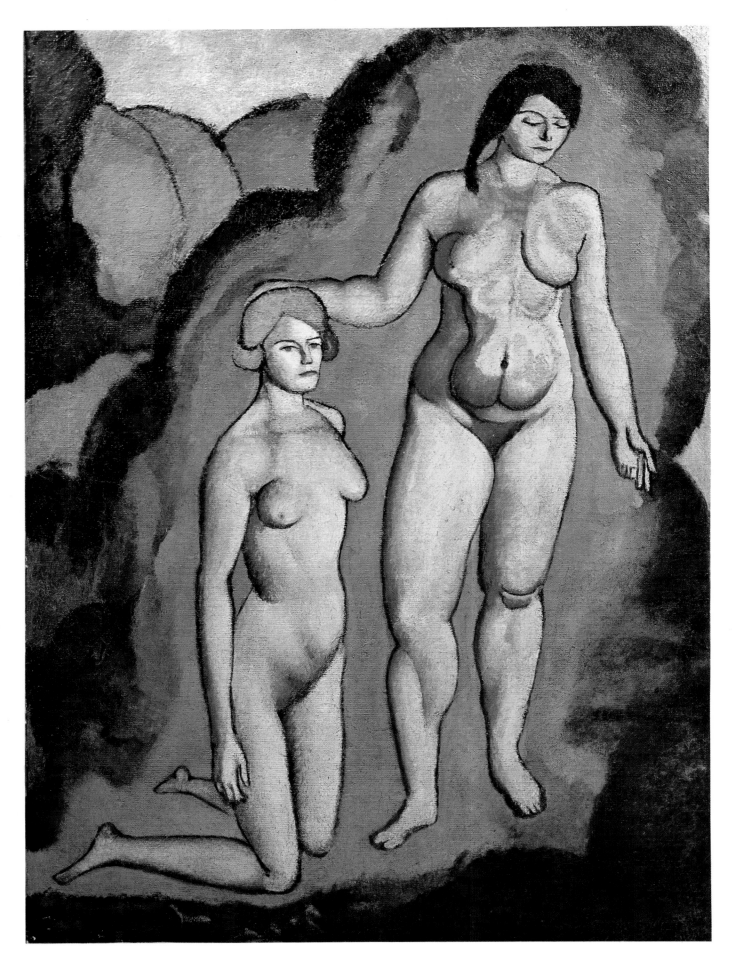

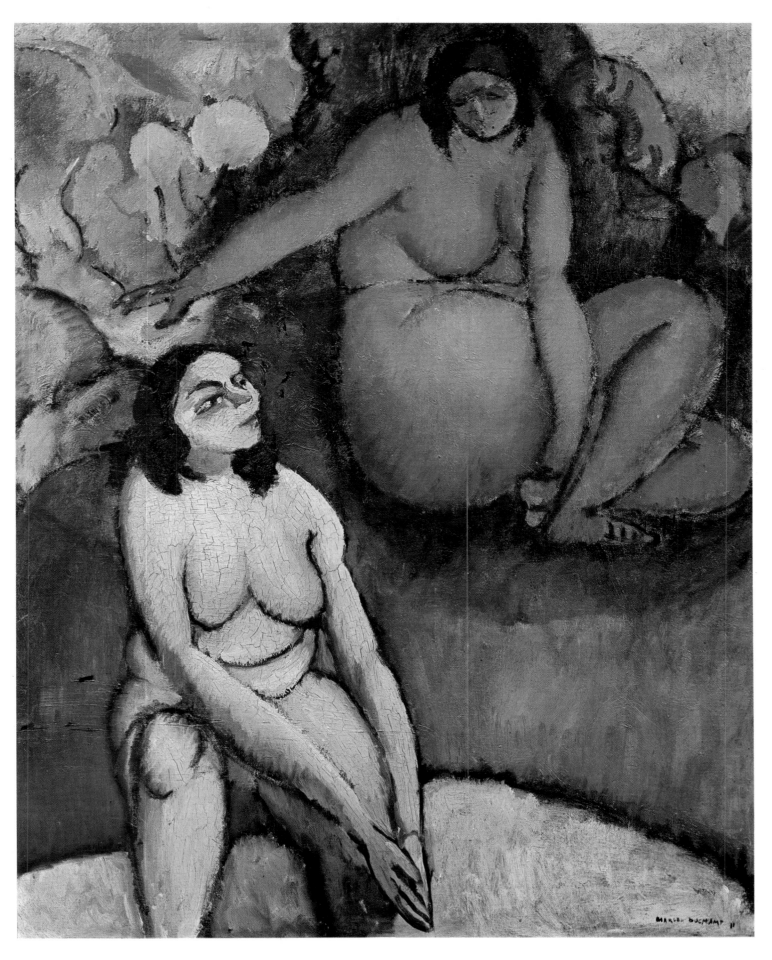

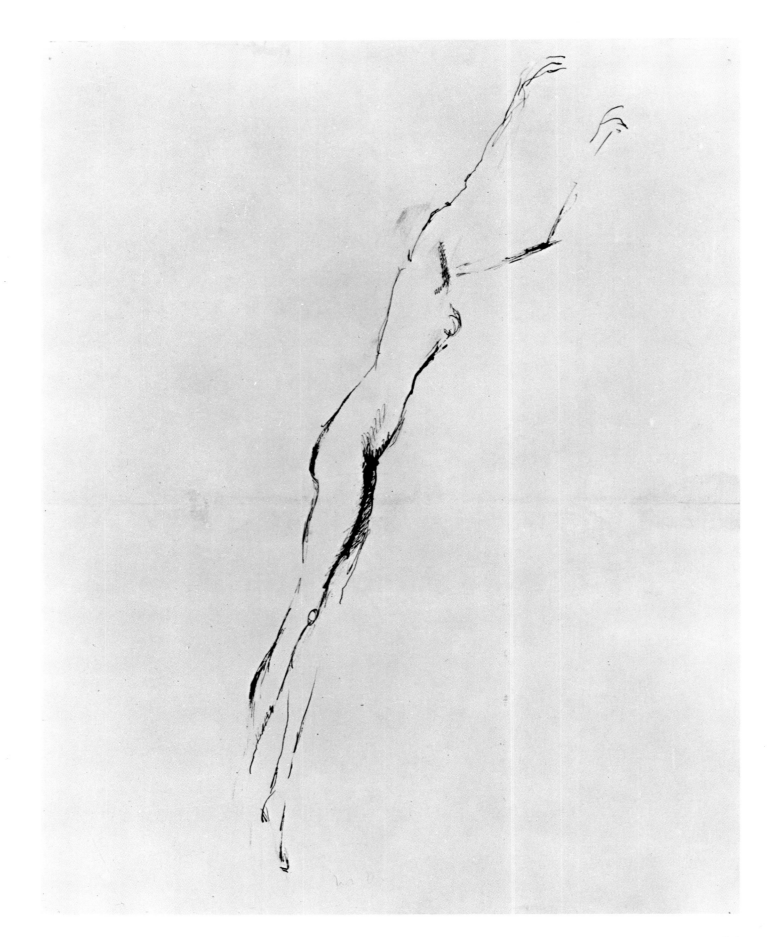

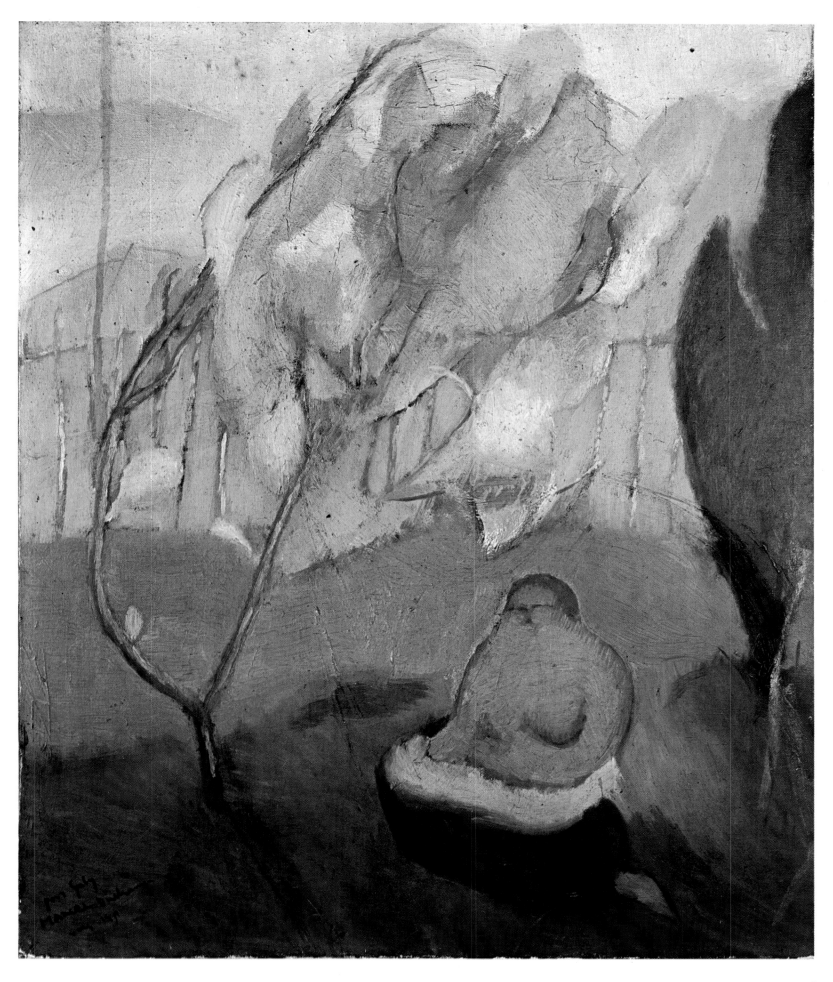

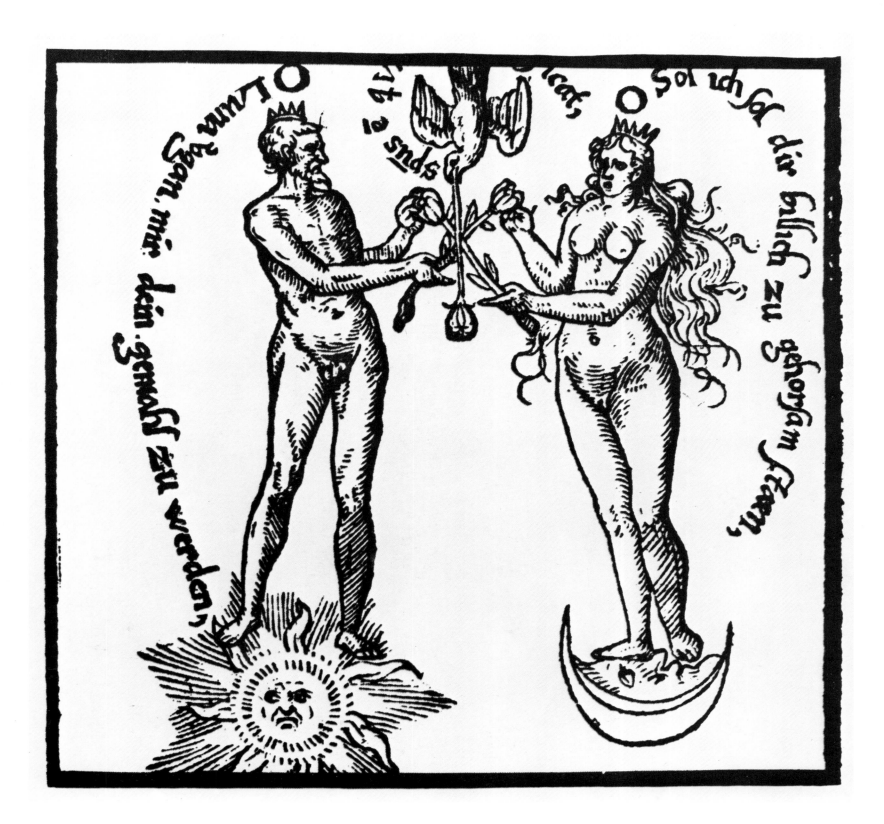

36

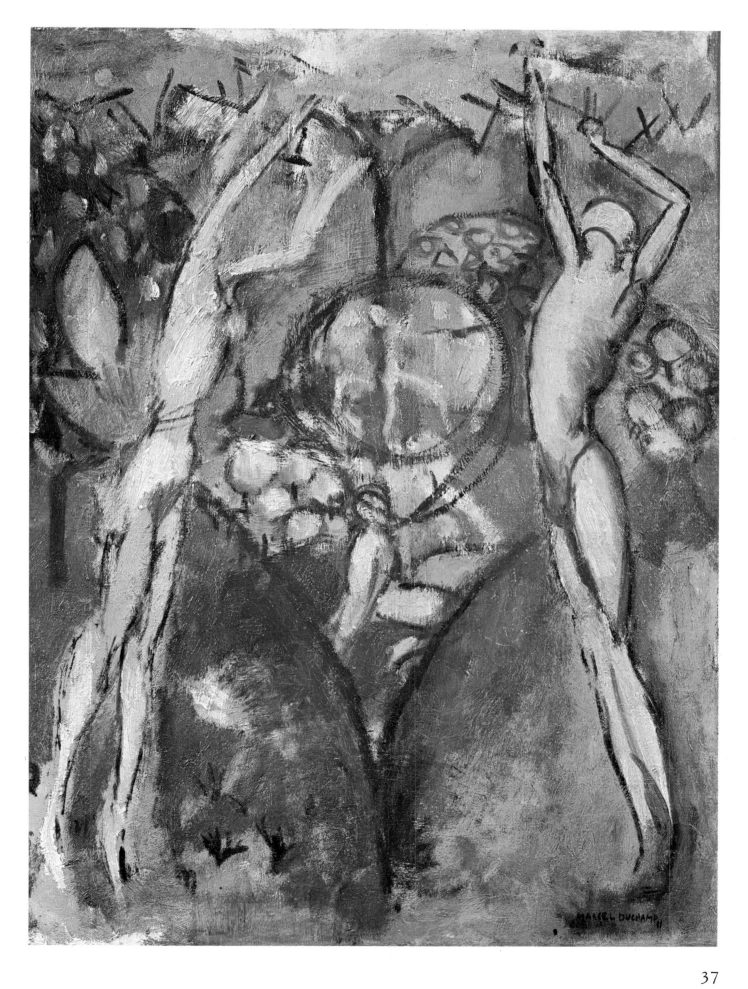

38

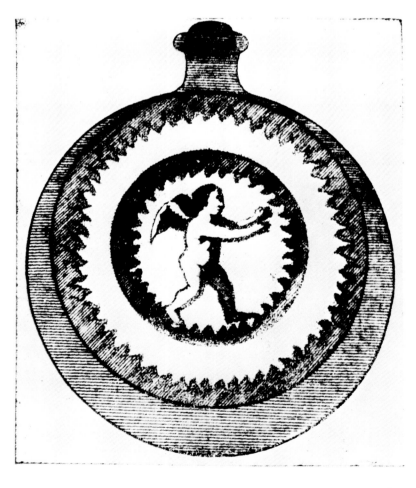

39

41

42

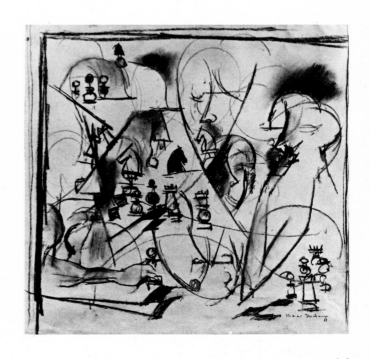

43

44

45

46

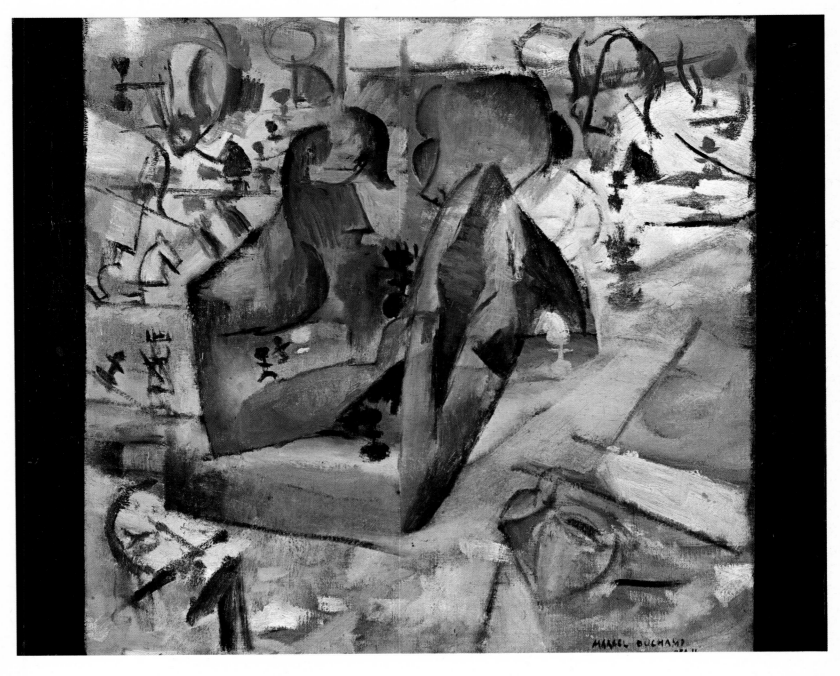

47

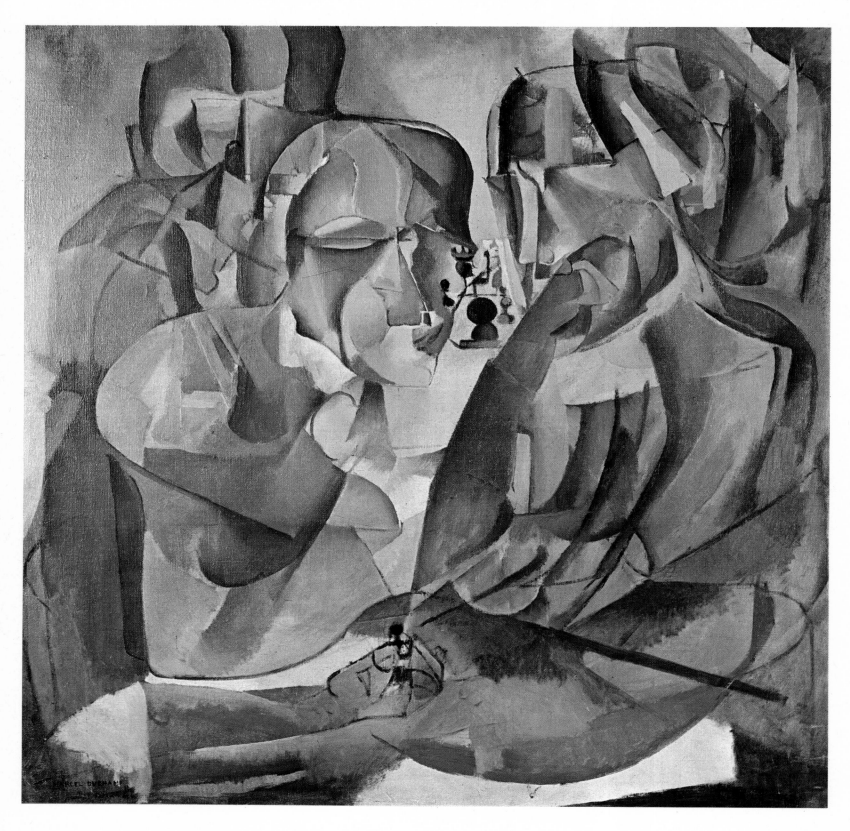

48

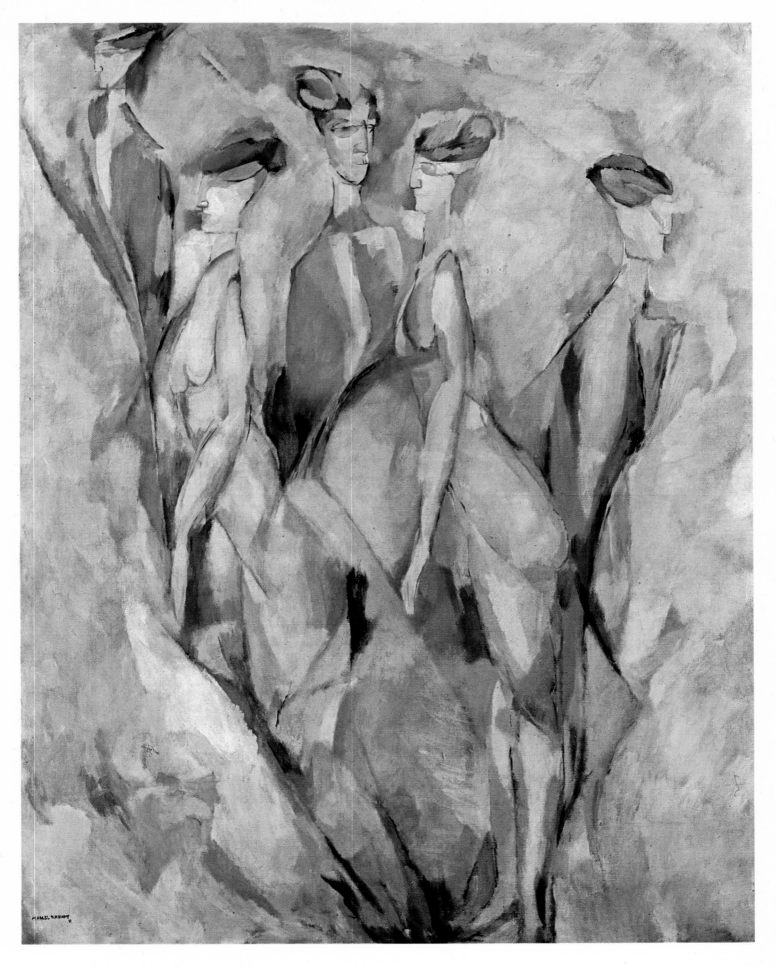

50

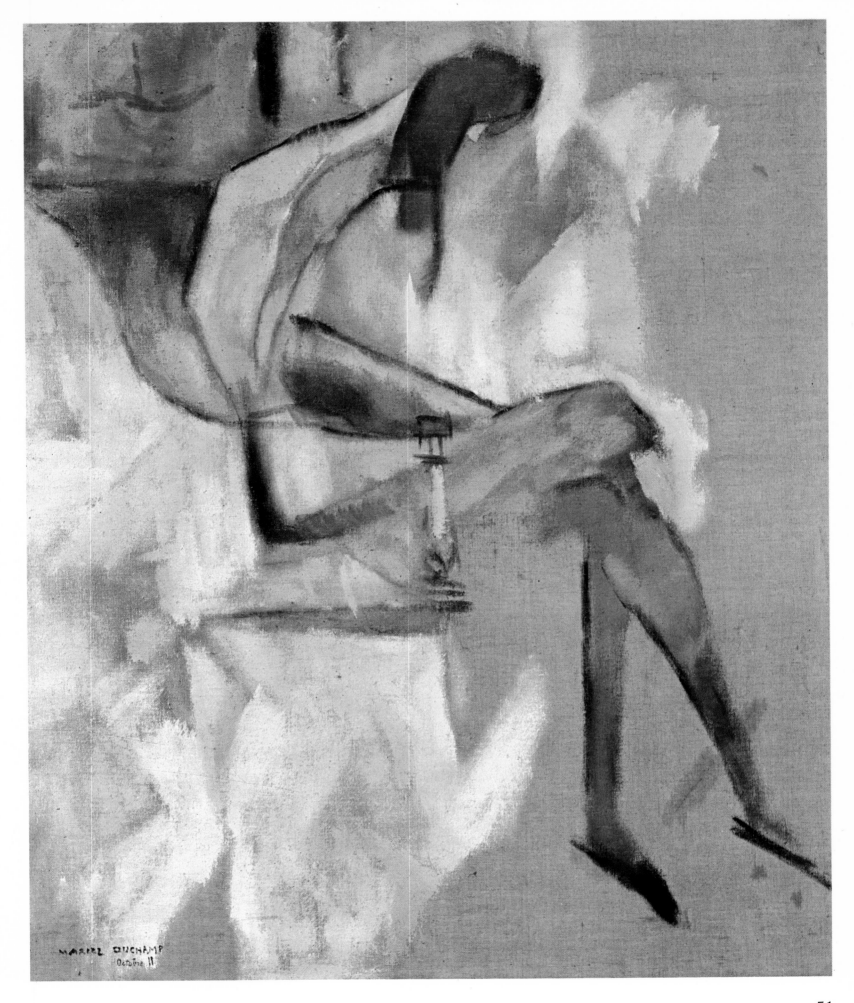

51

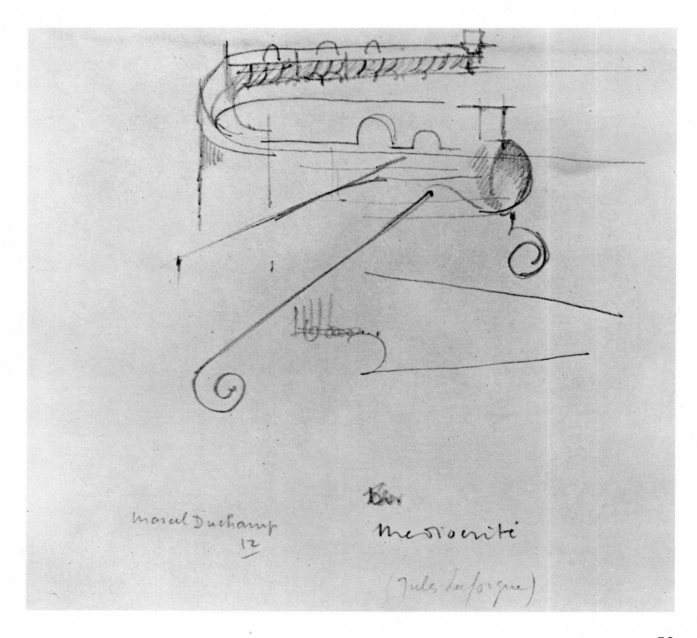

Marcel Duchamp
12

Bla
mediocrité

(Jules Laforgue)

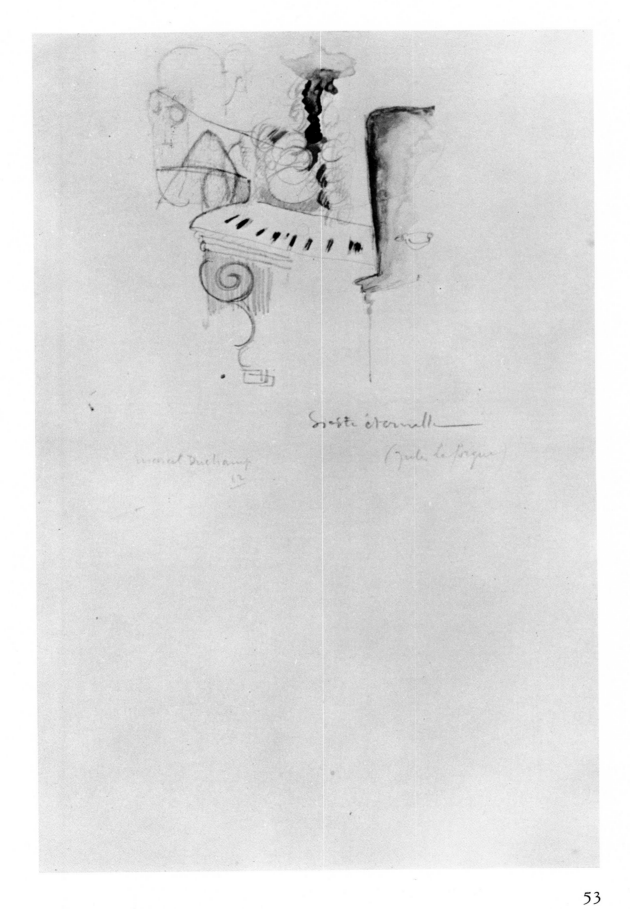

Sieste éternelle

(Jules Laforgue)

marcel Duchamp
12

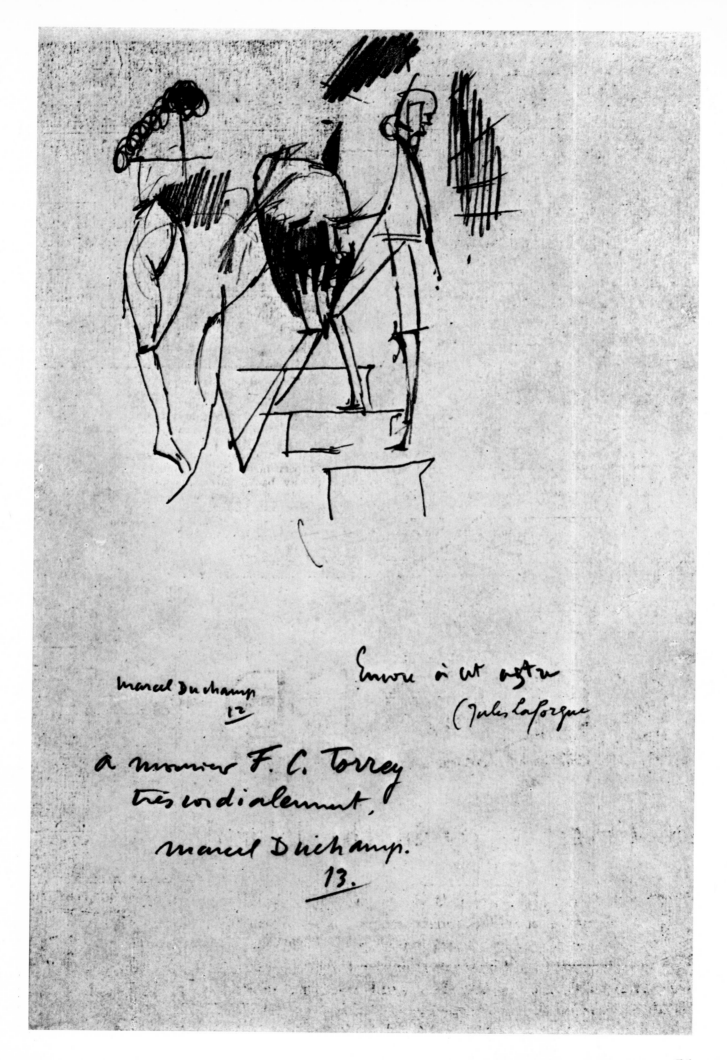

Marcel Duchamp
12

Envoi à cet astre
(Jules Laforgue

à monsieur F. C. Torrey
très cordialement,
Marcel Duchamp.
13.

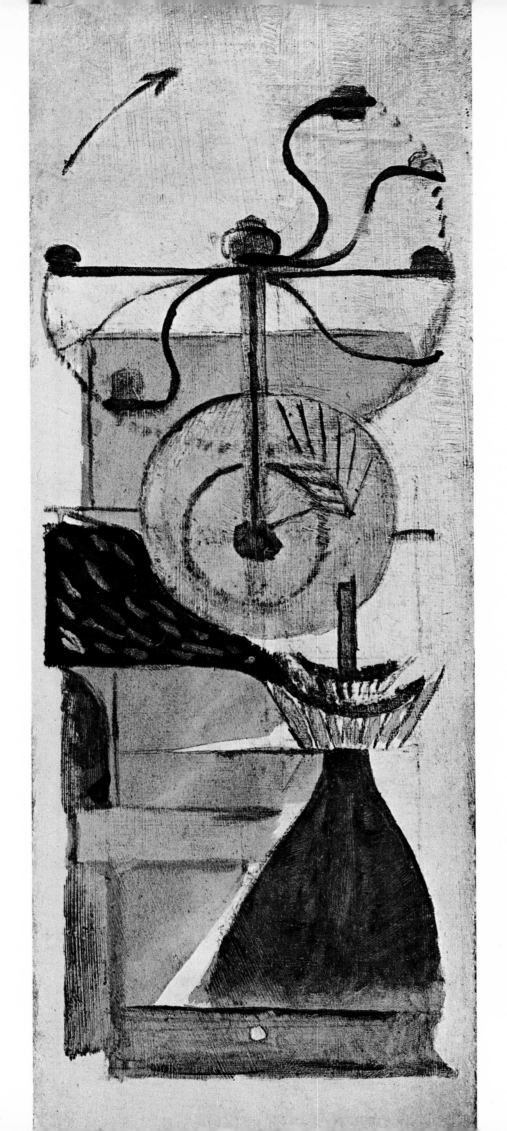

55

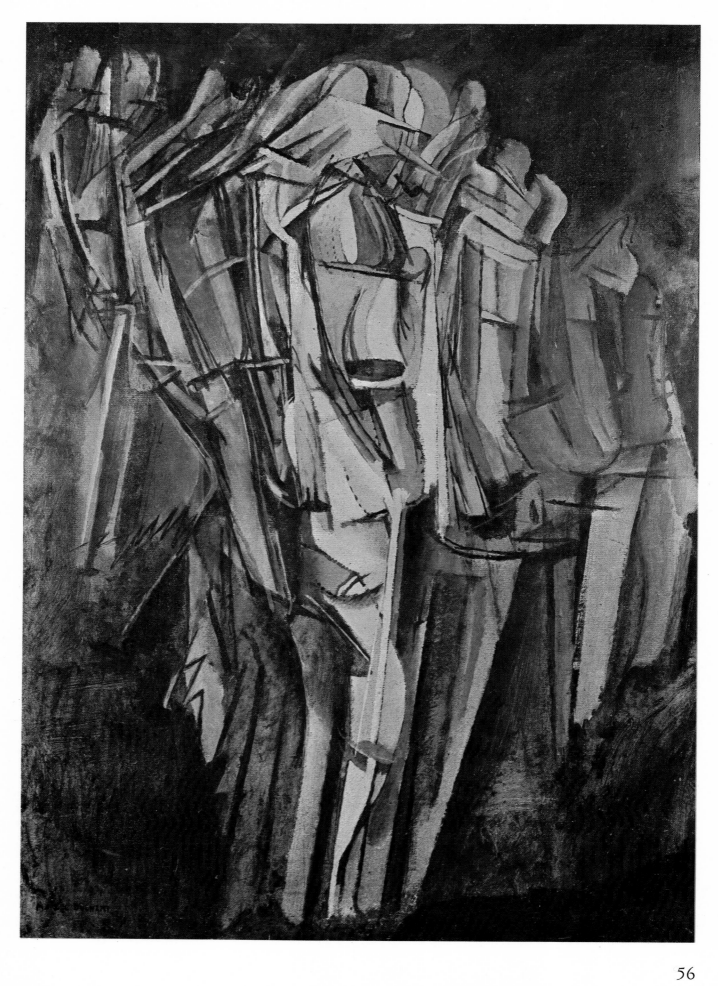

56

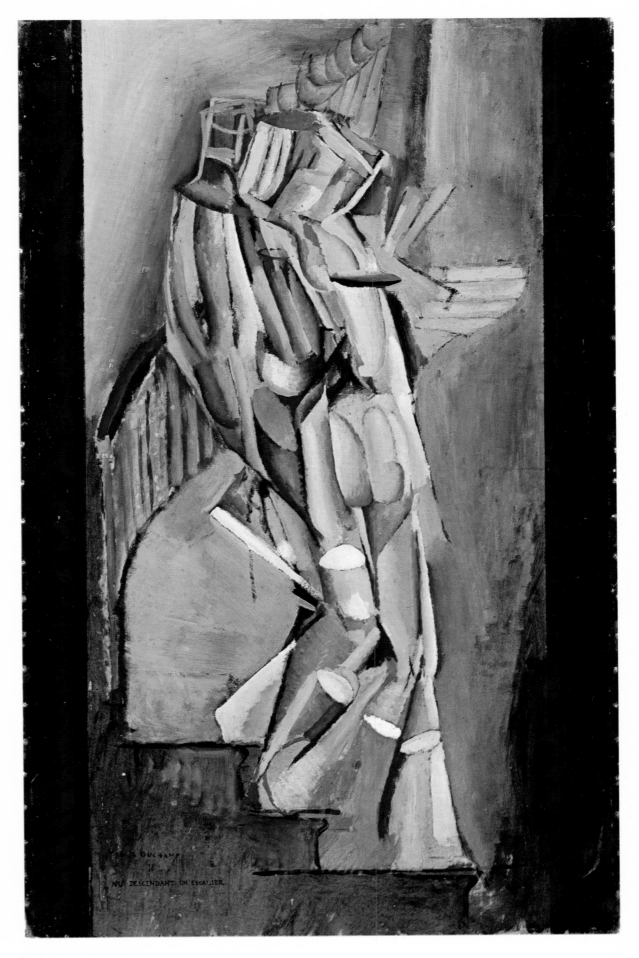

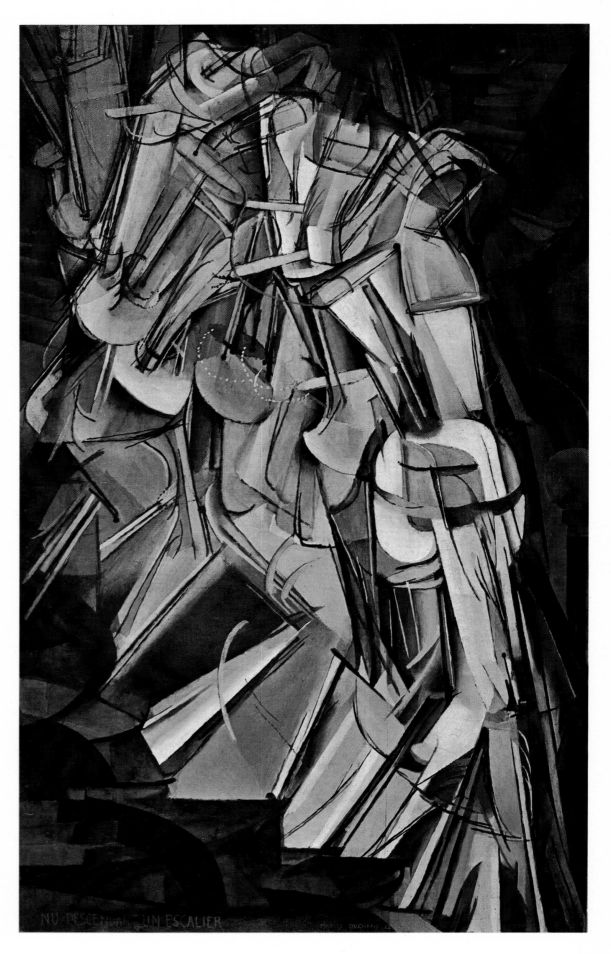

2 nus : un fort et un vite . MARCEL DUCHAMP 12

59

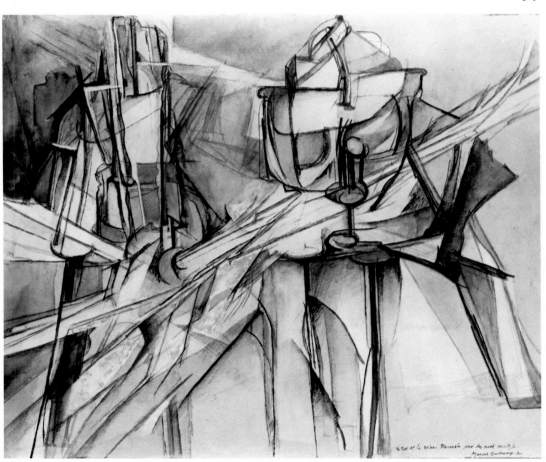

60

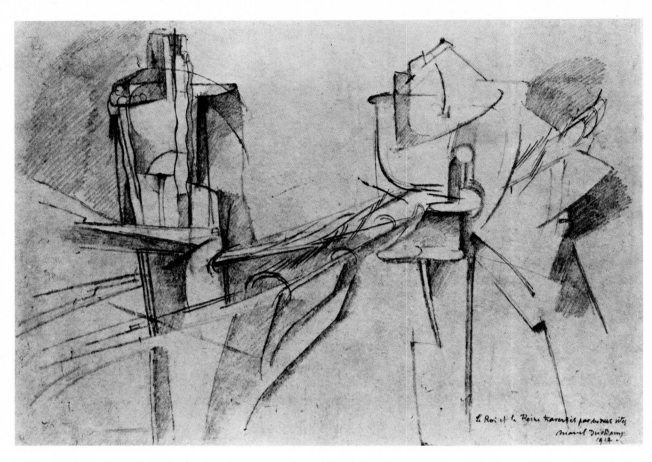

Le Roi et la Reine traversés par des vites
marcel Duchamp
1912.

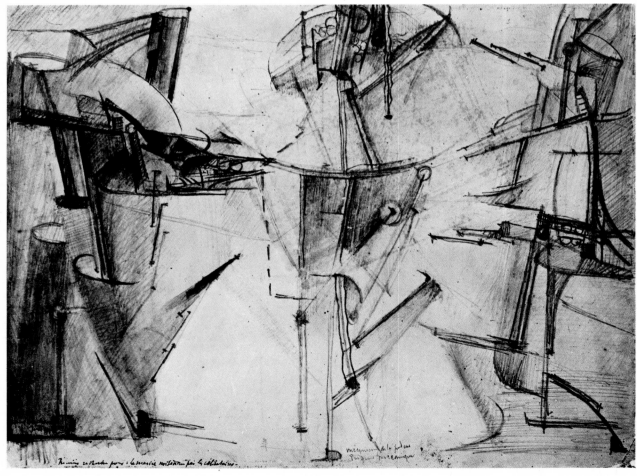

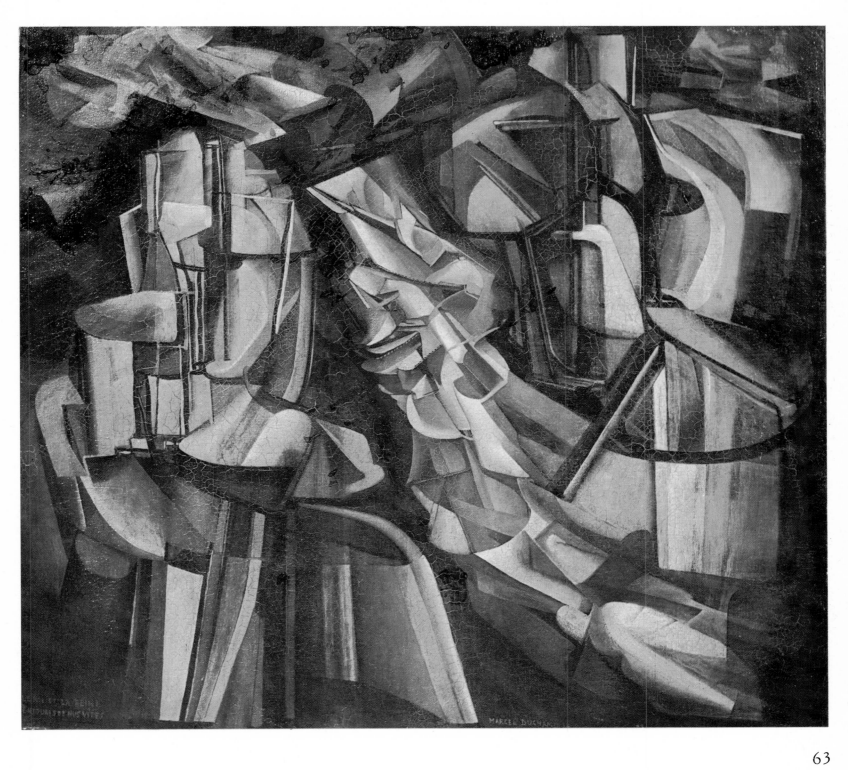

63

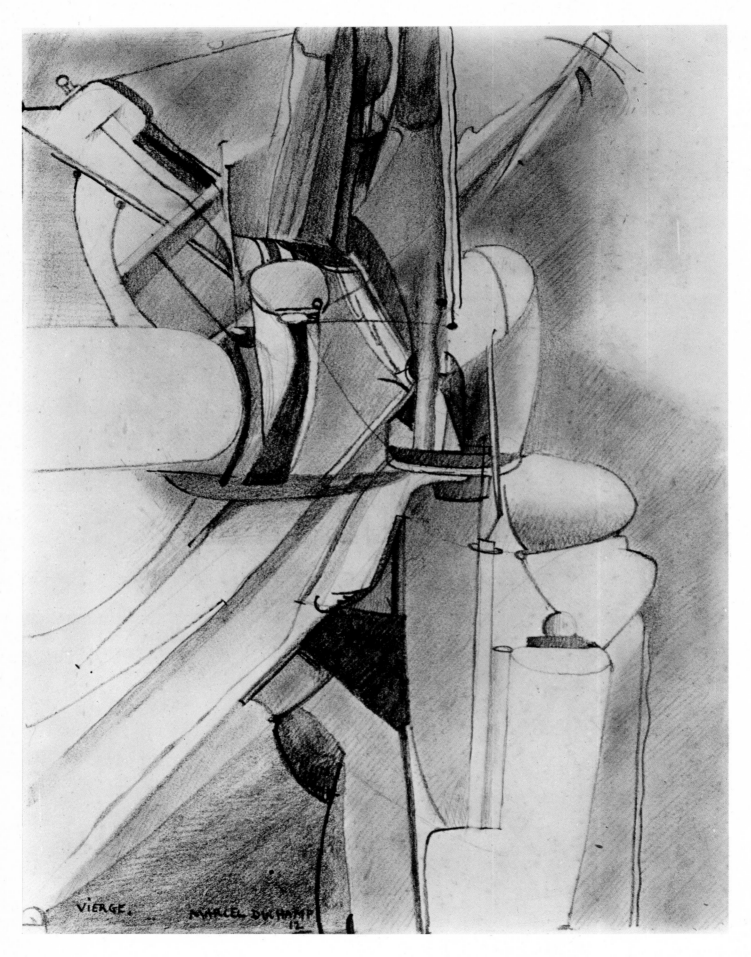

VIERGE. MARCEL DUCHAMP
12

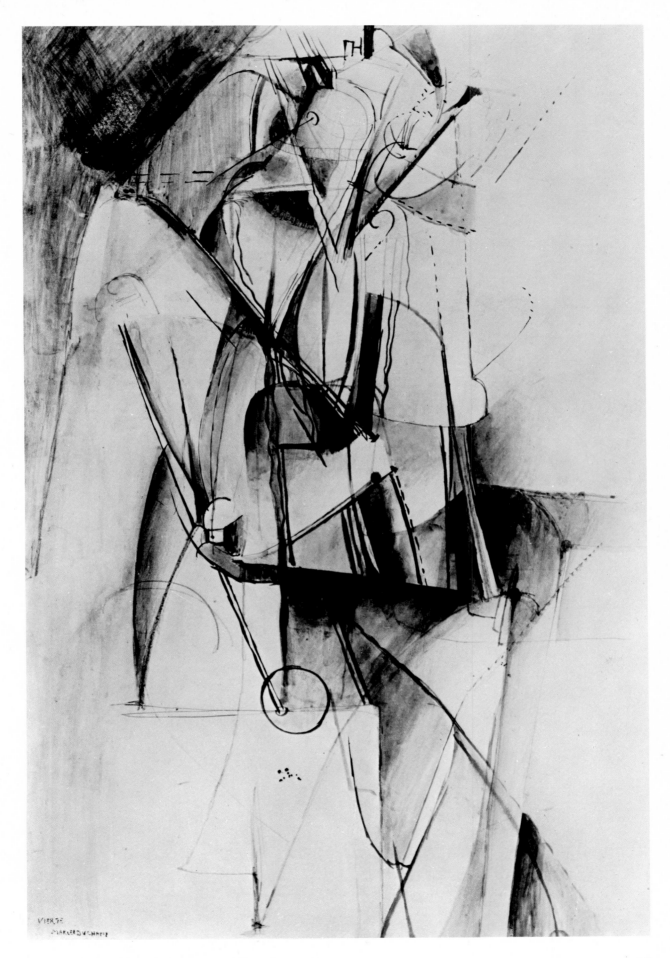

VIERGE
MARCEL DUCHAMP

65

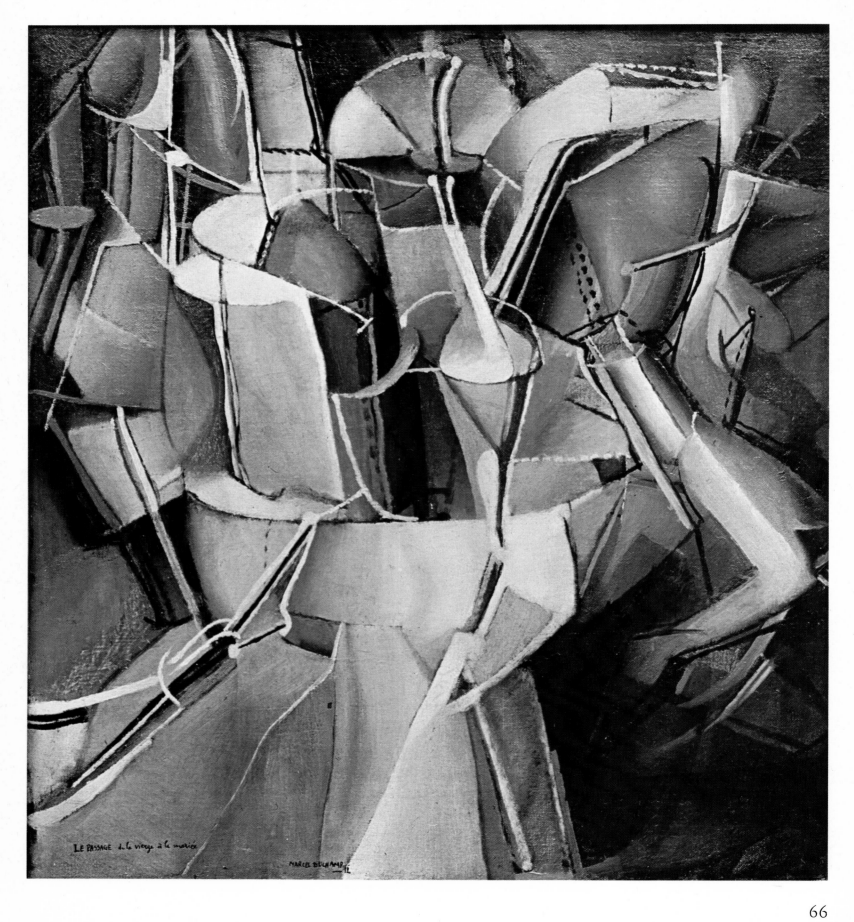

LE PASSAGE de la vierge à la mariée

MARCEL DUCHAMP 12

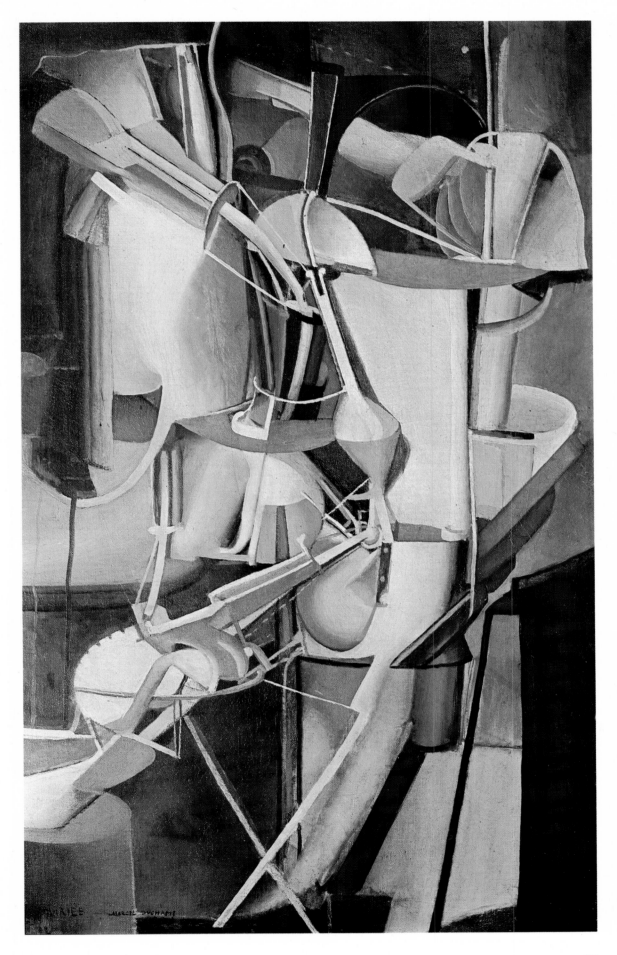

67

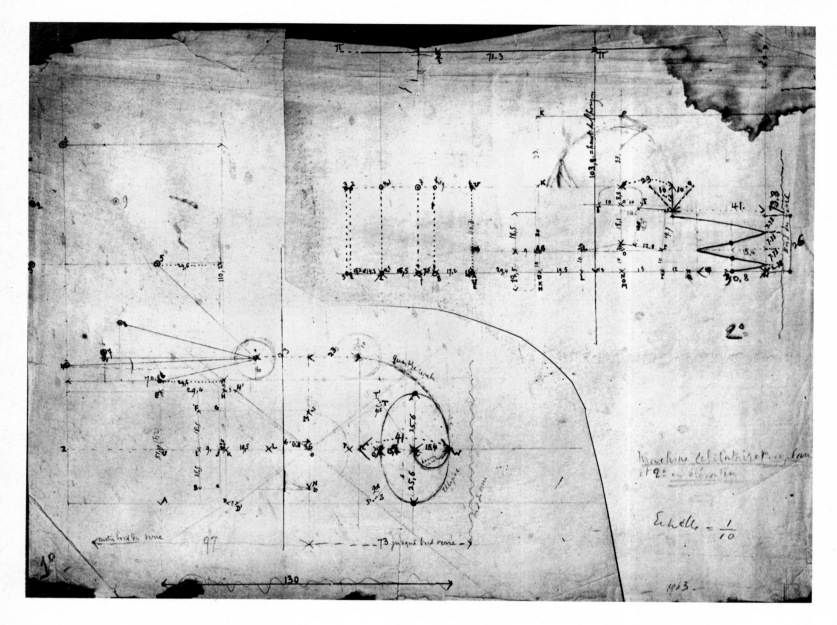

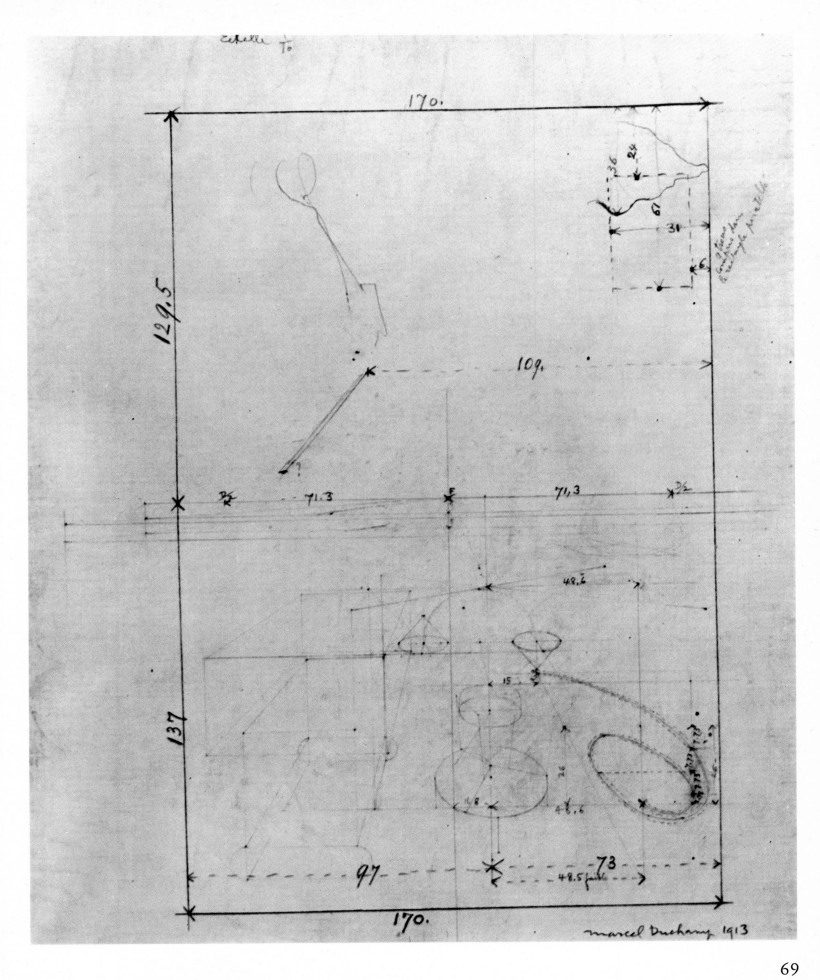

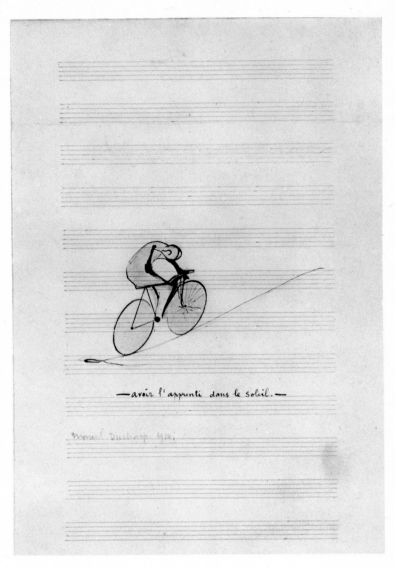

72

71

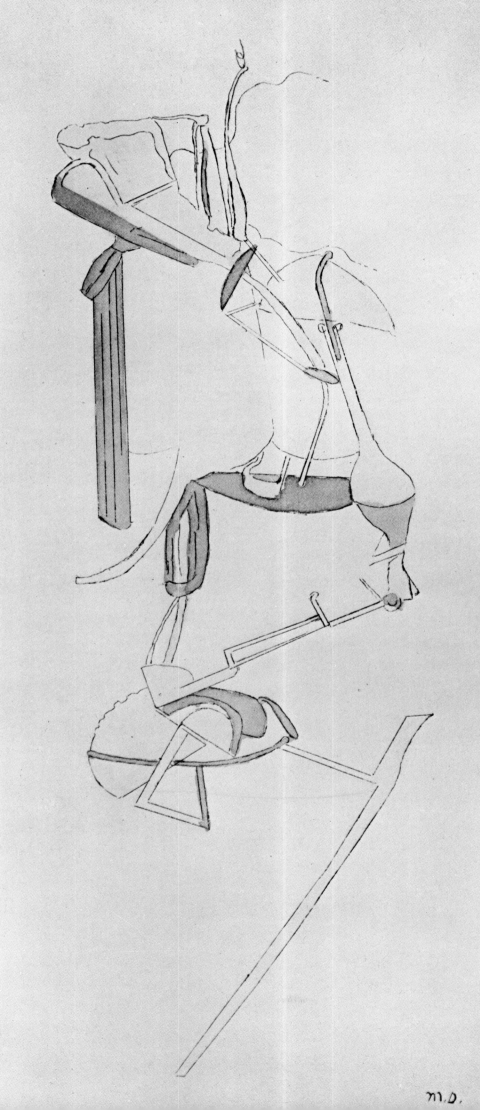

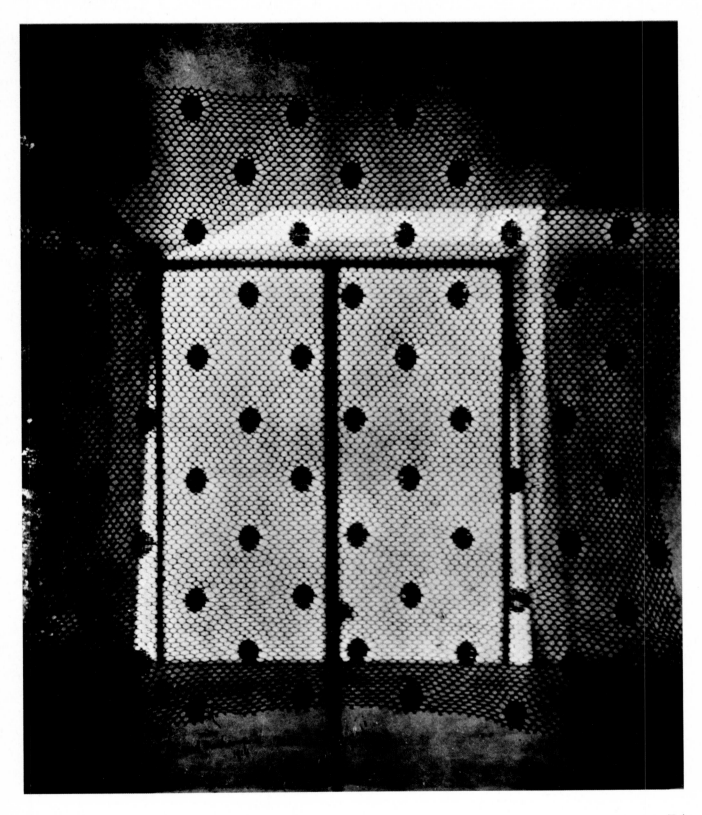

74

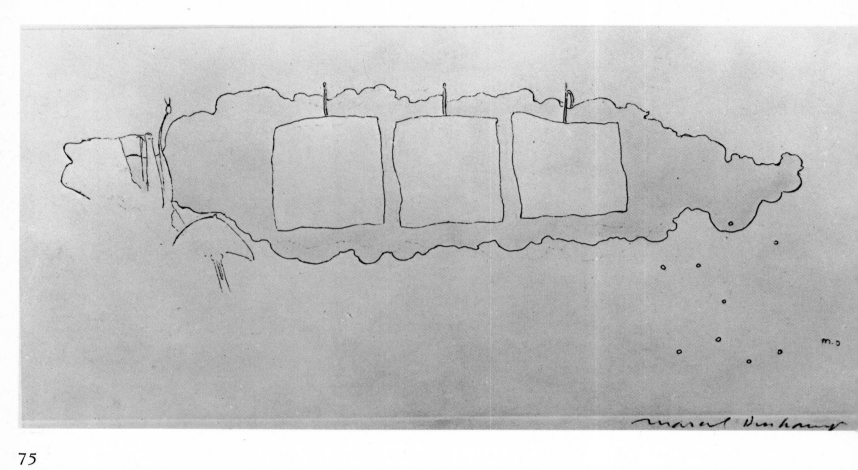

75

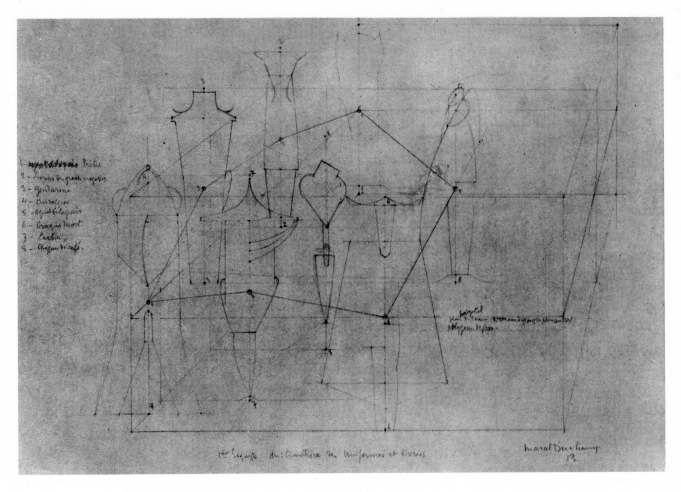

76

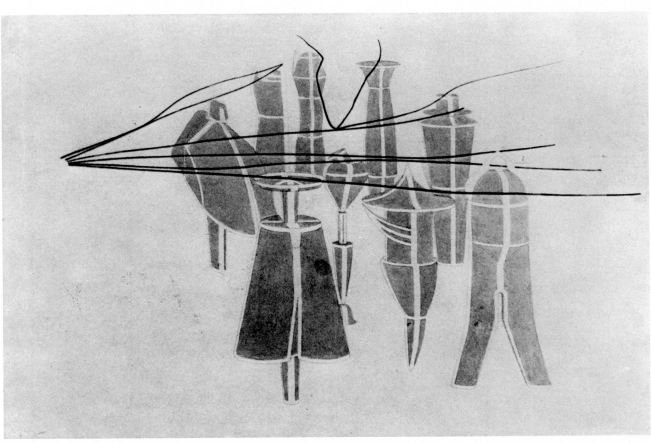

77

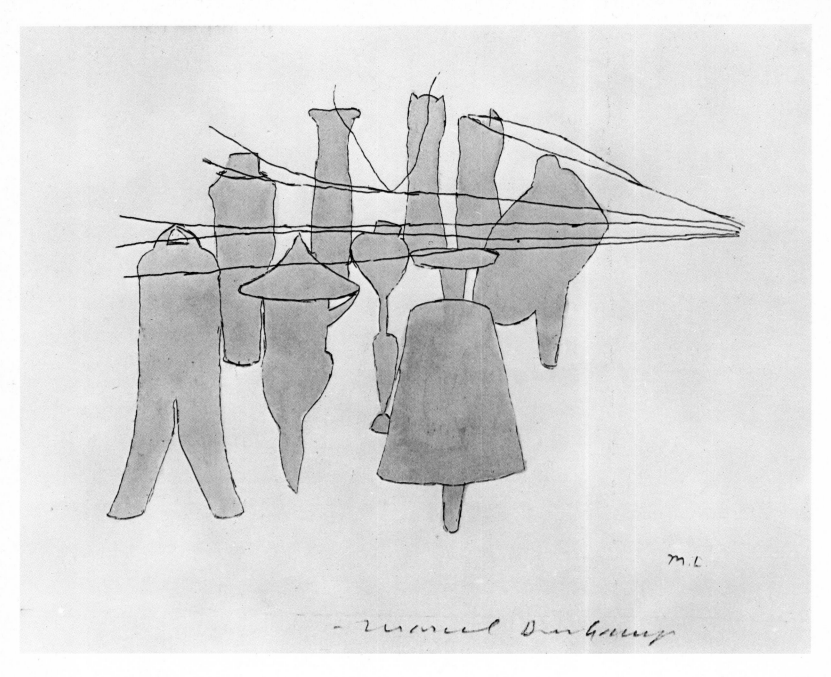

78

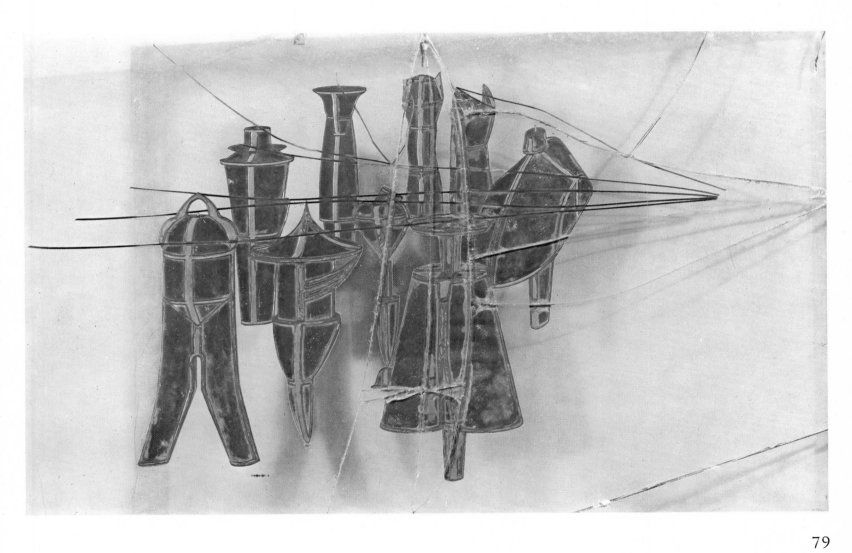

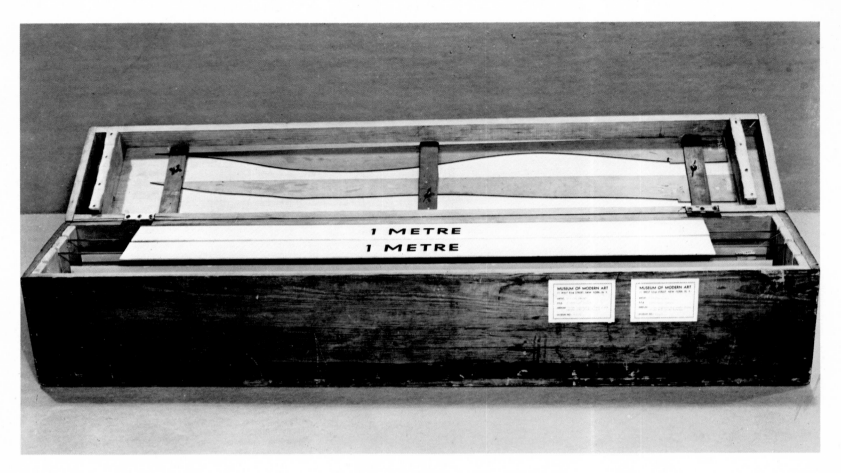

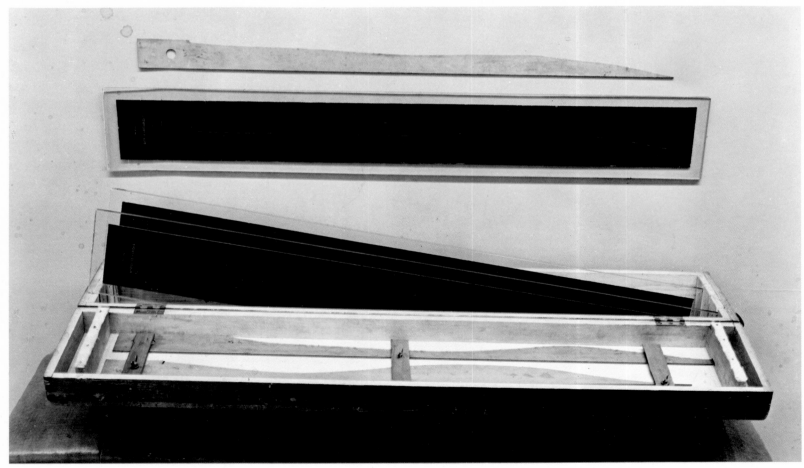

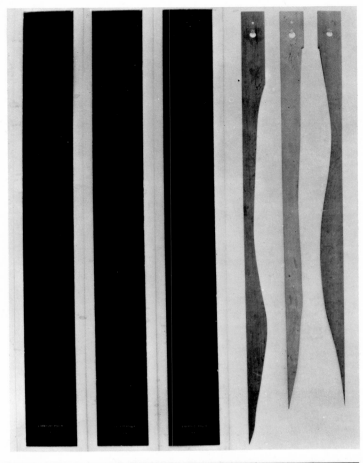

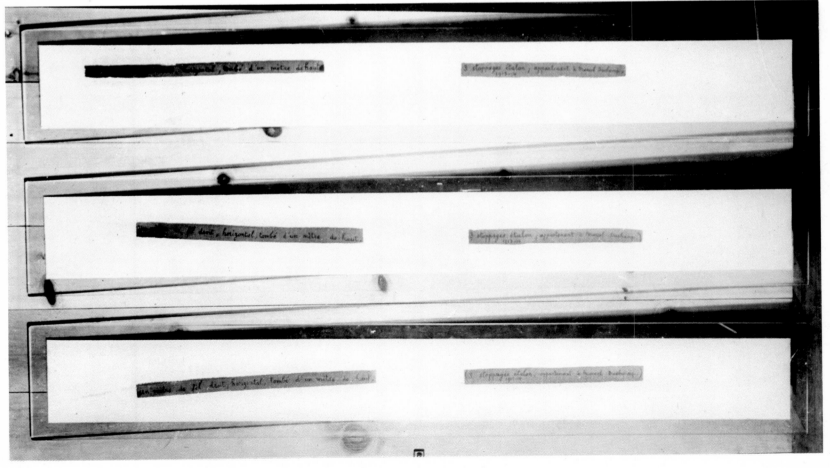

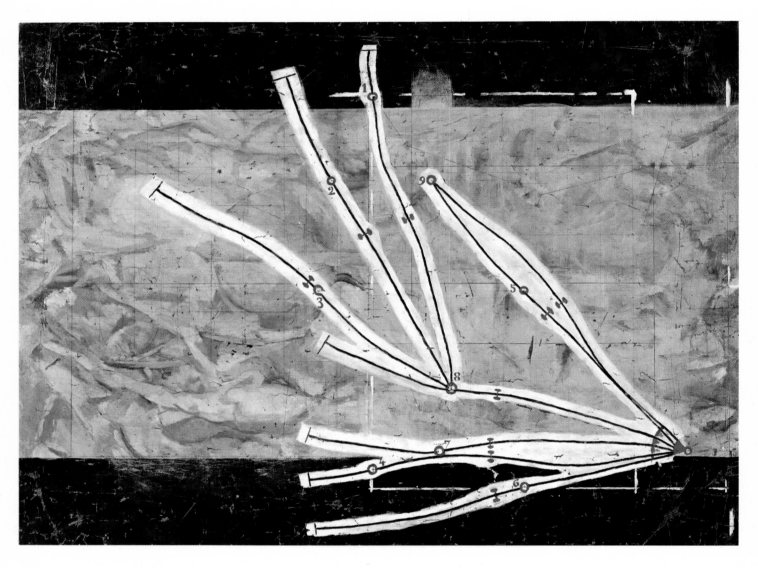

84

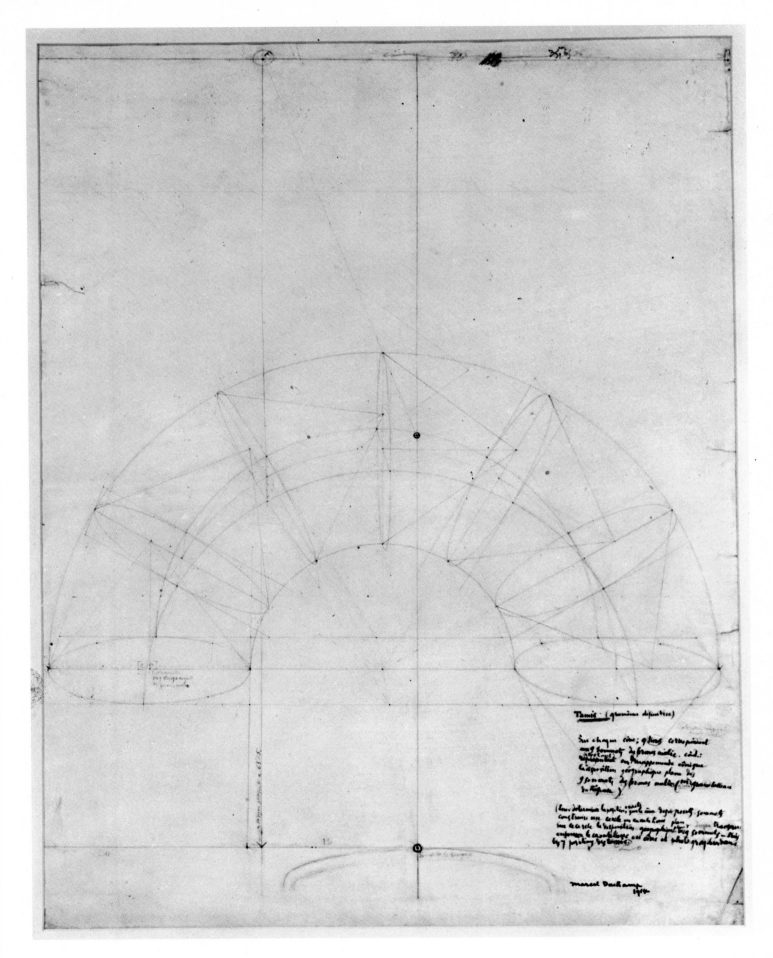

M.D.

marcel duchamp

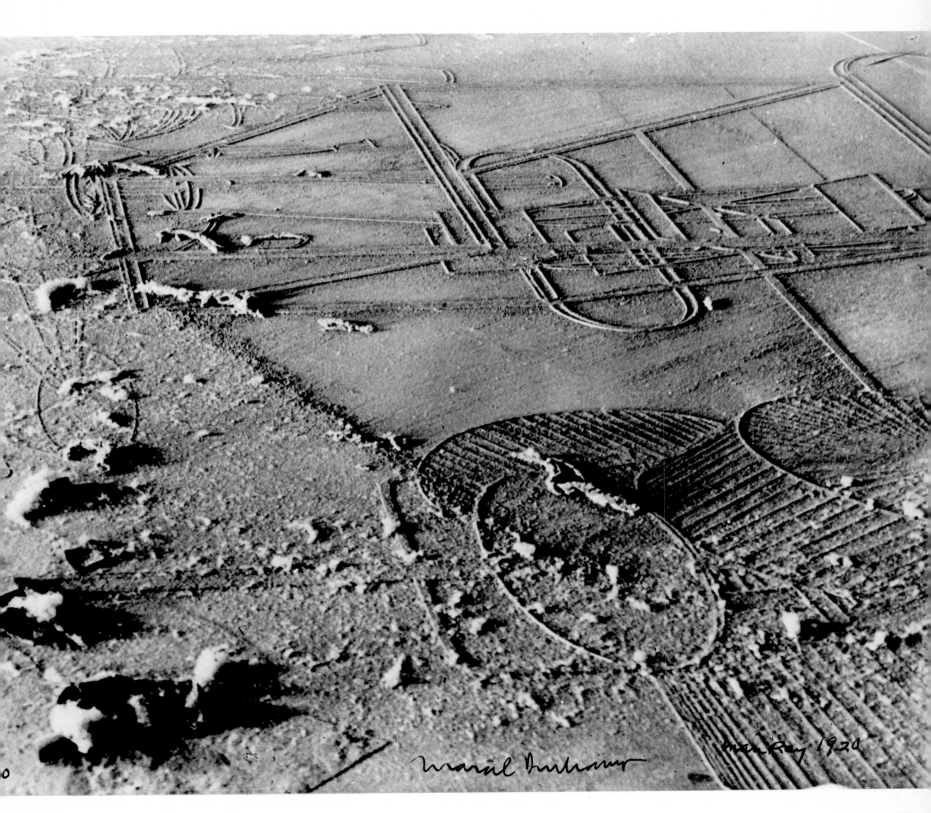

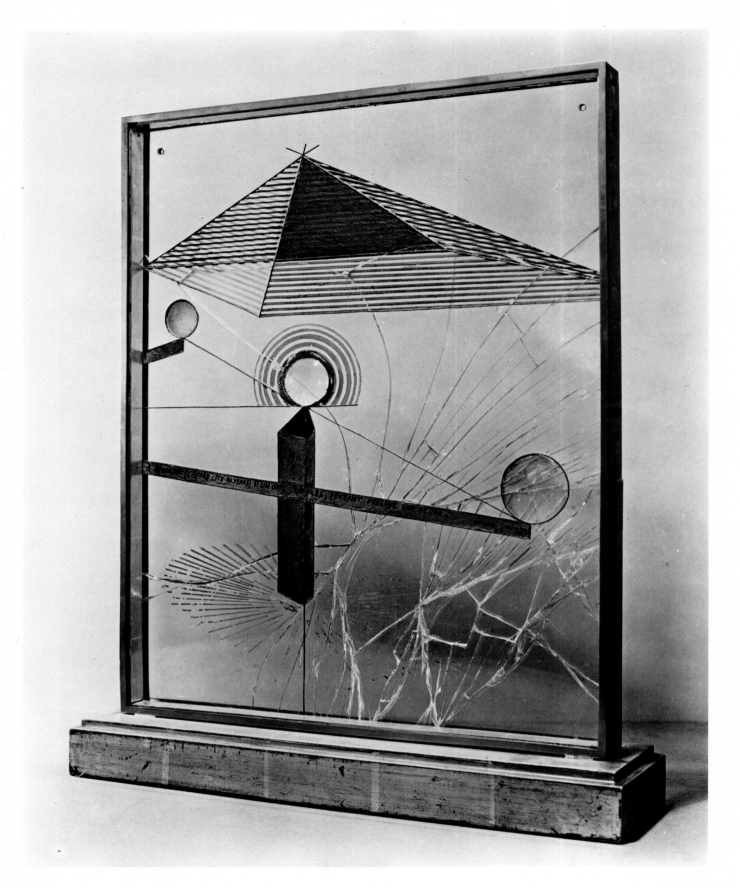

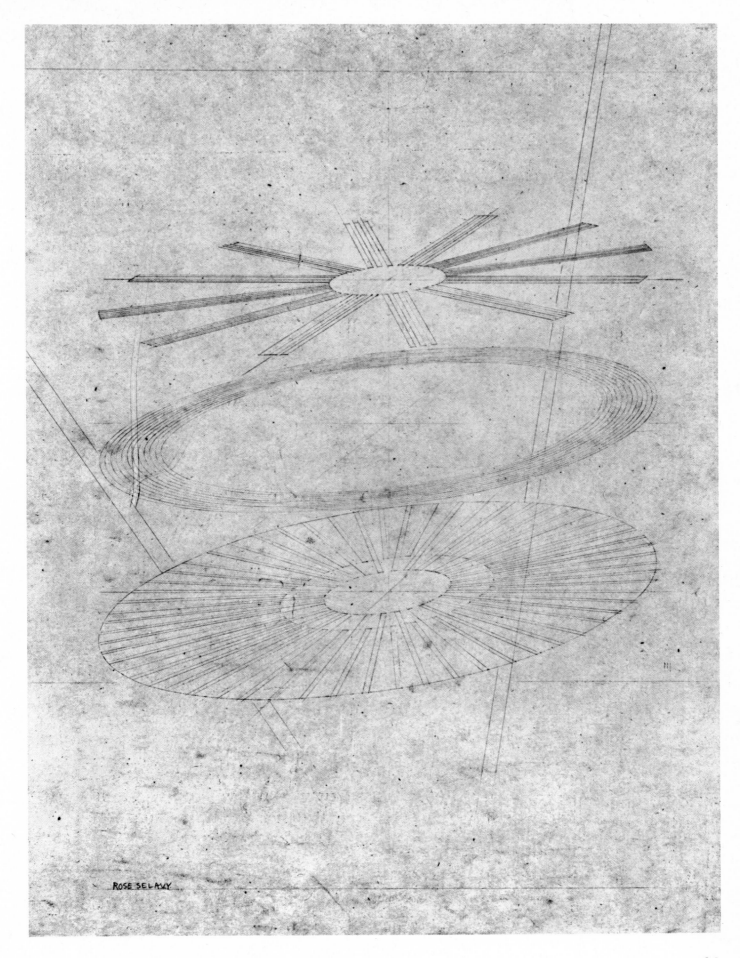

ROSE SELAVY

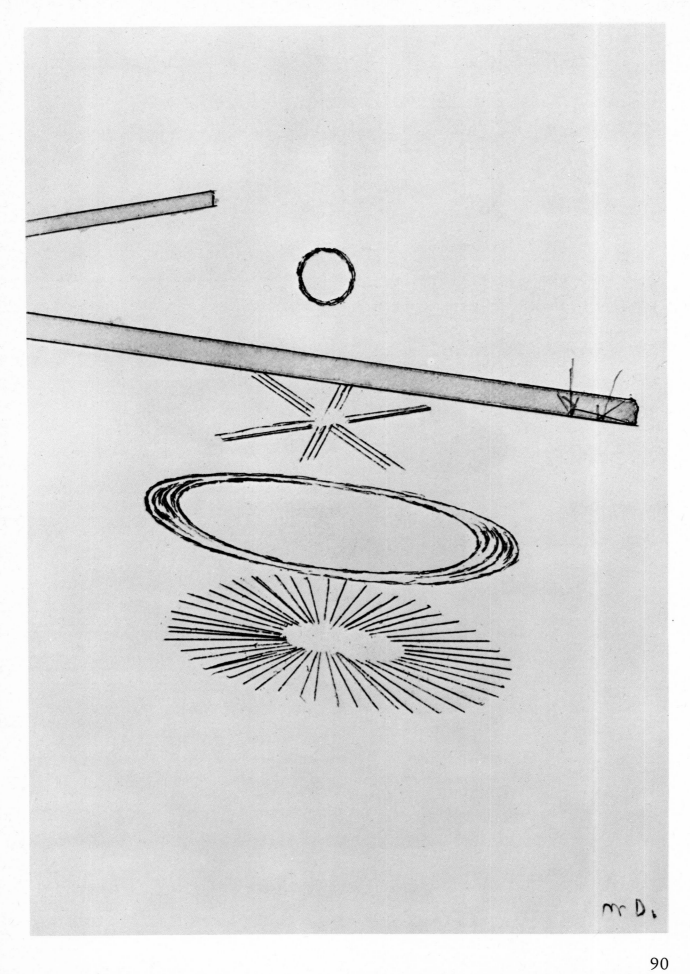

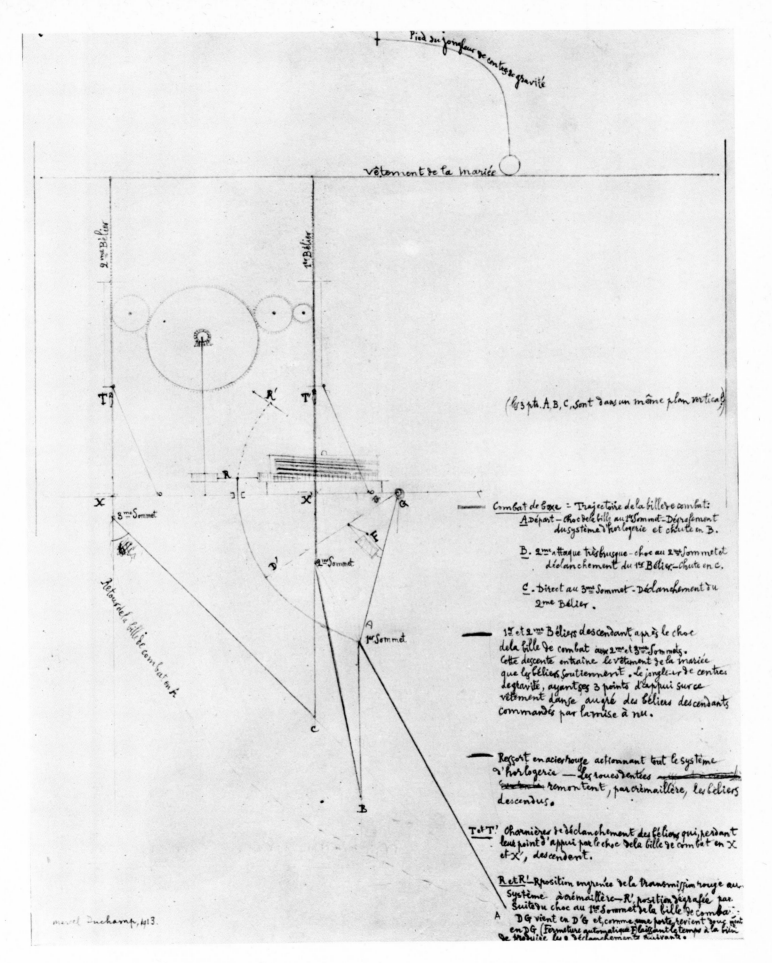

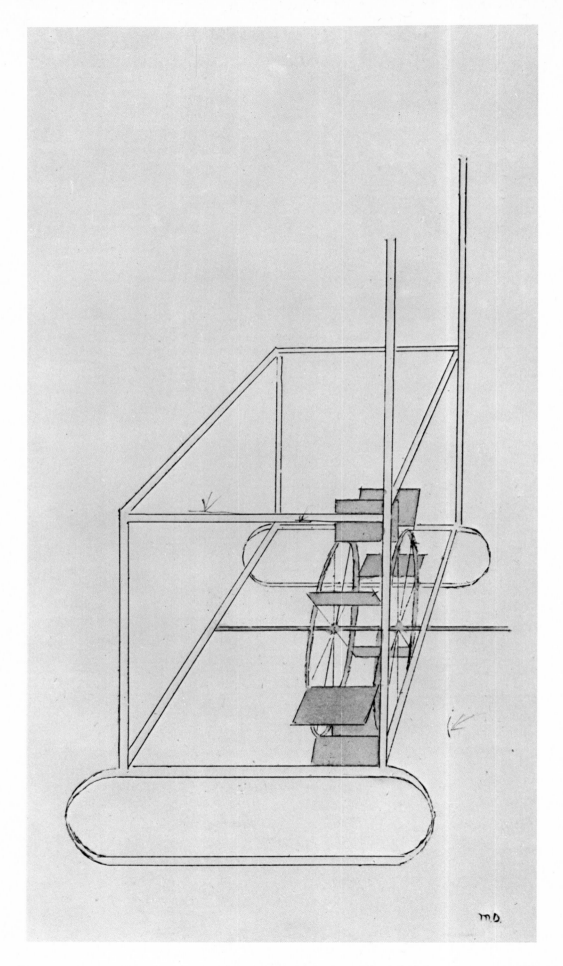

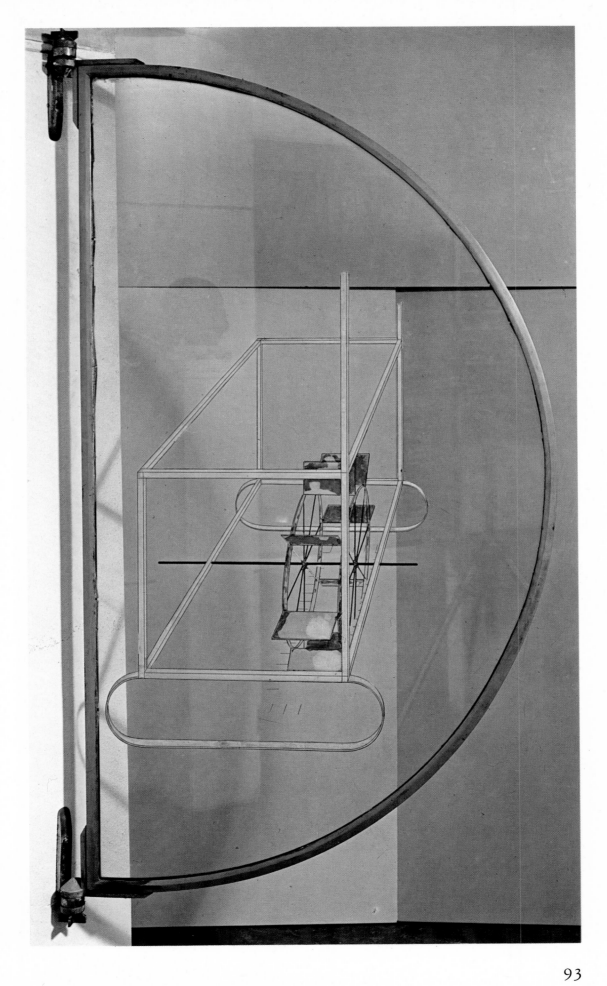

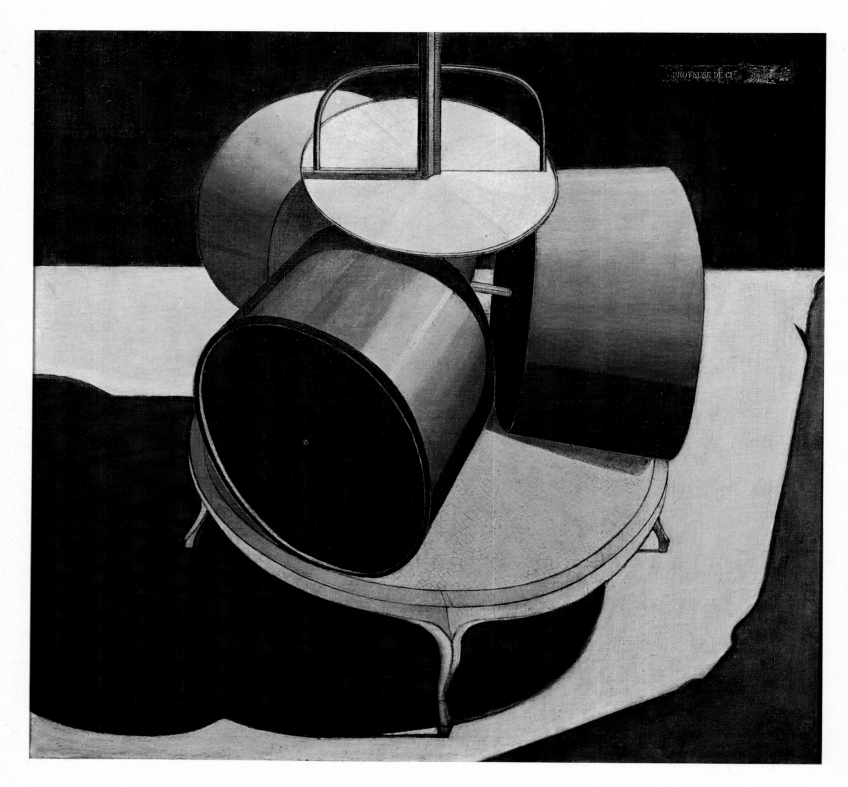

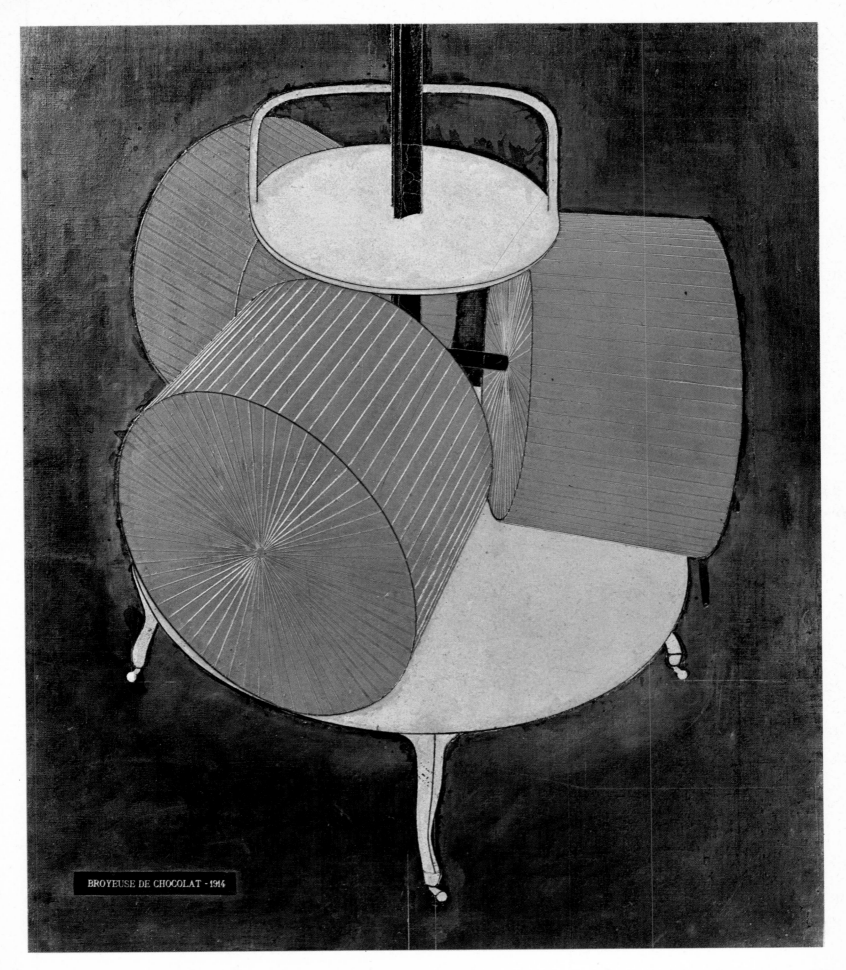

BROYEUSE DE CHOCOLAT - 1914

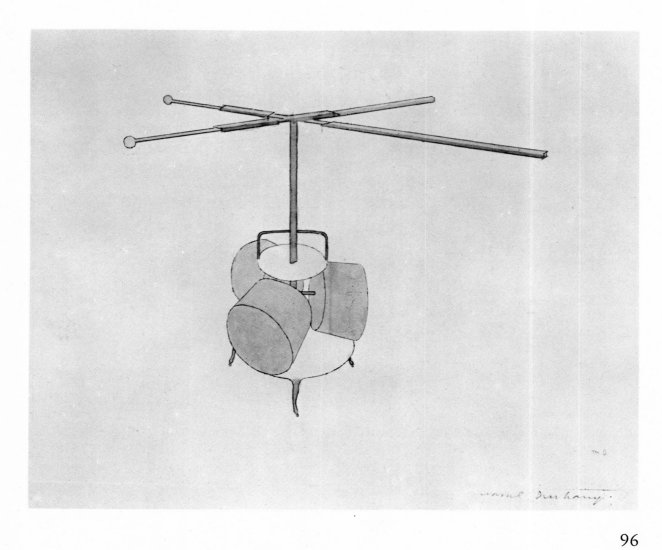

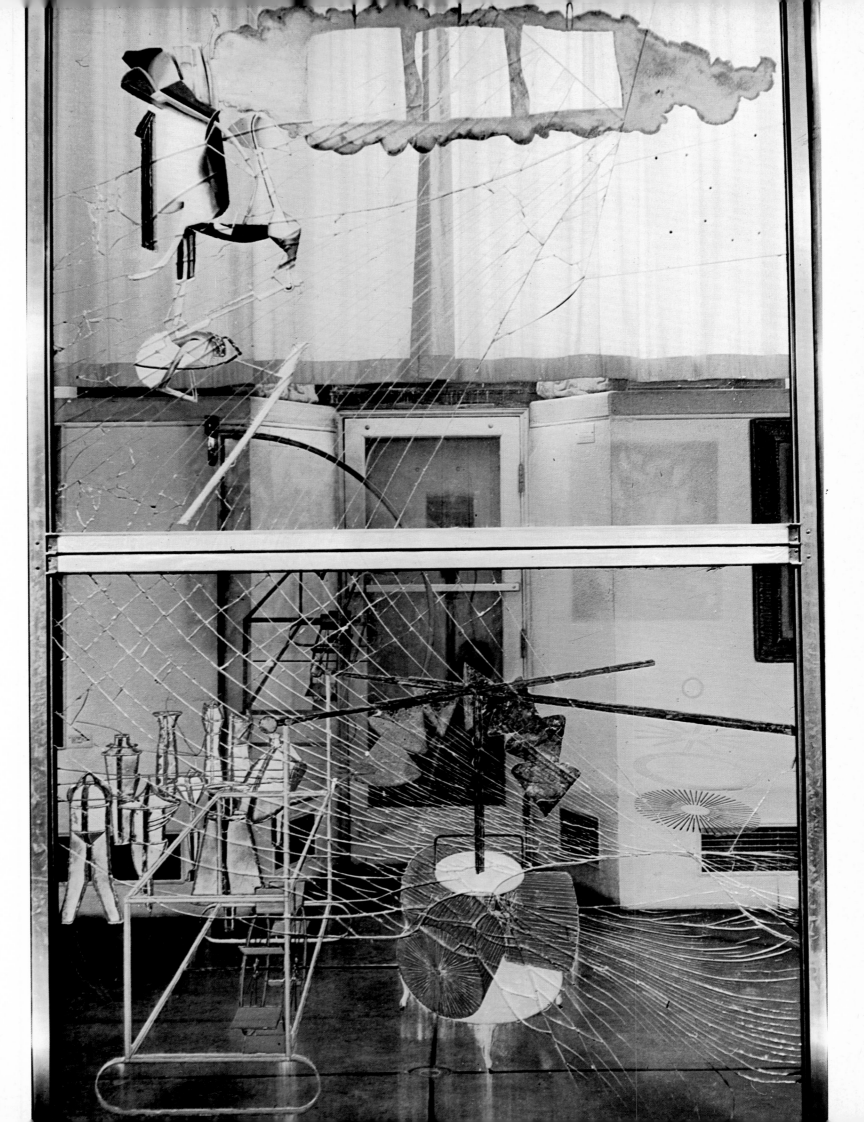

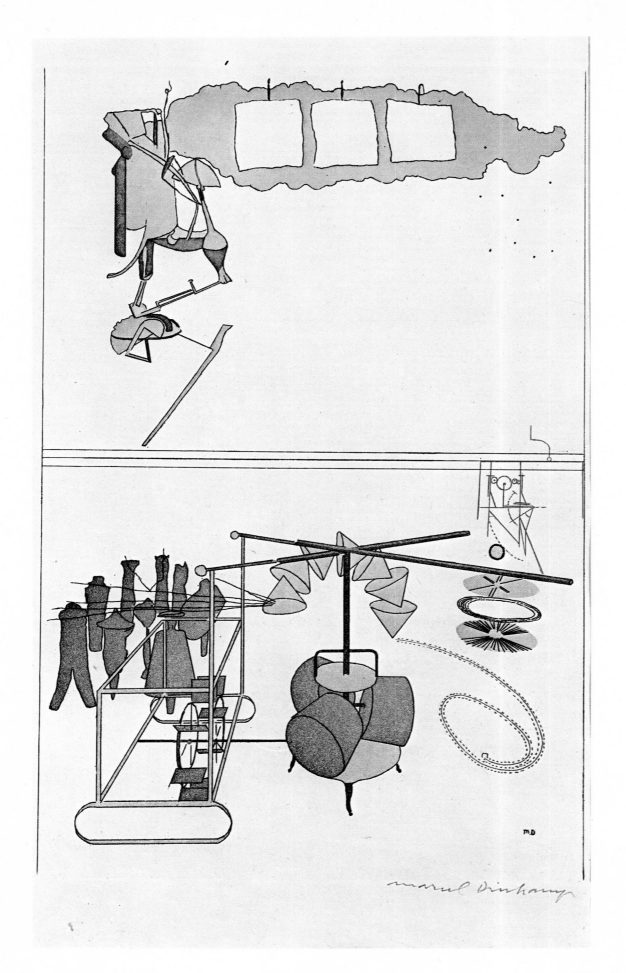

99

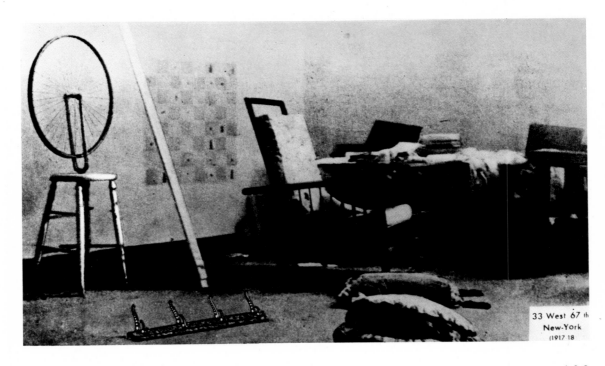

33 West 67 th
New-York
(1917 18

100

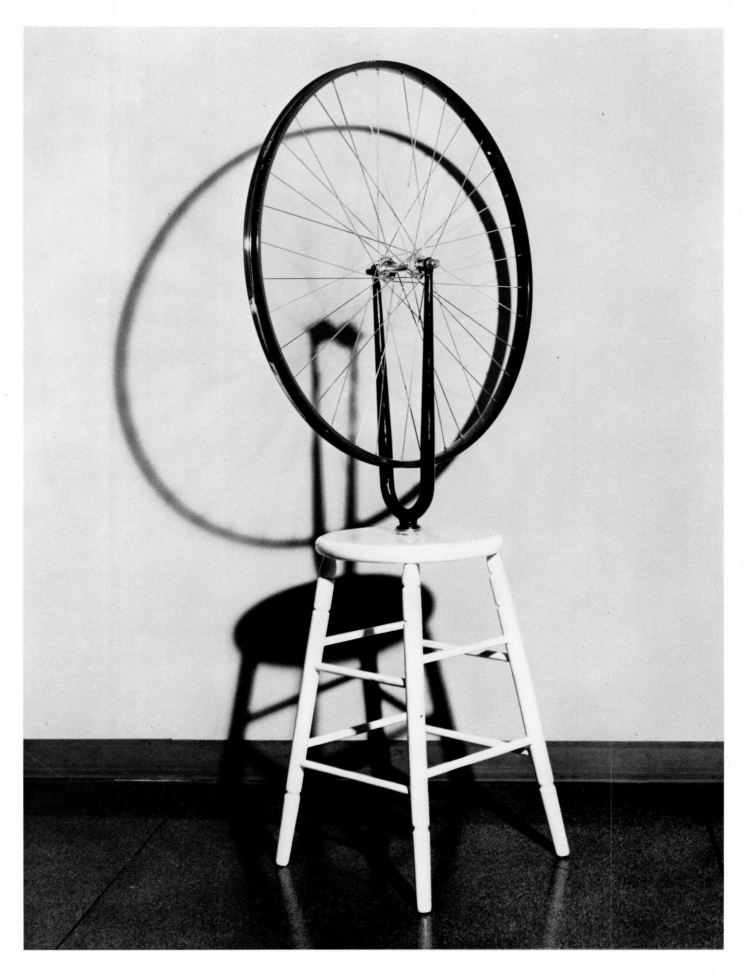

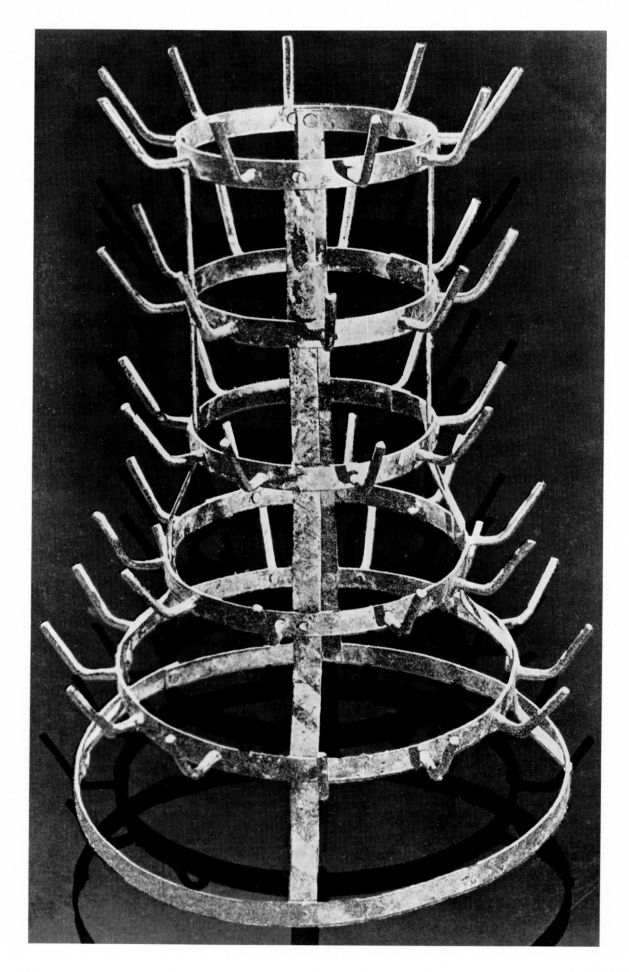

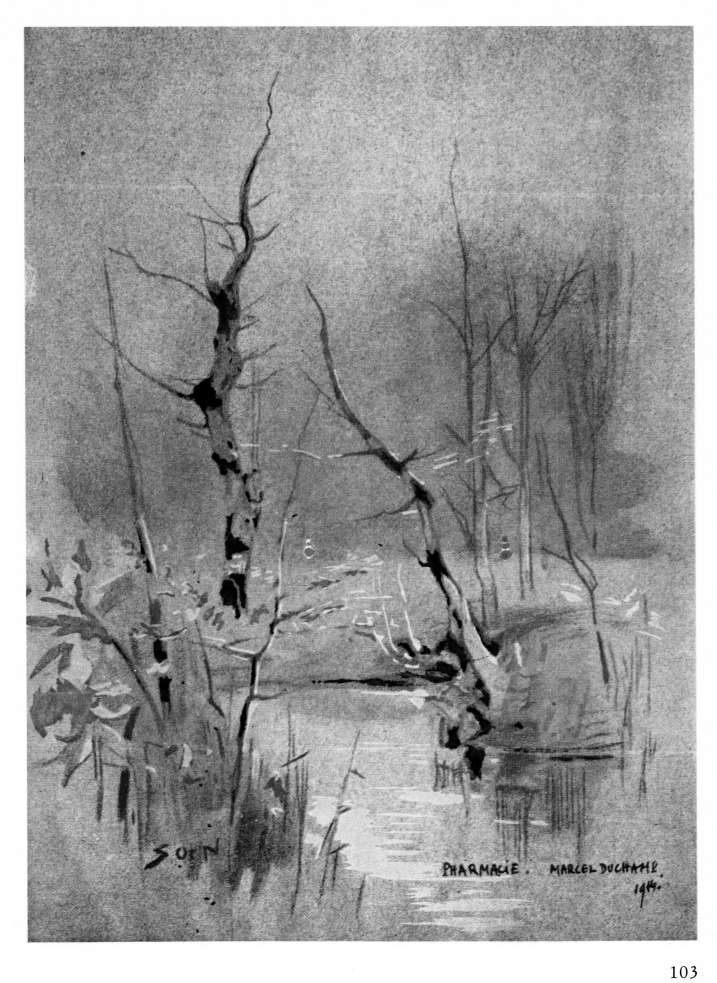

104

106

107

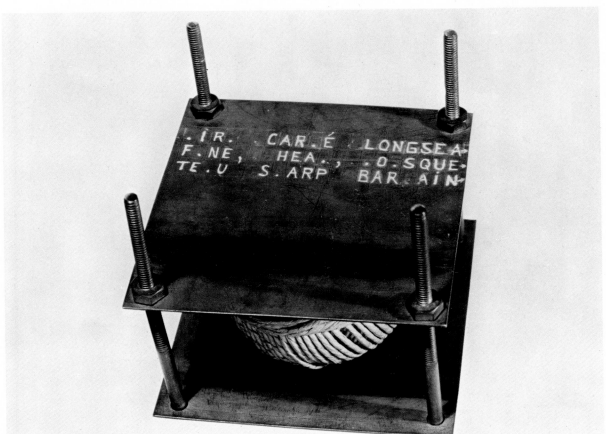

108

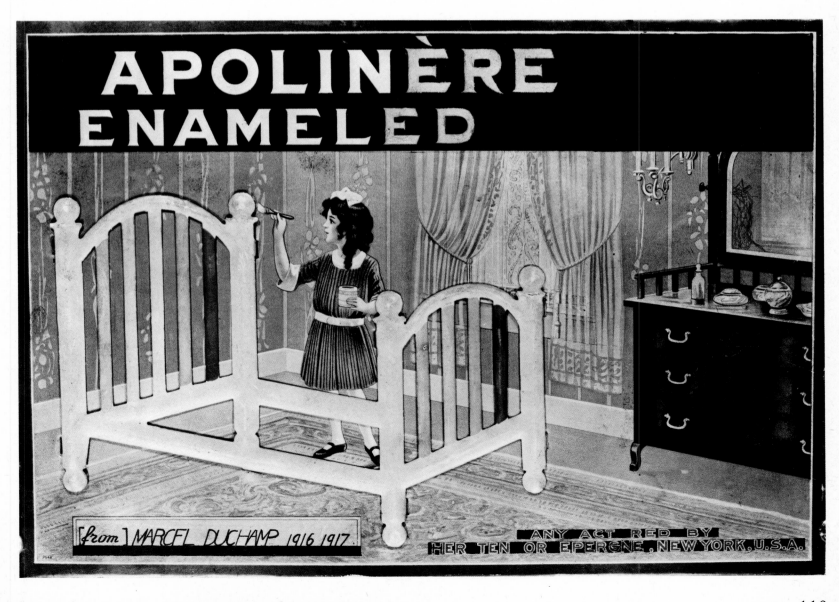

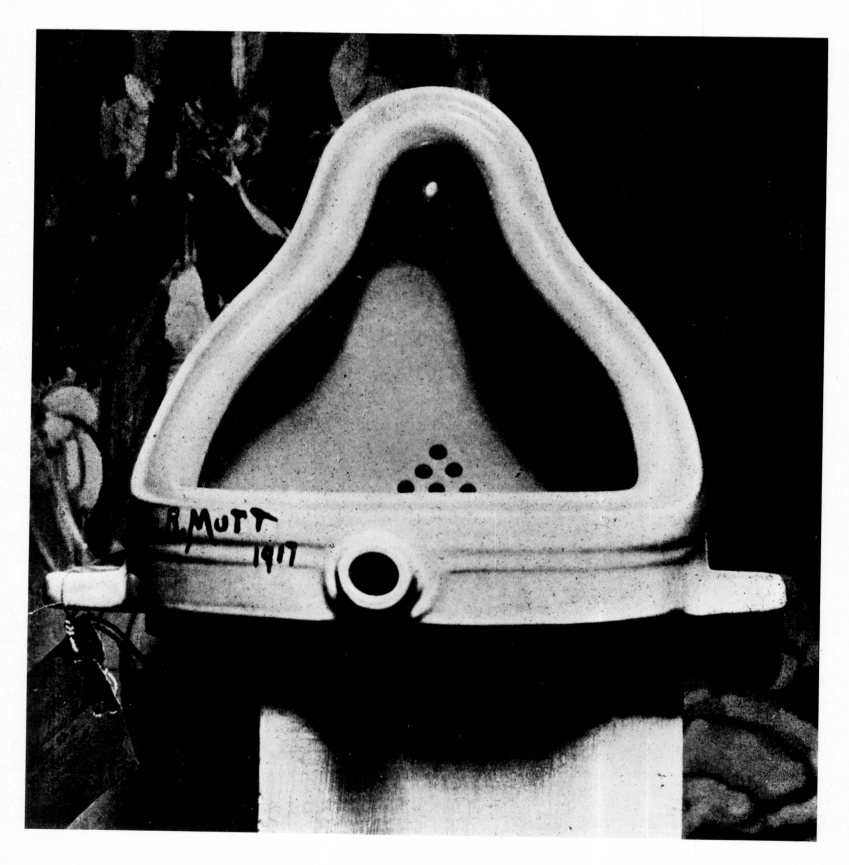

112

113

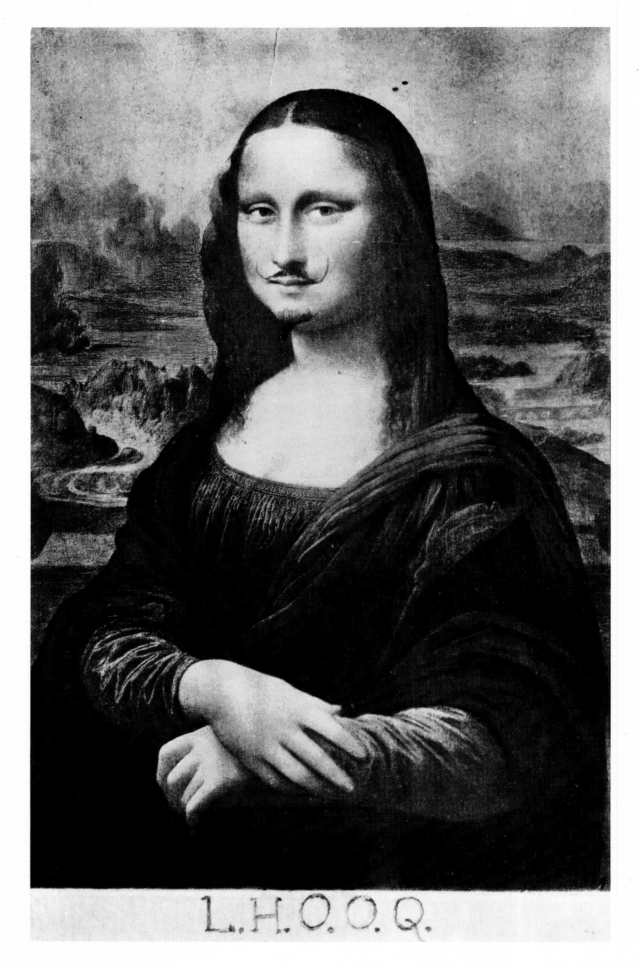

116

117

N° 4864 Paris December 3ʳᵈ 1919

The Teeth's Loan & Trust Company, Consolidated
2 Wall Street,
New York.

Pay to the Order of Daniel Tzanck
one hundred fifteen and no/100 Dollars

$ 115. 00/100 Marcel Duchamp

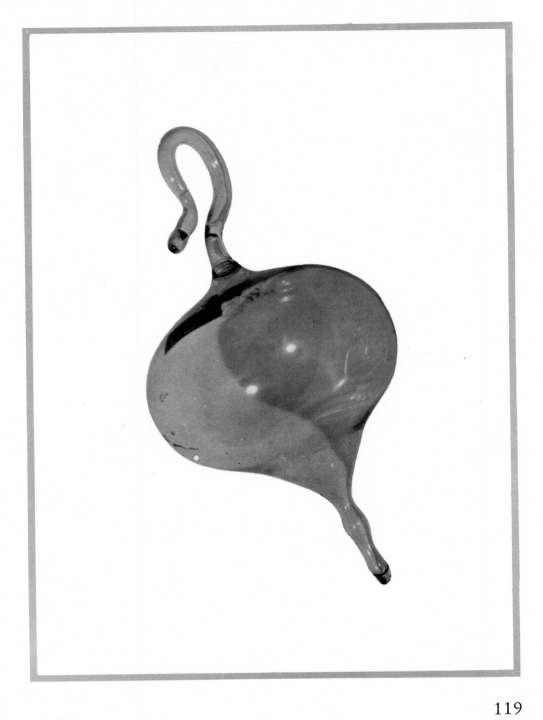

119

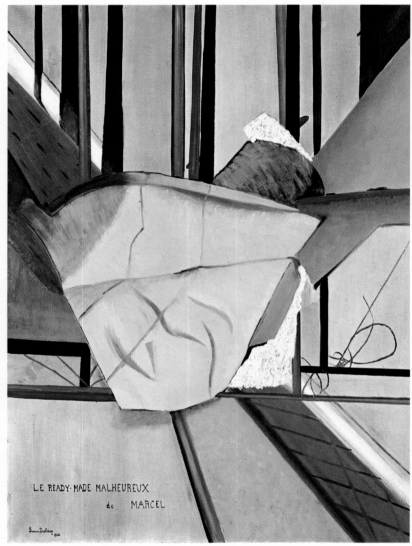

120

121

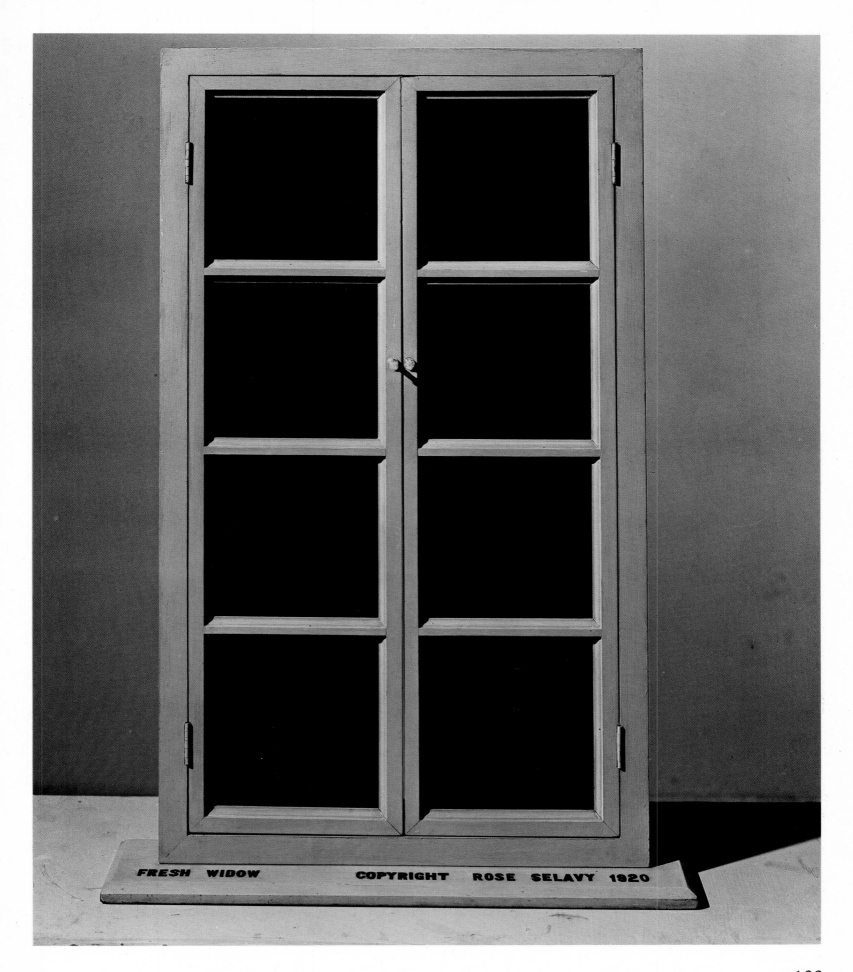

122

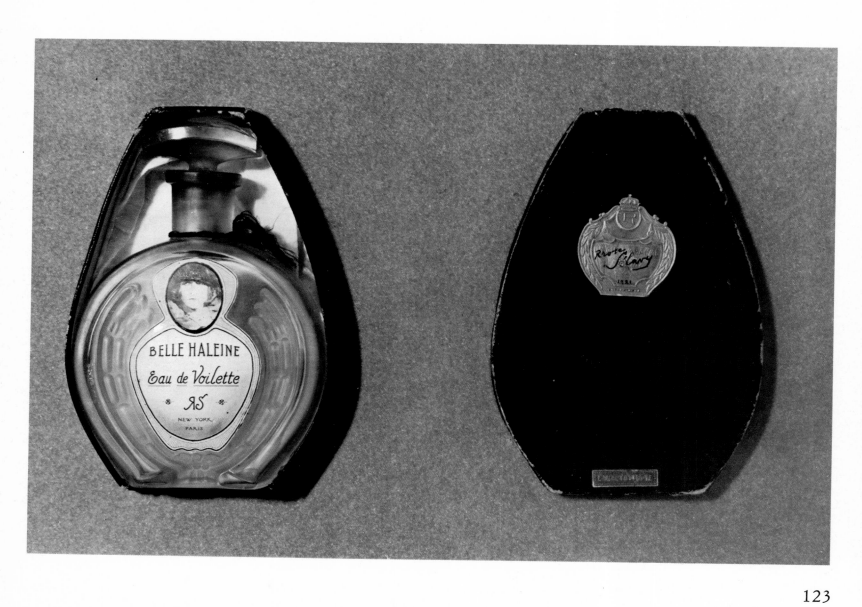

123

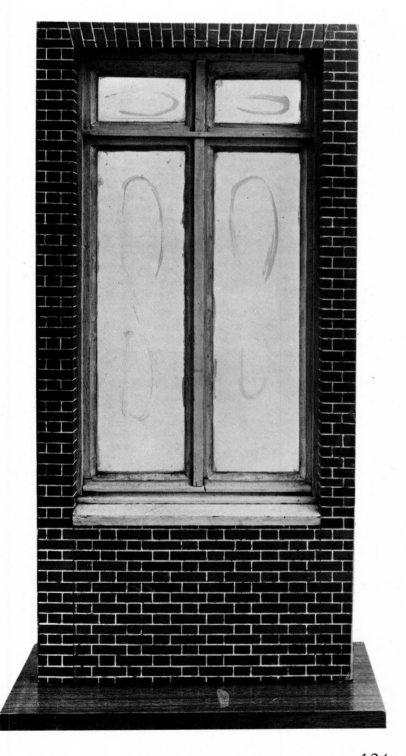

124

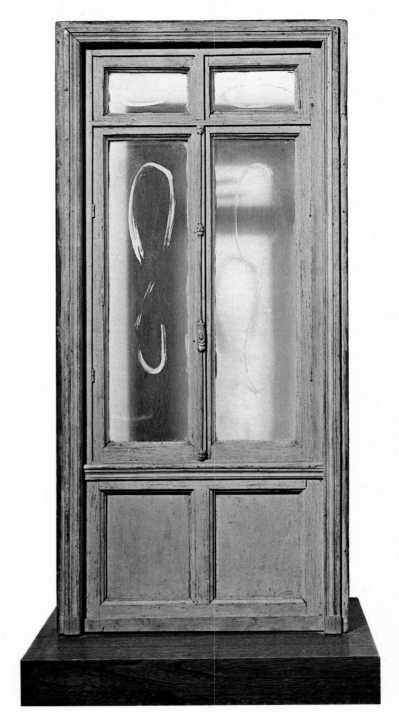

125

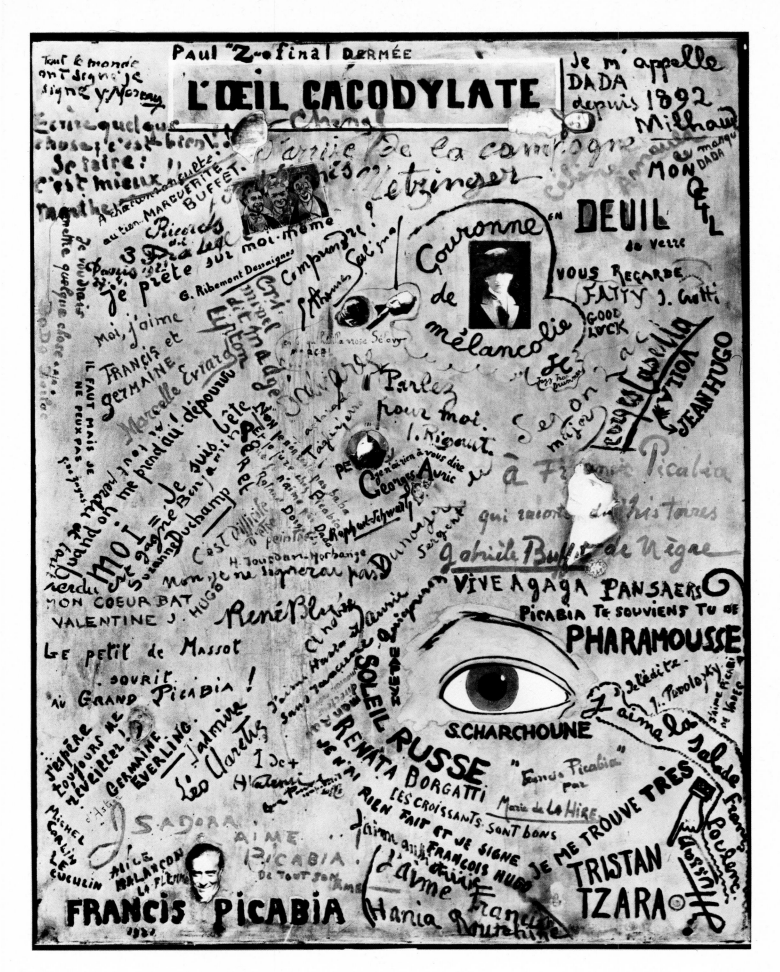

WANTED

$2,000 REWARD

For information leading to the arrest of George W. Welch, alias Bull, alias Pickens etcetry. etcetry. Operated Bucket Shop in New York under name HOOKE, LYON and CINQUER Height about 5 feet 9 inches. Weight about 180 pounds. Complexion medium, eyes same. Known also under name RROSE SÉLAVY

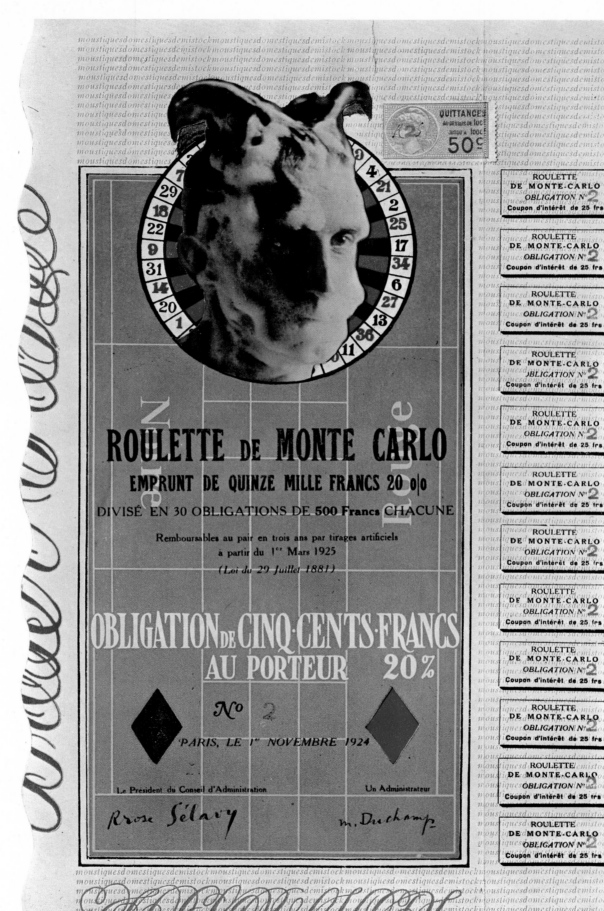

129

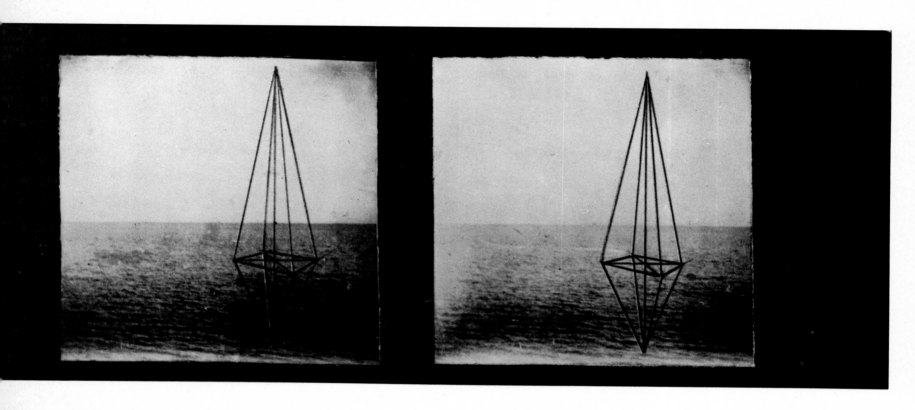

131

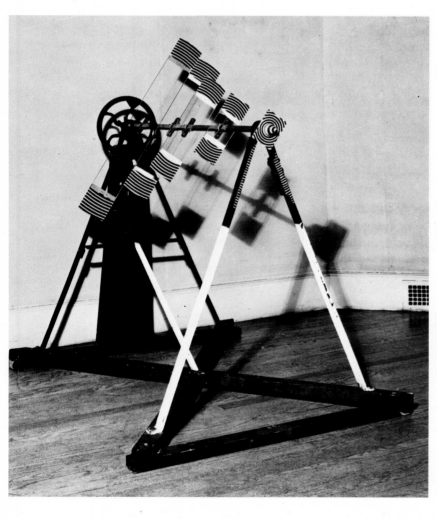

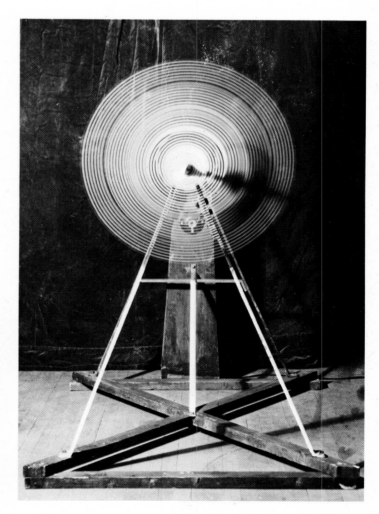

132

133

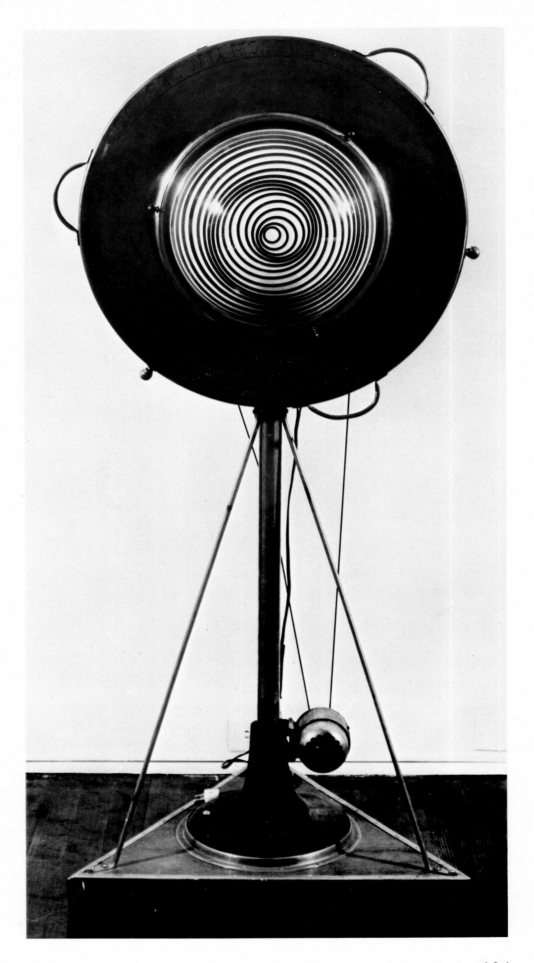

135

136

137

138

139

140

141

142

143

144

145

146

147

148

149

150

151

152

153

154

155

156

157

158

159

160

161

162

163

164

165

16

167

168

169

170

171

172

173

174

ROTORELIEF N° 9 — MONTGOLFIÈRE

175

ROTORELIEF N° 10 — CAGE — MODÈLE DÉPOSÉ

176

ROTORELIEF N° 11 — ÉCLIPSE TOTALE

177

ROTORELIEF N° 12 — SPIRALE BLANCHE — MODÈLE DÉPOSÉ

178

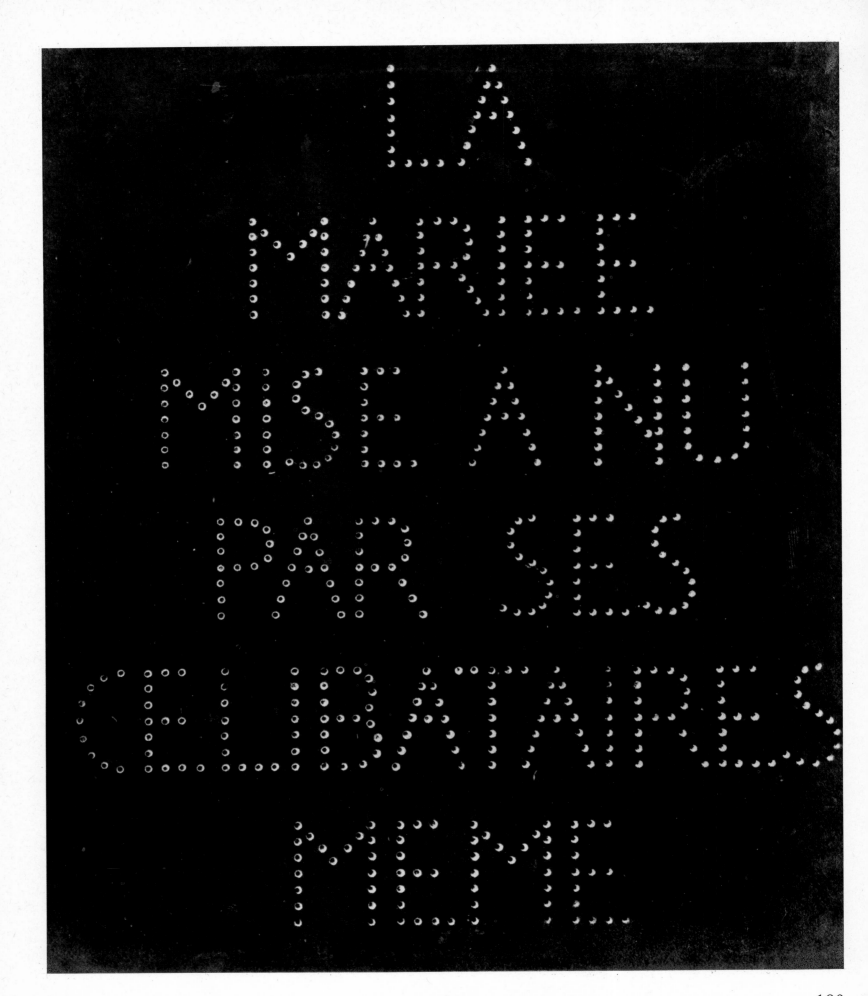

182 183

184

186

187

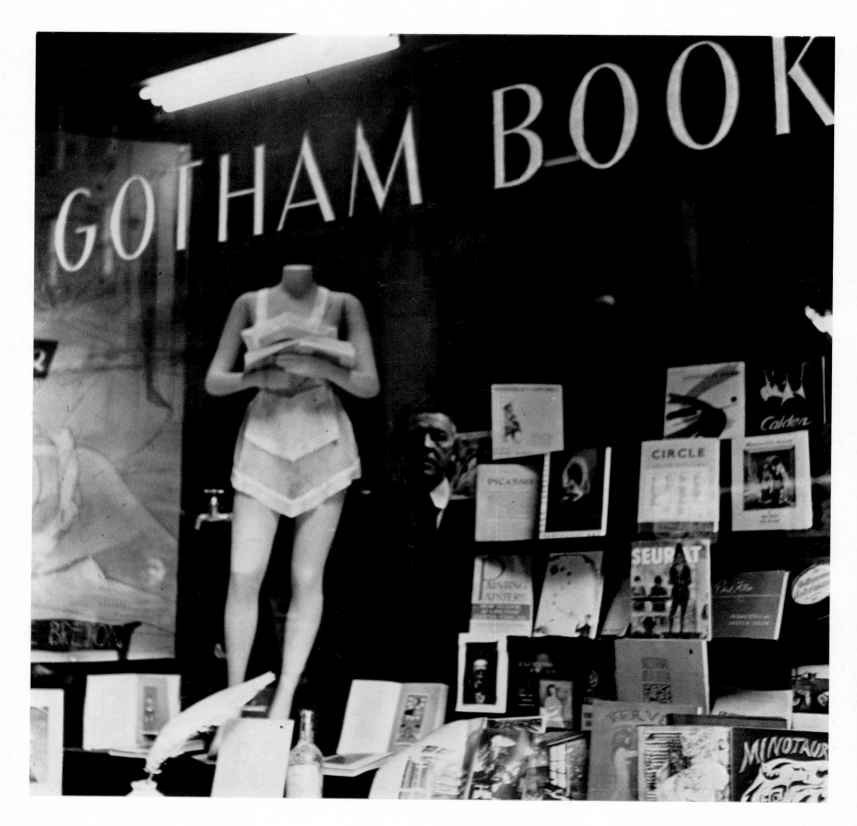

190

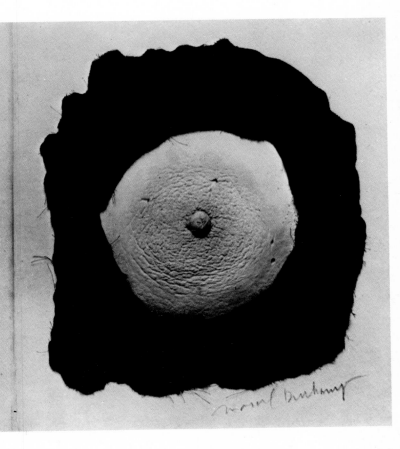

**PRIÈRE
DE
TOUCHER**

LE SURRÉALISME EN 1947

191

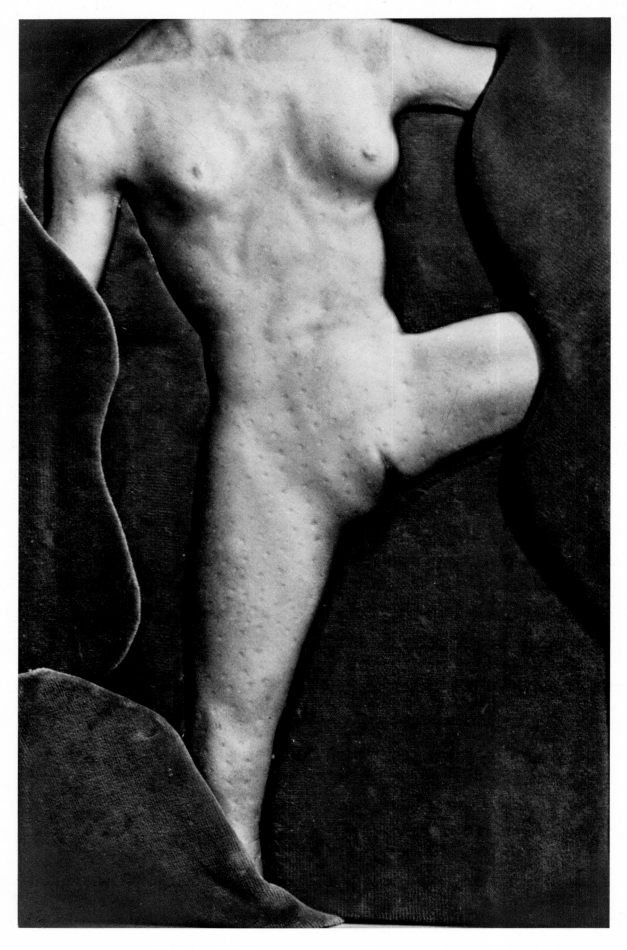

196

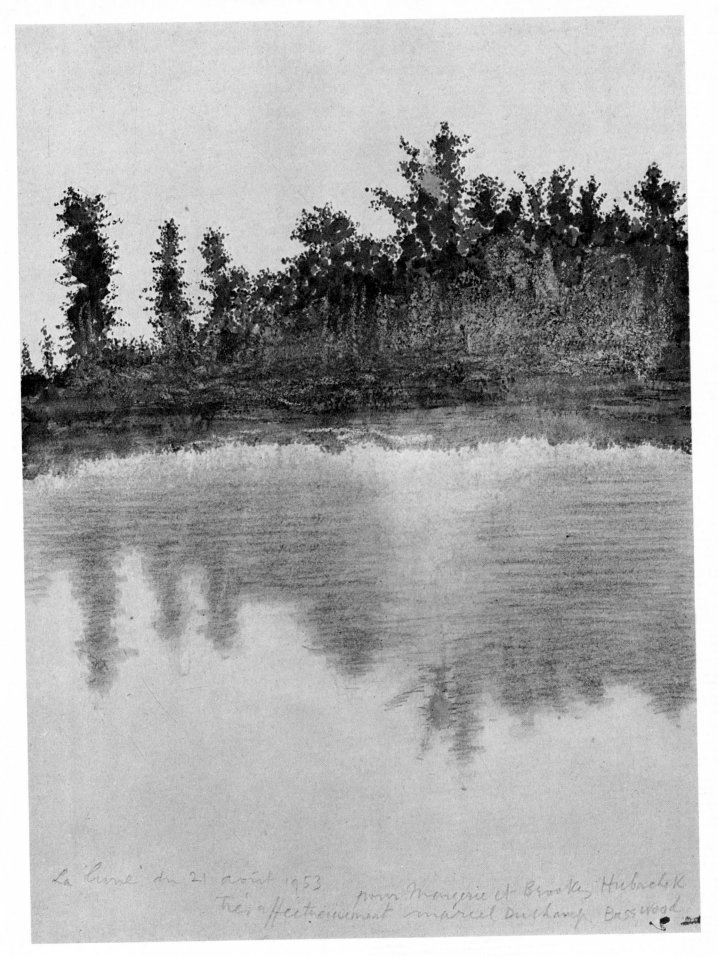

La "lune" du 21 août 1953
Très affectueusement marcel Duchamp Basswood

pour Margerie et Brookes Hubachek

201

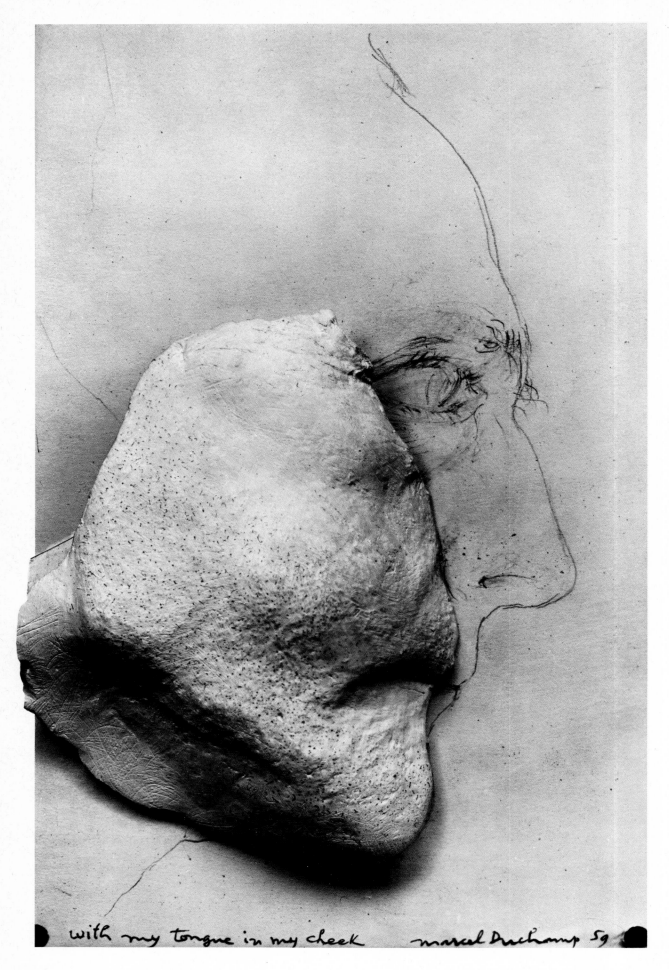

with my tongue in my cheek marcel Duchamp 59

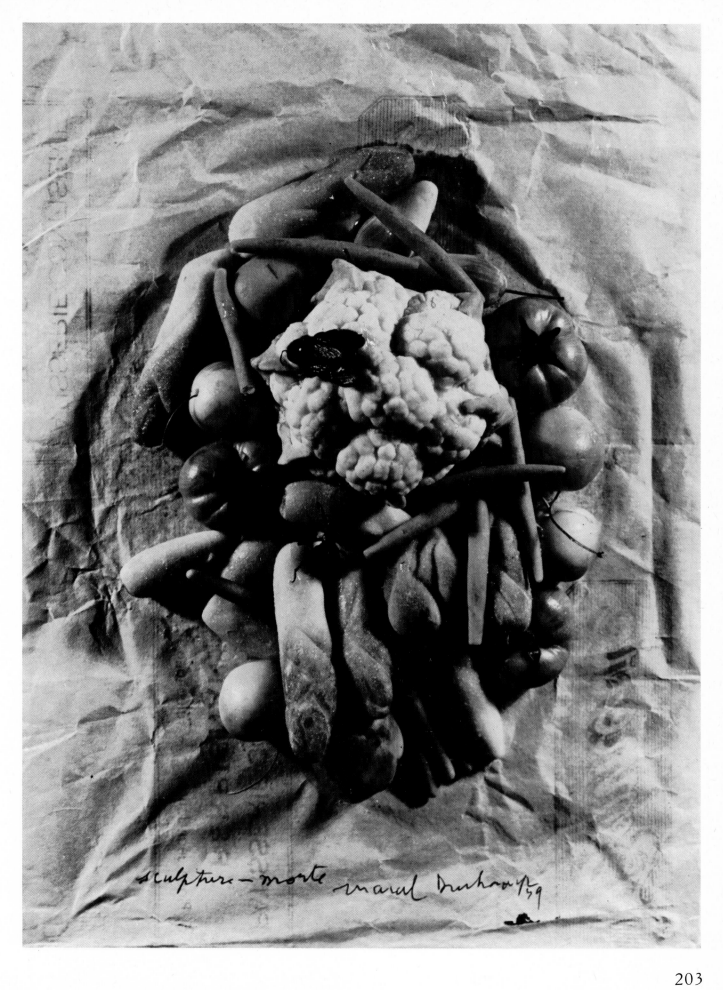

sculpture—morte Marcel Duchamp '59

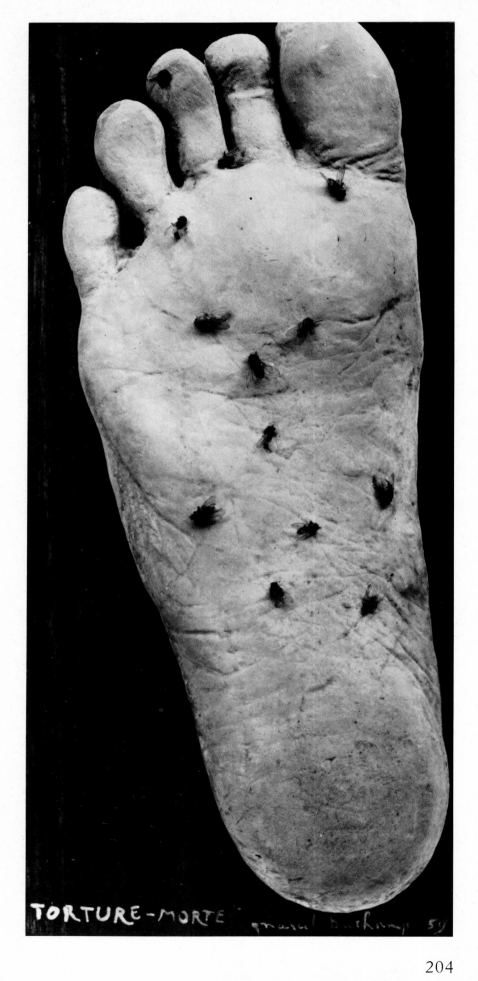

TORTURE-MORTE marcel duchamp 59

204

204 bis

Bon à tirer
Marcel Duchamp

M.D.

210 bis